P9-CKX-151

DEALERS

Galka Scheyer

Dalzell Hatfield

Frank Perls

Earl Stendahl

ACTOR-PATRONS

Paulette Goddard

Vincent Price

Fanny Brice

Edward G. Robinson

Facilitated the creation of the Modern Institute of Art, 1948

Fred Sexton

Walter and Louise Arensberg

Jake Zeitlin

Beatrice Wood

Lloyd Wright

Albert Lewin

William Copley

Gloria de Herrera

ood Keyes

Spaulding

Man Ray

m

Browner] Man Ray

Marcel Duchamp

NEW YORK

Hans Richter

NEW YORK

Salvador Dalí

mice

White

Florence Homolka

Max Ernst — m — Dorothea Tanning

SEDONA, ARIZONA

Charles Henri Ford

NEW YORK

Assisted in bringing Picasso's *Guernica* to Los Angeles, 1939

— — — Presumed

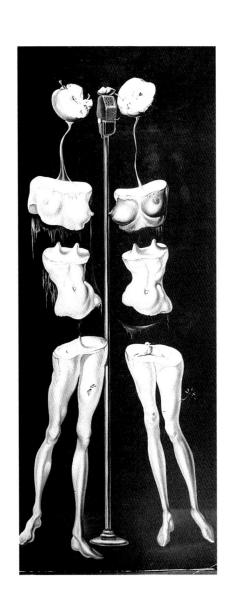

Mark Nelson and Sarah Hudson Bayliss

EXQUISITE CORPSE
SURREALISM AND THE BLACK DAHLIA MURDER

BULFINCH PRESS
NEW YORK · BOSTON

FRONTISPIECE:
SALVADOR DALÍ, *ART OF RADIO,*
CA. 1944 (SEE PAGE 44)

THIS PAGE: ANDRÉ BRETON, MAN RAY,
MAX MORISE, AND YVES TANGUY,
CADAVRE EXQUIS (EXQUISITE CORPSE),
1927 (SEE PAGE 97)

Contents

There is every reason to believe that
*[surrealism] acts on the mind very
much as drugs do; like drugs, it creates
a certain state of need and can push
man to frightful revolts.*

ANDRE BRÉTON
"MANIFESTO OF SURREALISM," 1924

*Supposin' I did kill the Black Dahlia.
They couldn't prove it now. They can't
talk to my secretary anymore because
she's dead.*

GEORGE HODEL, FEBRUARY 18, 1950,
FROM AUDIO SURVEILLANCE TRANSCRIPTS

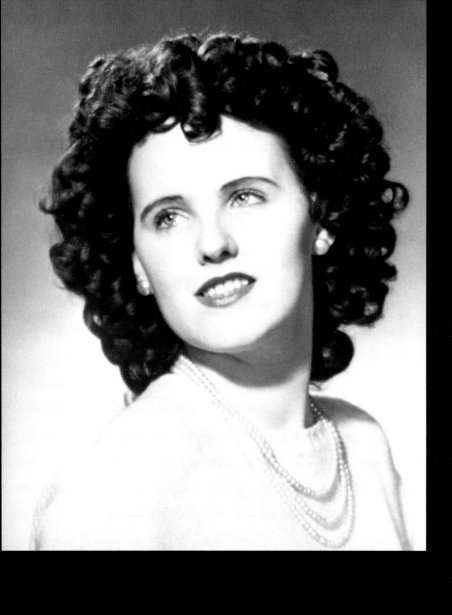

Introduction: A Death and Its Aftermath

This book is a hypothesis, built from a wealth of visual and factual material. Unlike others who have preceded us, we make no definitive claim to resolve one of the most notorious unsolved crimes of the twentieth century, the so-called Black Dahlia murder of 1947. We do suggest that answers to key questions about this crime may have been hiding, for decades, in plain sight.

On January 15, 1947, the naked body of a young woman, neatly bisected and carefully posed, was found in the grass in the Leimert Park neighborhood of Los Angeles. The killer had left his mark on the body in many ways. He had removed geometric sections of flesh from the woman's breasts and left leg and had positioned the body in a very particular and unusual way. Police and reporters at the scene said that she looked like a disassembled mannequin or a discarded marionette.

The slaying of Elizabeth Short (fig. 1) launched one of the most celebrated manhunts and crime-related media spectacles in history. There were more than three hundred initial suspects and over a dozen confessions. No one was charged with the crime. Today, the Black Dahlia case remains officially unsolved. It is one of the most compelling murder mysteries of our time and has spawned several competing theories about who did it and why. Along with such notorious incidents as the recall of corrupt Los Angeles mayor Frank Shaw and the murder of gangster Benjamin "Bugsy" Siegel, the Black Dahlia murder has come to symbolize a sordid and politically corrupt aspect of midcentury Los Angeles that coexisted, and sometimes commingled, with Hollywood wealth and glamour.

Bridging the worlds of art and crime, *Exquisite Corpse* shows that Elizabeth Short's body and the killer's crime-scene signatures bear a startling resemblance to elements in works by leading surrealist artists of the time. We posit that the killing may have been directly linked to surrealist art and ideas — in particular, the movement's many representations of beautiful but fragmented and anatomically distorted women.

FIGURE 1
Photographer unknown
Portrait of Elizabeth Short
ca. 1946
PHOTOGRAPH © BETTMAN/CORBIS

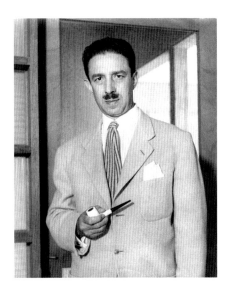

FIGURE 2
Photographer unknown
Portrait of George Hodel
ca. mid-1950s
COLLECTION OF STEVE HODEL

In its origins, our theory is indebted to ideas in the book *Black Dahlia Avenger* (2003), by Steve Hodel, a former LAPD homicide detective. That book asserts that the author's own father, George Hodel (fig. 2), a physician, took Elizabeth Short's life.[1] Though substantiating Steve Hodel's claims is not our primary goal, we believe that much of the evidence he presents is credible. Some of Hodel's charges are given further weight by our findings.

At one point in his book, Steve Hodel describes his father's friendship with the artist Man Ray and suggests that his father arranged Short's body to mimic a position in Man Ray's photograph "Minotaur" (ca. 1933). Here, we propose that the surrealist connection to the Black Dahlia murder may have been profound. A far-reaching relationship between surrealist art and the killing appears to have existed for decades before and after the murder. Notable artists—not only Man Ray but Salvador Dalí, Max Ernst, and many others—may have unwittingly inspired this act of bizarre violence. Others may have referred to the murder in later works and may even have hinted at a knowledge of who the killer was.

Included here are rare crime-scene and autopsy photographs of Elizabeth Short, seldom seen photographs by Man Ray, and many surrealist artworks that reveal similarities to the ways in which Short's body was damaged.

·

Part 1, Death Imitates Art, shows how the murderer's crime-scene signatures—the bisection and treatment of Elizabeth Short's body, involving removing pieces of flesh from her breasts and leg and creating a surgical incision in her lower abdomen—reveal parallels to visual motifs in surrealist portrayals of women (fig. 3). In essence, the killer may have considered the artfully composed corpse his masterpiece and believed he was upstaging well-known artists of the day.

In addition, the killer may have been motivated by misguided interpretations of popular intellectual ideas. These range from the theories of Sigmund Freud to the writings of the Marquis de Sade, the latter revered by the surrealists for his iconoclasm and belief in the pursuit of personal liberty above all else.

These pages explore surrealism's founding players and principles, as well as the evolution of surrealist ideas regarding women. Female figures bisected or with fantastical reproductive organs and geometric cutaways—all of these damaged muses relate to the surrealist preoccupations with lawlessness, desire, whimsy, and violence (fig. 3).

We explore the circle of intellectuals with whom George Hodel socialized in Los Angeles, among them the writer Henry Miller and the filmmaker John Huston. We look at works in literature and film that served as a cultural backdrop in the years leading up to the killing.

Finally, we raise the question of whether the murder was a real-life version of a surrealist parlor game turned deadly. That game was called Exquisite Corpse.

FIGURE 3
Man Ray
"White and Black" (variation)
1929
© 2006 MAN RAY TRUST / ADAGP (ARS) / TELIMAGE

•

Part 2, Art Imitates Death, paints a picture of the Los Angeles scene in the 1930s, 1940s, and early 1950s. It describes the players in this milieu—a group of individuals brought together by their interest in art. This circle included the surrealist art patrons Louise and Walter Arensberg; the artist and art dealer William Copley; the filmmaker and surrealist patron Albert Lewin; the married artists Max Ernst and Dorothea Tanning, who visited occasionally from their Sedona, Arizona, home; and Marcel Duchamp, Man Ray's closest friend, who visited in 1936, 1949, and 1950 from New York. Among the Hollywood celebrities collecting and supporting contemporary art were Vincent Price, Edward G. Robinson, and Fanny Brice.

A chart mapping how these and other key personalities in Los Angeles knew one another situates George Hodel within the art and cultural elite of the time (see the endpapers). This web of connections links Hodel directly to or one degree of separation away from people in Los Angeles art circles from 1935 to 1950.

We also propose that in the years after the murder, surrealist artists may have engaged in a visual dialogue in their art about the killing. Last, we explore whether one of the most enigmatic and studied works within surrealism may have referred to the Black Dahlia murder.

THE FACTS

Betty Bersinger was walking with her young daughter on Norton Avenue in Los Angeles, then an area of undeveloped housing lots, on the morning of January 15, 1947. They were between Coliseum and Thirty-ninth streets when Bersinger noticed something white in the tall grass. Realizing it was a human body, she went to a nearby home and called the police. The call was logged at 10:54 a.m. The officer she spoke with did not ask her for her name, and she forgot to give it.

Initially, the police dispatcher who announced the crime over the radios said that the incident was a "390 W" and a "415," referring to sightings of an intoxicated woman and indecent exposure, respectively. Then, as now, newspaper reporters often carried police radios in their cars to get a lead on stories as they developed. Will Fowler, a reporter for the *Los Angeles Examiner,* and Felix Paegel, an *Examiner* photographer, were among the first at the scene. Other reporters and police followed in quick succession.

It was immediately apparent that the killing was atypical. Even in Los Angeles, which one 1949 newspaper article referred to as "the port of missing persons" for its skyrocketing murder rate, the particulars were chilling.

The murderer had manipulated the young woman's dead body in disturbing and extraordinary ways (figs. 4, 5). He had cleanly cut her in two at the waist, yet her organs remained almost wholly contained in the two halves of her corpse. Her arms were laid out in a squared-off position above her head. The right breast was missing, and a small geometric section of flesh had been removed from the side of her left breast. The top part of her body lay above and to the left of the lower portion, calling attention to the fact that the woman had been cut in two.

A rectangular shape had been carved in her left thigh. There was a deep, vertical slash in her lower abdomen, similar in placement to a professional hysterectomy incision, and there were lacerations on her limbs. Long cuts had been inflicted on either side of her mouth, creating a grisly smile. The specific positioning of the body indicated that the victim had been not just dumped but purposely readied for discovery.

The corpse was clean and had been completely drained of blood. Observers described it as "ivory white" and looking like a mannequin. Author John Gilmore relates Betty Bersinger's initial reaction in his book *Severed: The True Story of the Black Dahlia Murder* (1994): "It had to be a dummy. . . . There were legs and a section of hip that seemed disconnected from the dummy's waist like a mannequin in a department store window when displays were changed and the clothing removed."[2]

A paper cement bag lay a few feet from the body. Because there was no blood at the scene, homicide detectives Harry Hansen and Finis Brown, who were assigned to the case, concluded that the woman had been killed somewhere else and then transported to Norton Avenue.

Newspaper photographs that appeared the next day were touched up to hide the most gruesome aspects of the crime. Airbrushing concealed the woman's lower body and the wounds around her mouth. The victim was identified as Elizabeth Short, a twenty-two-year-old woman born in Boston and raised in Medford, Massachusetts. Short had had

FIGURE 4
**Crime-scene photograph—
Elizabeth Short murder
January 15, 1947**

•

The Leimert Park neighborhood of
Los Angeles. West side of Norton Avenue
between Coliseum and Thirty-ninth streets.
View looking north.

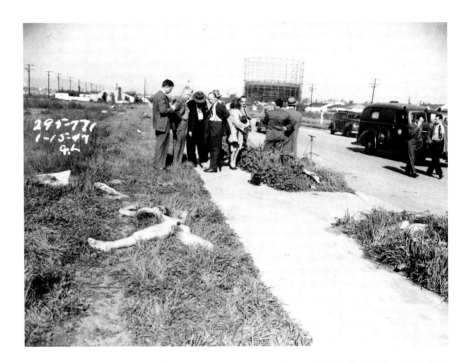

FIGURE 5
**Crime-scene photograph—
Elizabeth Short murder
January 15, 1947**

•

View looking east.

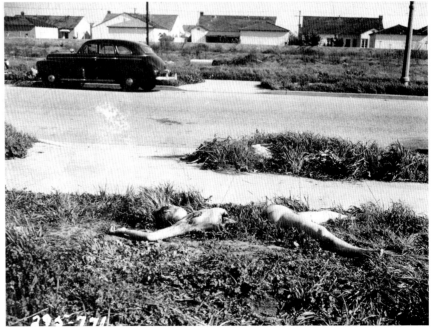

one previous police infraction, in 1943, so her fingerprints were on file and matched those taken from the corpse.

In an effort to gather personal details about Short, Wayne Sutton, a rewrite man for the *Los Angeles Examiner,* called Elizabeth Short's mother, Phoebe May Short, in Medford. Taking instructions from the paper's City editor, James Richardson, Sutton told Phoebe that he was calling because Elizabeth had won a beauty contest. She began talking animatedly about her daughter. After getting the information he wanted, Sutton revealed that Elizabeth had been slain.

Ten days after the murder, the killer mailed some of Elizabeth Short's personal belongings to the *Los Angeles Examiner.* The package included her birth certificate, Social Security card, and an address book that she had taken from nightclub owner Mark Hansen, who also became a suspect in her death.

The police investigation often lagged behind newspaper reports on the story, which frequently turned up pertinent information first. Collectively, the newspapers and police work unearthed enough details about Short to form a composite characterization. Interviews with friends and acquaintances portrayed someone who was friendly and beautiful and who dated many men. One of five sisters, she had lived off and on in California since the age of eighteen, initially staying with her father, Cleo Short, in Vallejo. An aspiring actress, she worked as a waitress and a cashier. She moved around a lot and was often in need of money.

Short told people that she had become engaged in 1945 to Matt Gordon Jr., a major in the Air Force, and that Gordon was killed in a plane crash in India that same year. She reportedly carried a clipping in her purse of a newspaper article announcing Gordon's engagement, but the fiancée's name had been crossed out.

Witnesses who saw her shortly before she was killed testified that she was terrified of someone — or something. A man named Robert

"Red" Manley, who drove her to the Biltmore Hotel, was thought to be the last person to have seen her alive. He told investigators that Short had an Italian boyfriend who was "intensely jealous." A woman she had stayed with also said that Short was "living in fear of a jealous boyfriend." Myrl McBride, a policewoman, stated that she had encountered Short "sobbing in terror" near a downtown bus depot the day before her death. Later, however, McBride was less certain that the woman she saw was in fact Elizabeth Short.

Investigating the case in Long Beach, Bevo Means, a police reporter for the *Herald Express,* found out that Short had been given the nickname the Black Dahlia at a Long Beach soda fountain she frequented, because she wore black clothes and had black hair. The name may also have been a reference to the 1946 film *The Blue Dahlia,* starring Veronica Lake and Alan Ladd. After "the Black Dahlia" appeared in print, Short's name became inseparable from this mythologizing moniker.

The police did not reveal full details about the condition of her body, hoping that they would be able to identify the killer by his knowledge of undisclosed information. Experts now agree that because of the precision of the bisection, the murder must have been performed by someone with surgical training. The investigation was active for six months before slowing down. Speculations about why it ebbed include the fact that the police could not turn up enough convincing evidence, as well as rumors of corruption and cover-ups.

Today, the stretch of Norton Avenue between Coliseum and Thirty-ninth streets is a row of tidy homes. The unkempt grass of the crime-scene area has been replaced by well-manicured lawns maintained by automatic sprinklers. On a typical afternoon, there is little sign of human activity, and few cars pass by. As with the eleven other unsolved murders of women in Los Angeles that year,[3] nothing marks the site where Elizabeth Short's body was found.

THEORIES AND COUNTER-THEORIES

In the decades since the murder, bitter rivalries have developed among self-styled Black Dahlia experts who claim to have proven, definitively, who committed it. Some of these theories are published in books; others on the Internet. None has prompted the case to be actively reinvestigated by LAPD robbery-homicide detective Brian Carr, currently assigned to the case file.

The fact that the murder was never officially solved, paired with the bizarre nature of the killing, has fostered an astoundingly wide range of speculations.

The high-profile status of the case nurtured a fascination with who Elizabeth Short was — an obsession with her life and a morbid interest in her death. The murder has become a cultural myth that has attracted a sizeable subculture of individuals, from those harboring painful personal wounds to those seeking financial gain. Followers range from people haunted by the murder since childhood to artists using Black Dahlia references in their work. In 2002 the rock musician Marilyn Manson created watercolor paintings based on photographs of Short. A metal band took The Black Dahlia Murder for its name, and the jazz composer Bob Belden released the musical suite "The Black Dahlia" in 2001. A 1998 computer game called "Black Dahlia" incorporates Nazis and occult rituals. The now-defunct Museum of Death in Hollywood hosted a Black Dahlia look-alike contest in 2000.

False and unverified information about the case abounds, much of it emphasizing that Short was both sexually promiscuous and a withholding tease. Harry Hansen described her in 1971 as a "man-crazy tramp," fueling the idea that she was in part responsible for what happened to her — that her own actions caused her fate. "She was a lazy girl, and irresponsible," Jack Webb wrote of Elizabeth Short in *The Badge: True and Terrifying Crime Stories That Could Not Be Presented on TV, from the*

Creator and Star of Dragnet (1958). Webb maintained that "the wrong way of life [led] to her death."

Three categories of books about the murder have emerged: first, those retelling, from a personal point of view, the alleged facts of the case and the investigation; second, fictional works using the killing as a plot motif; and third, investigative books and web sites professing to identify the killer.

Books with first-person accounts include *For the Life of Me: Memoirs of a City Editor* (1954) by James H. Richardson, City editor at the *Los Angeles Examiner* at the time, and Will Fowler's *"Reporters": Memoirs of a Young Newspaperman* (1991). In his book, Richardson describes a phone call he received that he was convinced was from the killer. The person with a "soft sly voice" and a "soft laugh" said that he was going to send the paper some of Short's belongings. Two days later, a package arrived with Short's birth certificate, address book, and Social Security card.

Characterizing Short as "aimless" and "drifting," Webb's *The Badge* is a compendium of true crimes based on real LAPD cases that were deemed too grisly by the TV censors to be adapted for *Dragnet*. Elizabeth Short's murder is among them. Webb states, "When [Short] chose to work, she drifted obscurely from one menial job to another." Speculating about who killed her, he writes, "Was it perhaps a woman who had taken The Dahlia as wife in Lesbian marriage?"

Among early fictionalized narratives is a 1975 made-for-TV film, *Who Is the Black Dahlia?* starring Lucie Arnaz as the murder victim and Efrem Zimbalest Jr. as Harry Hansen. Two years later, John Gregory Dunne's acclaimed novel *True Confessions* (1977) used the murder as a plot device that affects the relationship of two brothers, a priest and a homicide detective. Dunne and his wife, Joan Didion, wrote the screenplay for the 1981 film that was based on the book, starring Robert de Niro and Robert Duvall.

James Ellroy's personal history impacted his interest in the Black Dahlia murder: His own mother was killed in Los Angeles when he was a child, and the perpetrator was never found. Ellroy's best-selling novel *The Black Dahlia* was published in 1987. The 2006 movie adaptation is directed by Brian De Palma and stars Josh Hartnett, Scarlett Johansson, and Hilary Swank.

Projects aiming to solve the case include *Severed: The True Story of the Black Dahlia Murder* by John Gilmore, which maintains that Jack Anderson Wilson, an alcoholic burglar, killed Short. Gilmore, a former child actor, interviewed Wilson in the early 1980s and insists that Wilson revealed specific details about the murder. Wilson died in a hotel fire before the book was published.

Proposing a radically different theory, Mary Pacios's book *Childhood Shadows* (1999) questions whether Orson Welles, whose stage shows included an act in which a woman appeared to be cut in half, might have committed the murder. Pacios also refers to photographs of a carnival funhouse set for Welles's film *The Lady from Shanghai* (1947) that featured women's body parts and other motifs she says were related to the murder. (The set was not included in the film.) The book is a sympathetic portrait of the victim, and Pacios knew Short during childhood.

Daddy Was the Black Dahlia Killer (1995), by Janice Knowlton and Michael Newton, maintains that Knowlton's own sexually abusive father, George Knowlton, was the killer. The book relies on Knowlton's repressed memories.

The TV documentary *Case Reopened: The Black Dahlia with Joseph Wambaugh* (1999) is a survey of the theories about the murder at the time, with appearances by Gilmore, Fowler, Ellroy, and L.A. TV commentator Tony Valdez.

Larry Harnish, a copyeditor for the *Los Angeles Times*, maintains on his web site that Walter Bayley, a surgeon who had lived near the crime

scene and died in 1948, murdered Short. Bayley's daughter knew Short's sister Virginia, and Harnish posits that Bayley's mistress knew a "terrible secret" about him.

Vincent A. Carter had retired from the Los Angeles Police Department when he wrote *LAPD's Rogue Cops: Cover Ups and the Cookie Jar* (1993), detailing corruption in the Los Angeles Police Department during the 1940s. He theorizes that Short was killed by four powerful Los Angeles figures who were protected by an unnamed LAPD police captain.

The Black Dahlia Files: The Mob, the Mogul, and the Murder That Transfixed Los Angeles, by Donald Wolfe (2005), speculates on a possible connection between the murder and organized crime. Combining elements of John Gilmore's *Severed,* Vince Carter's *LAPD's Rogue Cops,* and his own gangland theory, Wolfe implicates four people: Gilmore's suspect, Jack Anderson Wilson; Maurice Clement, who allegedly procured prostitutes for the Hollywood madam Brenda Allen; Benjamin "Bugsy" Siegel; and Siegel's henchman, Albert Lewis Greenberg.

William T. Rasmussen's *Corroborating Evidence: The Black Dahlia Murder,* also published in 2005, posits that the Black Dahlia murder, the Cleveland Torso murders, and other killings in Los Angeles and Chicago were committed by a linked group of people, including Jack Anderson Wilson.

In *Black Dahlia Avenger,* Steve Hodel proposes that his own father, George Hodel, committed the murder. The book characterizes George Hodel as a brilliant, controlling, charismatic, and at times exceedingly cruel man. A prominent Hollywood doctor who had an interest in art, Hodel had a track record of physical and sexual abuse against women.

Though none of the books provides enough concrete evidence to definitively identify the killer, Hodel's theory is the most compelling. Aspects of his father's extraordinary life suggest that he may well have been the type of person to carry out an act as cruel, logistically complex, and stylistically bizarre as the Black Dahlia murder.

SUSPECT: GEORGE HODEL

George Hodel's career was wide-ranging, his personal life complicated. He was born in Los Angeles in 1907 to parents of Ukrainian descent and was a child prodigy on the piano. His career path involved stints as a classical radio announcer and crime reporter as well as a taxi driver, publisher of a literary magazine, and aspiring photographer. His primary career, however, was as a physician. As the head venereal disease officer for the Los Angeles County Health Department during the 1940s, he operated private and public clinics in the city. For about eight months in 1946, Hodel also served as the Public Health Administrator for the United Nations Relief and Rehabilitation Administration (UNRRA) in China.

In 1950 he left Los Angeles in the wake of a family scandal and moved to Hawaii. There, he trained in psychiatry and served, among other posts, as psychiatric consultant to the Hawaii prison system. In 1953, he relocated to the Philippines, where he also practiced psychiatry and launched a successful market research company. He returned to the United States in 1990, settling in San Francisco. He died there in 1999.

Steve Hodel maintains that his suspicions about his father began shortly after George Hodel's death at the age of ninety-one. George's third wife gave Steve a photo album containing pictures of his father's children, girlfriends, and other women. As he writes in *Black Dahlia Avenger*, Steve became convinced that two of the photographs were of Elizabeth Short.

From that hunch, Steve Hodel launched an investigation that ultimately revealed his father's history of violence and his possible connections to Elizabeth Short. He also disclosed details about an incest trial involving accusations of sexual abuse by Hodel's daughter Tamar. Most significantly, he found that George Hodel had indeed been a suspect in the crime.

Steve Hodel describes his father as a coddled child growing up in South Pasadena. He showed early talent as a musician, and the Russian

BOY'S HOME IS PLANNED BY RUSSIAN

Famous Architect Decides to Remain in City After Completing Work

BY ALMA WHITAKER

Not many boys can boast that a famous architect came over from Russia to build them a house as a fifteenth birthday present.

This was the distinction which fell upon young George Hill Hodel, who attained his fifteenth birthday on the 10th inst. and fell heir on the same day to a beautiful Swiss-Russian residence high on the hill at 6512 Walnut Hill avenue, built and completed by M. Alexander Zelenko of Moscow to the day.

FIGURE 6

Alma Whitaker
"Boy's Home Is Planned by Russian"
Los Angeles Times (detail)
October 15, 1922

COPYRIGHT, 1922, *LOS ANGELES TIMES*, REPRINTED WITH PERMISSION

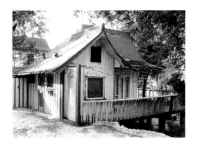

FIGURE 7

Alexander Zelenko
Residence at 6512 Walnut Hill Avenue (now, 6511 Short Way), Los Angeles, California, 2004
PHOTOGRAPH BY STEVE HODEL

FIGURE 8
George Hodel
Self-portrait
1924
Inscribed verso:
"Portrait of a Chap Suddenly Aware
of the Words of Sigmund Freud"
COLLECTION OF STEVE HODEL

.

The self-conscious inscription on the back
of this picture of George Hodel suggests
a youthful awakening prompted by the
discovery of Sigmund Freud's writings.
The photograph was taken the same year
that André Breton published the first
"Manifesto of Surrealism" in France,
an essay praising Freud's work. Breton's
explorations of dreams were also influenced
by Freud's theories. Later, Hodel became
interested in hypnosis, and he practiced
psychiatry in Hawaii and the Philippines.

FIGURE 9
George Hodel
Self-portrait
1924
Inscribed verso:
"Merlin Gazes at Cracked Mirrors"
COLLECTION OF STEVE HODEL

.

The inscription on the back of this picture
probably references Miguel de Cervantes'
Don Quixote, a novel that also inspired
Pre-Raphaelite painters such as John Everett
Millais (see fig. 41). The Pre-Raphaelites
were in turn influential to the surrealists,
especially Dalí, who referred to *Don Quixote*
in many of his works.

FIGURES 10, 11
George Hodel
Untitled photographs
ca. late 1920s
COLLECTION OF STEVE HODEL

composer and pianist Sergei Rachmaninoff visited the household to hear George play piano. For his fifteenth birthday, George's parents commissioned the Russian architect Alexander Zelenko to build a second house on their property for George's private use (figs. 6, 7).

Early photographs taken by George Hodel reveal a romantic, precocious intellectual with a strong interest in art and literature. A 1924 photographic self-portrait is inscribed "Portrait of a Chap Suddenly Aware of the Words of Sigmund Freud" (fig. 8). A similar photograph of Hodel as a teenager bears the inscription "Merlin Gazes at Cracked Mirrors" (fig. 9), most likely alluding to a passage in Miguel de Cervantes' masterwork, *Don Quixote*.[4] George Hodel's photographs from the mid- to late 1920s reveal the influence of California school photographers such as Edward Weston, Margrethe Mather, and Johan Hagemeyer (figs. 10, 11).[5]

In 1935, while studying at the University of California at San Francisco School of Medicine, Hodel took a photograph of a surgical demonstration in an operating theater (fig. 12). The picture indicates that Hodel was familiar with surgical technique, as any medical student would have been. It also bears a resemblance to *The Gross Clinic* (1875), the monumental painting by Thomas Eakins, suggesting that Hodel probably had an awareness of art history (fig. 13). *The Gross Clinic* was purchased by and displayed at the Jefferson Medical College in Philadelphia, and Hodel's photograph was enlarged and displayed as a mural at the UCSF School of Medicine.

FIGURE 12
George Hodel
Operating theater
1935
COLLECTION OF STEVE HODEL

•

This photograph, published in the spring 1988 issue of the Bulletin of Alumni Faculty Association of the UCSF School of Medicine (University of California, San Francisco), was taken by George Hodel in an operating theater in San Francisco General Hospital. It was enlarged and used as a mural in the medical school building. The image suggests a number of things: first, that Hodel had a working knowledge of surgical technique; second, that he continued to develop his interest in photography; third, that he was very likely aware of art-historical precedent (see figure 13). Hodel's classmates are identified in the UCSF bulletin as: (front row, left to right) Drs. Glaven Rusk, Edwin Bruck, Leroy Briggs, Herbert Moffit, Salvatore Lucia, and Guido Milani; (back row, left to right) Urriola Goiota, Clayton Mote, and Walter Port. The lecturer is identified as Dr. Jesse L. Carr.

George Hodel was married three times and had numerous affairs. He fathered eleven children, the first when he was only fifteen. Steve Hodel is the son of George's second wife, Dorothy (fig. 14), who had previously been married to the film director John Huston (fig. 15), a teenage friend of Hodel's. The three remained friends after Dorothy married George Hodel, and Huston often visited the Hodels at their house.

George and Dorothy Hodel were married from 1940 to 1944 and had four sons, one of whom died in infancy. They remained together, for the most part, as a couple until 1949, living at the Franklin Avenue house. After Dorothy filed for divorce, she listed her husband's occupation as "physician and surgeon" on a 1944 sworn affidavit (fig. 148).

It has been reported that George Hodel was investigated regarding the death of at least one other woman, Ruth Spaulding,[6] his personal secretary. Spaulding was an aspiring writer who died of a suspicious overdose of barbiturates. According to Steve Hodel, George called Dorothy

from Spaulding's house on May 9, 1945, asking her to come over. When Dorothy arrived, Spaulding was unconscious. Hodel handed Dorothy two manuscripts that Spaulding had written and told her to burn them, which she did. Ruth Spaulding died soon after. Hodel was on a shortlist of Black Dahlia suspects in October 1949.[7] In a disturbing incident from January of 1950, Hodel admitted to drugging a young woman, Lillian Lenorak, who later identified Elizabeth Short in a photograph as one of his girlfriends.[8]

In 1945, Hodel bought a house at 5121 Franklin Avenue in the Los Feliz neighborhood of Los Angeles. The residence, designed by Lloyd Wright, the son of Frank Lloyd Wright, was constructed in the style of a Mayan temple. Hodel filled the house with Chinese artworks he had brought back with him following his post as Public Health Administrator. At that home, Hodel hosted gatherings attended by a range of film industry people, artists, writers, and others, some of which included drugs and hypnotism sessions. The writer Henry Miller (fig. 16) and the poet Kenneth Rexroth were friends and guests of George Hodel's.

Tamar Hodel recalls that Man Ray was a frequent visitor to their house and often photographed the family. He took nude photographs of Tamar, but the images disappeared in 1949 or 1950. Among the Man Ray photographs that Hodel owned was a 1946 self-portrait (fig. 17). The image, a version of which Man Ray gave to the Hodels that same year, shows the artist's face segmented by lines suggesting both the viewfinder of a camera and the crosshairs of a rifle scope.

This picture has been interpreted as a reference to Man Ray's interest in the Marquis de Sade. The writings of Sade were popular among broader artistic circles, as well as the surrealists. John Huston and Henry Miller were fascinated by Sade,[9] and Miller and Man Ray corresponded about their mutual admiration for his writings. Steve Hodel maintains that the treatment of Short's body bears similarities to an account of

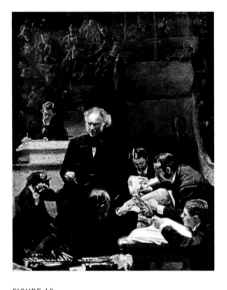

FIGURE 13
Thomas Eakins
The Gross Clinic
1875
PHOTOGRAPH © BRIDGEMAN ART LIBRARY

.
Among artworks picturing the operating theater and celebrating men of medicine is Thomas Eakins's *The Gross Clinic.* Probably influenced by Rembrandt's *The Anatomy Lesson of Nicolaes Tulp* (1632), this popular painting — monumental in scale at 96 x 78 inches — was purchased and publicly displayed by Jefferson Medical College at Thomas Jefferson University, Philadelphia, and was also disseminated widely in print form.

LEFT: FIGURE 14
George Hodel
Portrait of Dorothy Hodel
1946
Signed and dated recto
COLLECTION OF STEVE HODEL

RIGHT: FIGURE 15
Photographer unknown
Portrait of John Huston
1948
PHOTOGRAPH: PHOTOFEST, NY

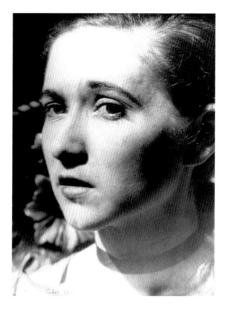

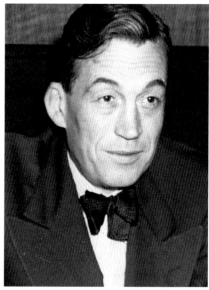

torture that Sade wrote in *The 120 Days of Sodom* dated January 15 — the same date on which Short's body was found.

In October of 1949, Tamar, George Hodel's then-fourteen-year-old daughter, with a former mistress, Dorothy Anthony, told police about an incident at the Franklin Avenue house that, when it became public, shrouded the family in scandal. Tamar described how during a gathering, her father had engaged in intercourse with her. Police later arrested a Beverly Hills physician and his assistant for performing an abortion on Tamar in September of 1949,[10] weeks before the case went to court.

During the trial that followed, two people who had been in the room confirmed seeing Hodel having sex with her. The artist Fred Sexton, a friend of Hodel's from the time they were teenagers, also testified that he was present and attempted intercourse with Tamar.

George Hodel was acquitted. Tamar, however, remained in a juvenile detention facility. Barbara Sherman, one of the women present in the room, refused to testify and recanted statements that she had participated in sex acts with Tamar that evening. Sherman was put on three years' probation for "pleading guilty to contributing to the delinquency of a minor," as a *Los Angeles Times* article of February 1, 1950, described.

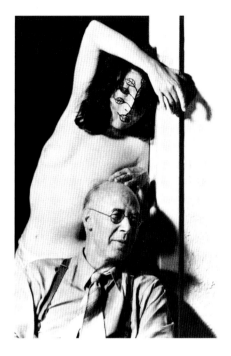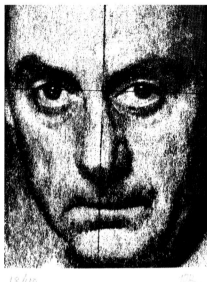

LEFT: FIGURE 16
Man Ray
Henry Miller and Margaret Neiman
ca. 1945
© 2006 MAN RAY TRUST / ADAGP (ARS) / TELIMAGE

•

Man Ray met Henry Miller through the writer Gilbert Neiman and his wife, Margaret, with whom Man Ray and Juliet spent many evenings. During those gatherings, "I painted papier-mâché masks for the girls, who put them on and danced weirdly, completely abandoned, secure in their anonymity," Man Ray wrote in *Self Portrait*. Here, Margaret Neiman, wearing a mask, poses with Miller.

After the trial, the Los Angeles District Attorney's Office was sufficiently interested in George Hodel to plant electronic audio surveillance in his home from February 18 to March 27 of 1950. The transcripts of those tapes were released for the first time after the initial publication of *Black Dahlia Avenger.* Among the hundreds of hours of talk and chatter, many passages stand out. "Supposin' I did kill the Black Dahlia," Hodel said to another man in the room, who remains unidentified. "They couldn't prove it now. They can't talk to my secretary anymore because she's dead." That secretary, Ruth Spaulding, might have been able to connect Elizabeth Short to George Hodel.

Steve Hodel's investigation began with his theory that two photographs in his father's personal album were of Elizabeth Short. Whether they are or are not, the pictures launched an investigation revealing that George Hodel was an official suspect in the murder.

Similarly, passages from *Black Dahlia Avenger* acted as the initial catalyst for our inquiry into whether there might be a broader dialogue between art and the killing. In order to further explore this link, it is essential to consider a general overview of surrealism—its origins, imagery, and ideas.

RIGHT: FIGURE 17
Man Ray
"Self-Portrait"
1963 treatment after 1946 original
© 2006 MAN RAY TRUST / ADAGP (ARS) / TELIMAGE

•

Man Ray used this graphically reduced variation of an original photographic print as the cover of his book *Self Portrait* (1963). He gave a slightly different version of the original to George and Dorothy Hodel in 1946. The inscription reads:

"To Dorero and George—and my homage as I am pleased when I am asked for my phiz—so much more than when I am asked for a portrait of a greater celebrity. I celebrate <u>you</u>. Man"

PART I: DEATH IMITATES ART

FIGURE 18
René Magritte
Les rêveries du promeneur solitaire
(The Musings of a Solitary Walker)
1926
Oil on canvas
PRIVATE COLLECTION
© 2006 C. HERSCOVICI, BRUSSELS / ARTISTS RIGHTS SOCIETY
(ARS), NEW YORK
PHOTOGRAPH © BANQUE D'IMAGES, ADAGP /
ART RESOURCE, NY

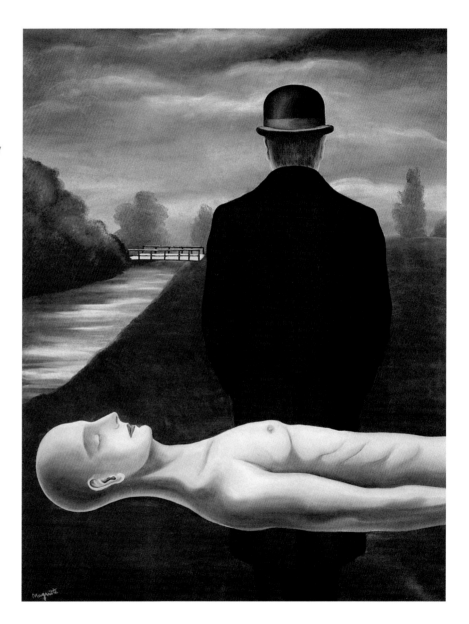

Surrealism: Damaged Muses and Mischievous Mannequins

"Max Ernst died on the 1st of August 1914. He resuscitated the 11th of November 1918 as a young man aspiring to become a magician and to find the myth of his time."
— Max Ernst[1]

With these words, the German artist Max Ernst described his metaphorical rebirth from the squalor of World War I, in which he served as a soldier in the German army. After the war, Ernst saw a world of absurdity and disconnects, which he rendered powerfully in his art. Other likeminded artists and poets shared Ernst's epiphany. André Masson, Paul Éluard, and André Breton were among those whose military experiences moved them to embrace the irrational in art and life.[2]

Surrealism began as a loose affiliation of writer friends in Paris. An outgrowth of Dadaism, the reactionary art movement launched in Zurich in 1916, the surrealist movement became official in 1924 when André Breton published the "Manifesto of Surrealism." While Dada was a general protest against societal ills and history, Breton's surrealism was a heady call to arms, extolling freedom of imagination and liberation from social constraints. Breton urged readers to end "the reign of logic"; to make the everyday marvelous; to listen to their dreams; and to interrupt the rules of society. "The imagination is perhaps on the point of reasserting itself, of reclaiming its rights," he wrote in the "Manifesto of Surrealism."

An interplay of irrationality, eroticism, and violence was at the heart of surrealist expression, recurring in a broad array of writings and art. In addition, the surrealists explored the clash of ancient and modern, Western and non-Western motifs in art and film. Over the years, surrealism became a diverse artistic and political movement, spanning decades and continents and reinventing itself when necessary. Its stylistically disparate artworks include the magical-realist paintings of René Magritte, the enigmatic constructions of Marcel Duchamp, the grotesque,

FIGURE 19
Hans Bellmer
"La poupée"
(The Doll)
1935
Hand-colored black-and-white photograph
© 2006 ARTISTS RIGHTS SOCIETY (ARS), NEW YORK /
ADAGP, PARIS
PHOTOGRAPH © CHRISTIES IMAGES / CORBIS

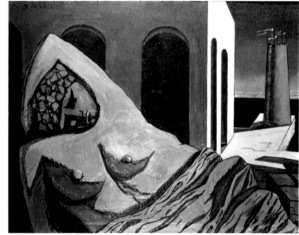

FIGURE 20
Giorgio de Chirico
The Silent Statue (Ariadne)
1913
Oil on canvas
COLLECTION KUNSTSAMMLUNG NORDRHEIN-WESTFALEN,
DUSSELDORF, GERMANY
© 2006 ARTISTS RIGHTS SOCIETY (ARS), NEW YORK / SIAE, ROME
PHOTOGRAPH © PETER WILLI / BRIDGEMAN ART LIBRARY

FIGURE 21
André Masson
Gradiva
1939
Oil on canvas
PRIVATE COLLECTION
© 2006 ARTISTS RIGHTS SOCIETY (ARS), NEW YORK /
ADAGP, PARIS

illusory figures and landscapes of Salvador Dalí, and the disturbing tied and bound dolls of Hans Bellmer (fig. 19).

By the time of the Black Dahlia murder, in 1947, surrealism had become absorbed into American mainstream culture. Articles in *Time* and *Life* were devoted to the subject, and surrealist art appeared in American galleries from coast to coast.

From the start, surrealism was a marriage of distinct influences. For Breton, the perceived senselessness of World War I paired with a romantic streak and a fascination with psychiatry were primary factors. As a medical student, Breton had worked with a former assistant of Jean-Martin Charcot, the neuropsychiatrist who specialized in studying "hysterical" symptoms in women. Later, during the war, Breton served in a hospital psychiatric ward, where he witnessed the delusional fantasies of shell-shocked soldiers. These exposures to mental disturbances in part sparked his philosophical interest in the irrational, along with his reverence for Freud. As Breton wrote, "I believe in the future resolution of . . . dream and reality, which are seemingly so contradictory, into a kind of absolute reality, a *surreality.*" Based partly on "the omnipotence of dream," surrealism, as Breton imagined it, was also "exempt from any aesthetic or moral concern."

By organizing early séance sessions (fig. 76) and group discussions about sexuality, Breton encouraged his colleagues to tap into mental processes ungoverned by reason. Surrealist parlor games, too, encouraged unconventional thinking and random associations. As a group, the surrealists were fascinated by events that would invoke an exalted mental state — the abandon of desire, the chance encounter, and the criminal act, for instance. The surrealist quest for free expression included concepts ranging from automatic writing to mad love — *l'amour fou* — to Sade's writings. Along with Sade, Breton named Jonathan Swift, Edgar Allan Poe, Charles Baudelaire, and other historical figures as surrealists

in some aspect.[3] He also admired artists including Hieronymus Bosch and Pablo Picasso and relentlessly courted Picasso in the hopes that he would identify himself as a surrealist. Picasso published in surrealist publications and was friends with surrealist artists, but he refused to be officially tied to the movement.

The surrealists also saw their key obsessions embodied in the canvases from the 1910s by Giorgio de Chirico. In these works, the illogical perspectives, looming architecture, and mysterious figures conveyed an alluring emptiness and anxiety onto which the artists projected their fantasies. "Where would you make love?" Breton asked other surrealists, referring to de Chirico's *The Enigma of a Day* (1914), with its deeply shadowed colonnade and massive towers. "Where would you defecate?" He published their responses in a 1933 issue of *Le surréalisme au service de la révolution.*

.

Surrealist muses often came from classical artistic or literary sources, their portrayals made irregular or disquieting. De Chirico's many paintings of Ariadne, portrayed in paintings throughout his career (fig. 20), find her abandoned and sleeping on the Greek island of Naxos. Dalí rendered the armless Venus de Milo with fetishistic additions. Gradiva, a character from a 1903 Wilhelm Jensen story that Freud analyzed in a 1907 paper, was another favorite surrealist subject. In the Gradiva story, an archaeologist becomes transfixed by an ancient frieze of a woman; after traveling to Pompeii to find her, he realizes that she is an incarnation of a girl he loved in childhood. Breton named his Paris gallery after this unlikely heroine, and artists from Dalí to Masson paid homage to her in distorted renderings—one of Masson's showing her accessorized with a large steak and a swarm of bees by a beehivelike breast (fig. 21).

FIGURE 22

Max Ernst
Celebes
1921
Oil on canvas
TATE GALLERY, LONDON
© 2006 ARTISTS RIGHTS SOCIETY (ARS), NEW YORK /
ADAGP, PARIS
PHOTOGRAPH © TATE GALLERY, LONDON /
ART RESOURCE, NY

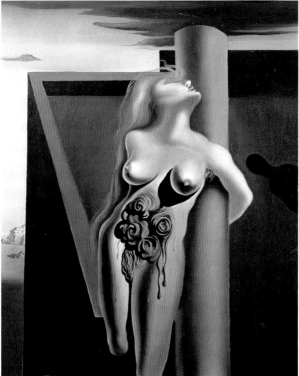

FIGURE 23

Salvador Dalí
Les roses sanglantes
(The Bleeding Roses)
1930
Oil on canvas
PRIVATE COLLECTION
© 2006 SALVADOR DALÍ, GALA-SALVADOR DALÍ FOUNDATION /
ARTISTS RIGHTS SOCIETY (ARS), NEW YORK
PHOTOGRAPH © BRIDGEMAN ART LIBRARY

LEFT: FIGURE 24
René Magritte
L'âge des merveilles
(The Age of Marvels)
1926
Oil on canvas
PRIVATE COLLECTION
© 2006 C. HERSCOVICI, BRUSSELS / ARTISTS RIGHTS SOCIETY
(ARS), NEW YORK
PHOTOGRAPH © HERSCOVICI / ART RESOURCE, NY

RIGHT: FIGURE 25
Hans Bellmer
La poupée
(The Doll)
1936
Linocut on pink paper; Paris, Editions GLM
ART INSTITUTE OF CHICAGO
© 2006 ARTISTS RIGHTS SOCIETY (ARS), NEW YORK /
ADAGP, PARIS

Indeed, women rarely appear as fully human entities in surrealist art, whether they are presented as peripheral motifs or central figures. Bisected and fragmented women are often found in a state of reverie — or apparent death. Such portrayals include Magritte's *The Musings of a Solitary Walker*, 1926 (fig. 18), with a gaunt, hairless woman floating in the foreground, and Dalí's *Woman Sleeping in a Landscape* (1931). In each of these works, the painting's edge cleaves the female figure, as it does in Max Ernst's *Celebes*, 1921, (fig. 22). Ernst portrays the headless shell of a woman severed by the picture frame, as her raised arm beckons the viewer into this scene.[4]

Other works reveal views into female reproductive organs, made magical through surrealist touches — from the bloody red bouquet in Dalí's *The Bleeding Roses*, 1930 (fig. 23), to the tidy plumbing in Magritte's *The Age of Marvels*, 1926 (fig. 24). More unsettling is the voyeuristic aperture in *La poupée* (The Doll), 1936 (fig. 25), a drawing by Hans Bellmer. In that work, a peephole reveals mechanical discs inside a truncated female

FIGURE 26

Max Ernst
Anatomie als Braut
(Anatomy as a Bride)
1921
Gouache, pencil, and collage
MUSÉE NATIONAL D'ART MODERNE, CENTRE GEORGES
POMPIDOU, PARIS (AM 1999-157)
© 2006 ARTISTS RIGHTS SOCIETY (ARS), NEW YORK /
ADAGP, PARIS
PHOTOGRAPH: GEORGES MEGUERDITCHIAN,
© CNAC / MNAM / DIST. RÉUNION DES MUSÉES NATIONAUX /
ART RESOURCE, NY

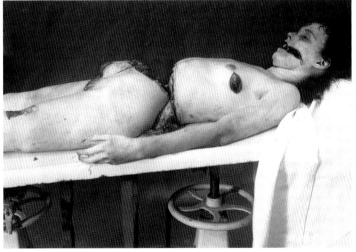

FIGURE 27
Dissecting table photograph —
Elizabeth Short murder
January 15, 1947

torso. An early Ernst image provides another view into the bisected body of a doll-like form, in *Anatomie als Braut* (Anatomy as a Bride), 1921 (fig. 26). These works, along with countless others, we argue, establish artistic antecedents upon which the Black Dahlia killing may have been modeled (fig. 27).

DOLLS AND MANNEQUINS

Dolls and fashion mannequins were also objects of fascination for the surrealists, used by artists as diverse as Bellmer, Dalí, de Chirico, and Man Ray. Breton celebrated mannequins in the "Manifesto of Surrealism" as contemporary examples of the "marvelous," whose incarnations included "the romantic *ruins,* the modern *mannequin,* or any other symbol capable of affecting the human sensibility for a period of time." In his 1928 book *Nadja,* Breton described a powerful response to a sculpted prostitute in a wax museum that he found more alluring than a living woman.[5]

The idea that a constructed woman could offer a special erotic charge had historical precedents. These range from the Galatea myth, in which an artist makes a sculpture of a woman more beautiful than any living being, which then comes to life, to "The Sandman," the 1817 story written by E. T. A. Hoffmann in which a man goes mad while falling in love with a clockwork wooden doll. Freud picked up on this peculiar confusion of the living and the inanimate in his 1919 essay on the uncanny, in which he refers to "The Sandman." In Freud's definition, the uncanny involves uncertainty about "whether an apparently animate being is really alive, or conversely, whether a lifeless object might not be in fact animate."

For surrealists, mannequins and dolls were machine-age Galateas to be willfully manipulated. Hans Bellmer's dolls (figs. 19, 25), portrayed in sculptural works and photographs, appear abused and dismembered. Man Ray used mannequins as props and in his imagery throughout his career (figs. 30, 31, 36).

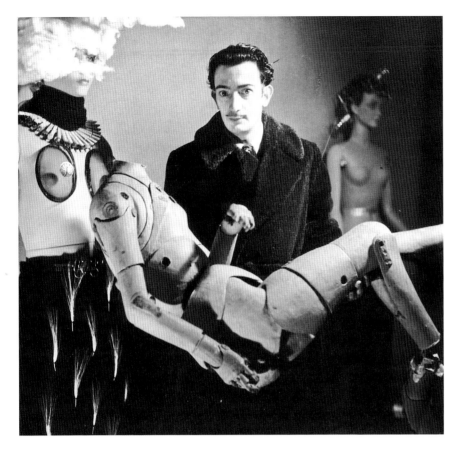

FIGURE 28
Denise Bellon
Salvador Dalí with mannequin,
International Exhibition of Surrealism,
Paris, 1938
© LES FILMS DE L'ÉQUINOXE-FONDS PHOTOGRAPHIQUE
DENISE BELLON

The surrealist mannequins were a focal point of the 1938 Exposition Internationale du Surréalisme at Paris's Galerie Beaux-Arts (figs. 28–31). The show featured more than sixty artists from fourteen countries. Marcel Duchamp gave participating artists sixteen unclothed fashion mannequins to adorn as they wished. The treatments ranged from the sado-masochistic to the whimsical. Masson imprisoned his model's face in a birdcage, stopping her mouth with a pansy and giving her a G-string and a plume. Duchamp's mannequin was dressed in a man's jacket with a red lightbulb in the pocket, and the bottom half was unclothed.

As Man Ray recalled in his autobiographical *Self Portrait*, "We each outdid each other with bird cages, roosters' heads, etc., for headgear; veils, cotton wadding and kitchen utensils for clothes; I left mine nude with glass tears on the face and glass soap bubbles in the hair, but Duchamp simply took off his coat and hat, putting it on his figure as if it were a coat rack. It was the least conspicuous of the mannequins, but most significant of his desire not to attract too much attention."

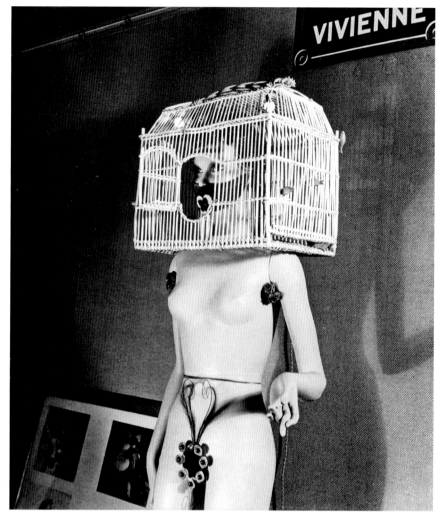

FIGURE 29
Denise Bellon
Mannequin by André Masson
International Exhibition of Surrealism,
Paris, 1938
© LES FILMS DE L'ÉQUINOXE-FONDS PHOTOGRAPHIQUE
DENISE BELLON

LEFT: FIGURE 30
Man Ray
Mannequin by Marcel Duchamp
International Exhibition of Surrealism,
Paris, 1938
© 2006 MAN RAY TRUST / ADAGP (ARS) / TELIMAGE

RIGHT: FIGURE 31
Man Ray
Mannequin by Man Ray
International Exhibition of Surrealism,
Paris, 1938
© 2006 MAN RAY TRUST / ADAGP (ARS) / TELIMAGE

 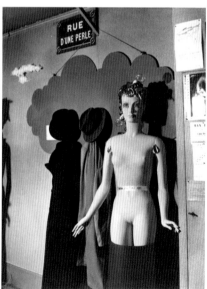

Displayed in a corridor dubbed *rue surréaliste* (Surrealist Street), the mannequins appeared alongside the graphic photographs of one of Bellmer's dolls. As the art historian Alyce Mahon describes, Bellmer's works "injected a note of death and sinister violence—the doll's grotesque imperfection contrasting starkly with the mass-produced beauty of the mannequins." She continues, "The various representations of mannequins at the Surrealist exhibition mixed appreciation of the erotic female form as harbouring a sense of life and death, attraction and repulsion."[6] A year later, Dalí would create a similarly disquieting array in his *Dream of Venus* pavilion for the 1939 World's Fair, featuring a mix of live women and mannequins, some modified to look like corpses.[7]

WOMEN AND CRIME

Surrealist writings frequently conveyed a captivation with violence, sometimes arbitrary, sometimes erotically charged. In the "Second Manifesto of Surrealism," published in 1930, Breton wrote, "The simplest surrealist act consists of dashing down into the street, pistol in hand, and firing blindly as fast as you can pull the trigger, into the crowd." (He followed up with a long footnote acknowledging that his statement was intentionally provocative and would inflame his critics.) The lavish journal *Minotaure* published articles exploring Sade's writings, as well as art-historical reproductions of scenes of religious and mythological torture, much of it directed against women.

The surrealists were intrigued by real criminals and murderers, viewing their crimes as acts of transgressive valor. In various publications, they pictured or wrote about criminals including Jack the Ripper; the Papin sisters, servants who murdered and mutilated their employers in 1933; and Violette Nozières, a woman who killed her sexually abusive father. While Nozières was awaiting trial in December of 1933, the surrealists published a tribute to her, and Man Ray created the cover design.

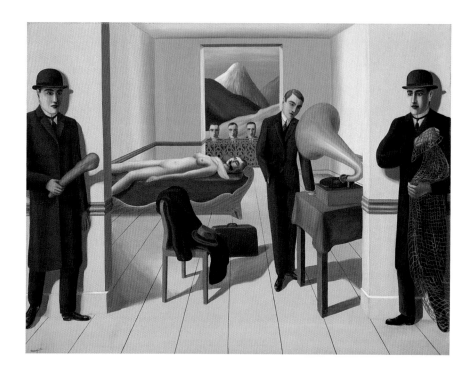

FIGURE 32
René Magritte
L'assassin menacé
(The Menaced Assassin)
1926
Oil on canvas
THE MUSEUM OF MODERN ART, NEW YORK
KAY SAGE TANGUY FUND (247.1966)
PHOTOGRAPH © THE MUSEUM OF MODERN ART / LICENSED
BY SCALA / ART RESOURCE

La révolution surréaliste 1 (1924) featured a photomontage centered on Germaine Berton, an anarchist and murderer who committed suicide. Berton's photograph appears in the center of the montage, surrounded by pictures of notable surrealists, as well as Freud and Picasso.[8]

The pulp literary character Fantômas, a criminal who targeted moneyed Parisians, was also a favorite. Artworks inspired by this figure include works by Yves Tanguy and Victor Brauner, as well as the painting *The Menaced Assassin* (1926), by René Magritte (fig. 32).[9] In Magritte's picture, a naked, dead woman lies on a couch, blood dripping from her mouth, while six clothed men stand by. Max Ernst's *Une semaine de bonté: Les sept éléménts capitaux* (1934), one of three novels by the artist that were made of collages based on nineteenth-century book illustrations, is a surrealistic pictorial narrative that includes depictions of torture and cruelty. Several images in the Ernst book are based on the 1883 crime novel *Les damnées de Paris,* by Jules Mary.[10]

The surrealists' interest in crime and subversion remained for the most part theoretical. Regarding their fascination with Sade, for instance, their conduct by and large bore little relation to their proclamations. "Intellectually, they flew close to the flame. Instinctively they were far from knowing the perverse appetites they so admired and glorified,"

recalled the artist and writer Dorothea Tanning, Max Ernst's wife, in her memoir *Between Lives: An Artist and Her World*. "As for emulating the fantasies of Sade's personae, they didn't even try."

Similarly, the provocative subject matter in surrealist art was not necessarily a reflection of the artists' characters or conduct. Speaking of Bellmer's dolls and surrealism more generally, the art historian Hal Foster points out, "These scenes are representations, not realities—a fact that some viewers still seem to overlook." He adds, "The subject implicated in these scenes, as elsewhere in surrealism, is not necessarily identical with the artist."[11]

In Dorothea Tanning's view, the surrealists' treatment of women in writing was not a form of debasement but an expression of admiration. "The millions of words they lavished on her were not diagrams for her degradation," she wrote. "They were disguised hymns to her mystery. I don't believe that even in the most romantic moments of literary history have writing men so adored the idea of woman."[12]

However, feminists have found much to criticize in surrealism, seeing in it "a pervasive misogyny, especially in the apparent violence done to the female body in representation," as the art historian Dawn Ades notes.[13]

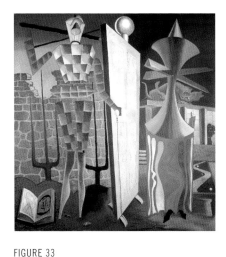

FIGURE 33
Man Ray
Le beau temps
(Fair Weather)
1939
Oil on canvas
© 2006 MAN RAY TRUST / ADAGP (ARS) / TELIMAGE

"SHIPWRECKED SURREALISM"

The onset of World War II in Europe forced surrealist artists to seek refuge elsewhere, and many fled to the United States. The forces of Fascism and Nazism gave rise to the appearance of nightmarish images in surrealism. Paintings from Max Ernst's *Europe after the Rain* (1940–42) to Man Ray's *Le beau temps* (Fair Weather), 1939 (fig. 33), referred to the long shadow cast over Europe by these destructive powers.

Surrealists were welcomed into New York. The 1942 exhibition "First Papers of Surrealism" at the Whitelaw Reid mansion in New York was

LEFT: FIGURE 34
Salvador Dalí
Art of Radio
ca. 1944
Oil on canvas

© 2006 SALVADOR DALÍ, GALA-SALVADOR DALÍ FOUNDATION /
ARTISTS RIGHTS SOCIETY (ARS), NEW YORK
PHOTOGRAPH: GEORGE KARGER © TIME & LIFE PICTURES /
GETTY IMAGES

•

Art of Radio, Dalí's painting of a microphone and two segmented women with apples for heads, was one of seven paintings commissioned by Broadway impresario Billy Rose for his production of *Seven Lively Arts.* Parts of the revue—a showcase for the lyrics and music of Cole Porter—were based on writings by Ben Hecht. Dalí's artworks were reproduced in *Life* magazine on January 1, 1945, with the article "Speaking of Pictures: Dalí Paints the Seven Lively Arts" (pp. 4–6). *Life*'s caption for *Art of Radio* reads, "It reminds Dalí of wormy apples and dismembered torsos." Other paintings in the series were *Art of the Ballet, Art of Cinema, Art of the Concert, Art of the Opera, Art of the Theater,* and *Art of Boogie-Woogie,* in which a woman's organs dance out of her abdomen.

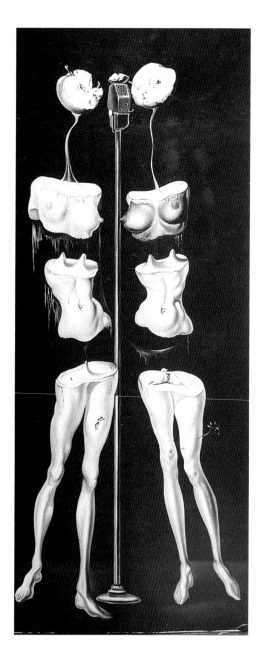

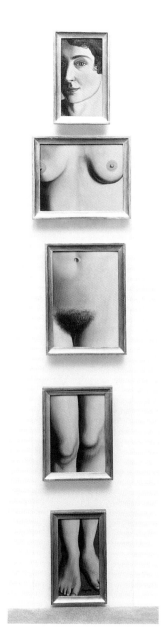

the first major show to feature works by artists in exile, and proceeds were slated toward war relief. Duchamp and Frederick Kiesler famously installed some sixteen miles of tangled string in the gallery for the exhibition, making it virtually impossible for visitors to navigate freely.

Distanced from its origins, surrealism in America—"shipwrecked surrealism," as Tanning called it—became increasingly commercialized and somewhat drained of its urgency. The declarations of surrealism came to seem trivial compared to the carnage caused by the war. The surrealists' iconography of the absurd had become stylized, absorbed into mainstream fashion and film.

Salvador Dalí, by then living in the United States, had become an art-world superstar, influencing fashion and receiving splashy magazine profiles. His painting *Art of Radio*, circa 1944 (fig. 34), appeared in *Life*,[14] recalling other surrealist pictures of laterally sectioned women's bodies, such as Magritte's far more demure *L'evidence éternelle* (The Eternally Obvious), 1930 (fig. 35). Though Dalí was publicly identified with the movement, many surrealists by then had developed a strong contempt for his unabashed commercialism, which included painting commissioned portraits that he produced in a surrealist style.

Hans Richter's 1947 film *Dreams That Money Can Buy* embodies this paradoxical stance of surrealism in America. Comprised of short segments created by six contemporary artists, Richter's film was a hybrid of avant-garde ideas and American Hollywood glitz that was also featured in *Life*.

.

By 1947, when Elizabeth Short was found dead, surrealism had transitioned from a revolutionary art and literary movement to a fashionably irreverent voice in American culture. Its influence was irrefutable, but its future as a vehicle for the avant-garde was far from certain.

OPPOSITE PAGE, RIGHT: FIGURE 35
René Magritte
L'évidence éternelle
(The Eternally Obvious)
1930
Oil on five separately stretched and framed canvases mounted on Plexiglas
THE MENIL COLLECTION, HOUSTON, TEXAS
© 2006 C. HERSCOVICI, BRUSSELS / ARTISTS RIGHTS SOCIETY (ARS), NEW YORK
PHOTOGRAPH: HICKEY-ROBERTSON, HOUSTON

.

In this Magritte painting, the radical fragmentation of the image contrasts with the relaxed pose of the nude woman's form and her demure smile. The motifs of sectioned or disassembled women appear in the works of Hans Bellmer, Victor Brauner, Salvador Dalí, Oscar Dominguez, Marcel Duchamp, Max Ernst, Man Ray, André Masson, Raoul Ubac, and many lesser-known surrealist artists.

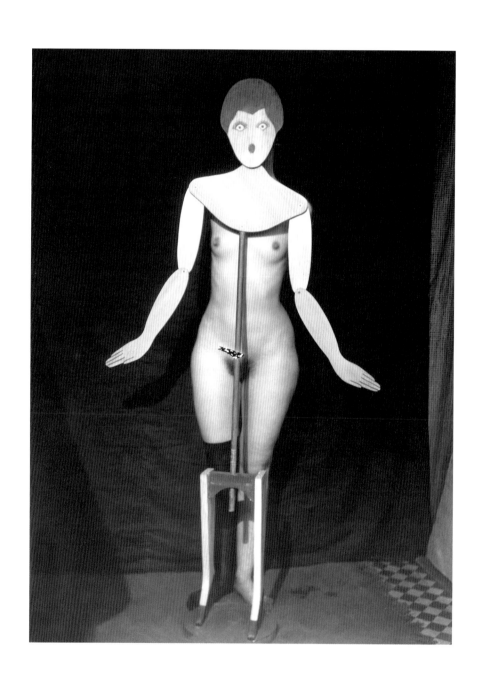

Man Ray: A Subversive Vision

"If the crowd really knew who we were and what we represented, we'd probably be lynched."

— Man Ray, *Self Portrait*, 1963

FIGURE 36
Man Ray
"Coat Stand"
1920
© 2006 MAN RAY TRUST / ADAGP (ARS) / TELIMAGE

Man Ray arrived in Los Angeles in 1940 at the age of fifty, after living in Paris for nearly two decades. Like many of his surrealist colleagues, he left France quickly at the onset of World War II. Other artists, including his close friend Marcel Duchamp, would wait out the war years in New York. It was typical of Man Ray's iconoclastic nature that he chose Los Angeles — a city that was not particularly friendly to avant-garde art. He said that he wanted to get as far away from the war as he could. He even suggested, perhaps jokingly, that he had considered moving to Tahiti.

Unsurprisingly, Man Ray did not meet with as much critical success in Los Angeles as he had enjoyed in Paris. However, his years there were not unproductive or unfruitful. He remained in California for eleven years, during which time he continued to photograph, paint, and exhibit.

In Paris he had made a reputation for himself as a fashion photographer and became widely respected as an artist. His fashion work was elegant and innovative for its time. A sense of glamour pervaded his personal photography as well, where he experimented with darker themes. As he described in his memoir, *Self Portrait*, "I photographed as I painted, transforming the subject as a painter would, idealizing or deforming as freely as a painter." He counted among his influences philosophers from Walt Whitman to Baudelaire to Lautréamont to Sade — and artists including Jean-Auguste Dominique Ingres, Picasso, and Alfred Stieglitz.

While Man Ray was living in Los Angeles, it would have been all but impossible to ignore the media storm surrounding the death of Elizabeth Short. Given the surrealists' interest in the subversive allure of crime, it is not inconceivable, as we will examine in part 2, that Man Ray communicated details of her slaying to Marcel Duchamp.

MAN RAY AND MARCEL DUCHAMP

Man Ray—born Emmanuel Radnitsky in 1890—was the eldest child of Russian immigrants and grew up in Brooklyn. He passed up an architecture scholarship to New York University to make his own way as an artist. He became enthralled with the work of Marcel Duchamp in 1913, when he saw Duchamp's painting *Nude Descending a Staircase* (1912) at the Armory Show in New York. They met two years later through the art patron Walter Arensberg.

The friendship between Man Ray and Marcel Duchamp (figs. 37, 38) has been well chronicled, as have the contrasts between the two. Duchamp was tall, reserved, and elegant, while Man Ray was short and could come across as unrefined. "Duchamp was made of patience. Man Ray wanted to cut all corners to everything," as the artist and art patron William Copley wrote.[1] Possessing very different personal and aesthetic styles, both were artistic innovators who enjoyed their association with the surrealist movement while also keeping a cultivated distance from it. Both artists' work was often suffused with a Dadaist wit. Duchamp's best-known contraptions convey his fascination with optics, mechanics, and eroticism, and were often accompanied by intentionally confusing explanations. Man Ray's visual puns were more accessible, as were his points of inspiration.

Born in Normandy, France, in 1887, Duchamp was an established artist when he met Man Ray, and he became an early supporter of Man Ray's art. Both artists were part of the Arensbergs' salon parties at their house on West Sixty-seventh Street in New York, along with artists and writers including Francis Picabia, Charles Sheeler, Mina Loy, and William Carlos Williams.

In 1920, Man Ray and Duchamp were driving forces behind the Société Anonyme, an avant-garde artists' society and noncommercial gallery supported by the artist and art patron Katherine Dreier. It was there

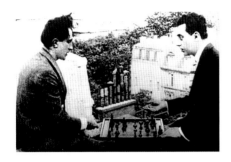

LEFT: FIGURE 37
Man Ray
Marcel Duchamp and Man Ray playing chess on the roof of the Théâtre Champs-Élysées in the film *Entr'acte* by René Clair
1924
© 2006 MAN RAY TRUST / ADAGP (ARS) / TELIMAGE

RIGHT: FIGURE 38
Man Ray
Marcel Duchamp and Man Ray at Man Ray's studio on rue Férou
1965
© 2006 MAN RAY TRUST / ADAGP (ARS) / TELIMAGE

that Man Ray exhibited one of his earliest Dadaist creations, *Lampshade* (1919, 1921). The original piece was made from objects Man Ray found in his apartment. He hung a broken paper lampshade on a dress stand whose torso had been removed. After a janitor accidentally threw out the lampshade, Man Ray made a replica out of twisted metal, declaring it "indestructible" and easily remanufactured. This revolutionary idea that the original artwork, and the creative hand of the artist, did not really matter corresponded with Duchamp's notions of "readymade" artworks, the most famous and inflammatory of which was his *Fountain* (1917), a porcelain urinal that Duchamp bought and signed "R. Mutt."[2]

From early in their relationship, Man Ray and Duchamp engaged in a private, long-running, personal, and artistic dialogue, influencing and informing each other's work. Man Ray was the only person to see and photograph Duchamp dressed up as his female alter ego, Rrose Sélavy, an invented persona to whom Duchamp sometimes attributed his own artworks and who became a beloved surrealist character. (Duchamp first named this character "Rose Sélavy" in 1920, changing it to "Rrose Sélavy" in 1921.)

Both artists were fascinated by the interplay of the human and the mechanical, a phenomenon that appears throughout their work. Man Ray's images of mannequins and mannequin-like forms, including "Coat Stand," 1920 (fig. 36), are one expression of this impulse. "Coat Stand" is a photograph of a model wearing a single black stocking and standing

FIGURE 39

Man Ray

"Primat de la matière sur la pensée"

(Primacy of Matter over Thought)

[Meret Oppenheim]

1929

© 2006 MAN RAY TRUST / ADAGP (ARS) / TELIMAGE

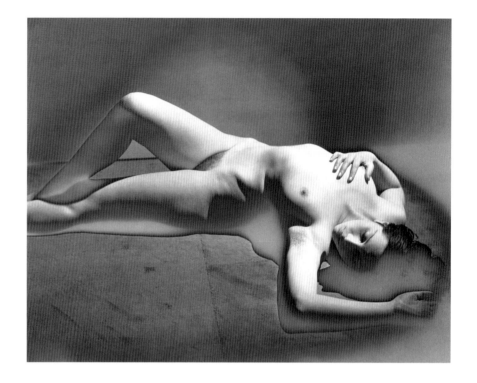

FIGURE 40

Man Ray

Self-portrait with "dead" nude from the

series *La prière* (The Prayer)

ca. **1930**

© 2006 MAN RAY TRUST / ADAGP (ARS) / TELIMAGE

behind a coat stand that appears to include a mannequin's crudely painted head and arms. In this marriage of a woman and a utilitarian object, the model's mouth is a comical "O," her eyes are wide open, and the jointed arms bend out unnaturally like the limbs of a puppet. It is an early portent of the *rue surréaliste* at the 1938 International Exhibition of Surrealism, wherein Duchamp gave artists mannequins to transform into art objects (figs. 28–31).

The two men viewed sensuality as a subject of artistic exploration. Duchamp described eroticism as "a way to bring out in the daylight things that are constantly hidden . . . because of social rules. To be able to reveal them, and to place them at everyone's disposal." Man Ray used photography and art to explore themes of unconventional eroticism. He described his camera as his "passport, permitting safe passage across otherwise perilous boundaries." And he occasionally veered into the pornographic, as in his photographic series Mr. and Mrs. Woodman (1947), showing a pair of male and female mannequin dolls in twenty-seven erotic positions. Writing about the photographs, Man Ray suggested that the Woodmans, "liberated from their trees or from the same tree," were brother and sister. "Only an insect would dare say that incest is nicest," he wrote with anagrammatic wordplay typical of his edgy sense of humor.[3]

His art reveals a gift for mixing the ruinous with the erotic. As Werner Spies, director of the Musée National d'Art Moderne in Paris, has written: "There is perhaps no finer defense of surrealism's central theme of transgression via eroticism than Man Ray's wanton nudes, who point more to death than to sexuality."[4] This pairing of sex and death is evident in Man Ray's *"Primat de la matière sur la pensée"* (Primacy of Matter over Thought), 1929 (fig. 39), and in his stagey untitled self-portrait with a nude woman apparently dead from a gunshot wound, from the series *La prière* (The Prayer), circa 1930 (fig. 40). These romantic portrayals

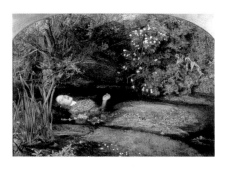

FIGURE 41
Sir John Everett Millais
Ophelia
1852
Oil on canvas
TATE GALLERY, LONDON
PHOTOGRAPH © TATE GALLERY, LONDON / ART RESOURCE, NY

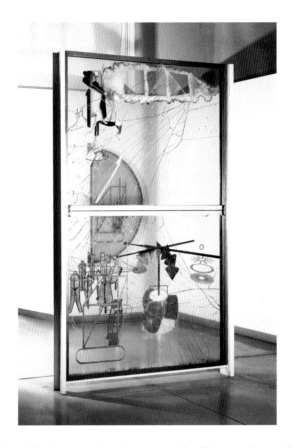

FIGURE 42
Marcel Duchamp
La mariée mise à nu par ses
célibataires, même
(**The Bride Stripped Bare by Her**
Bachelors, Even; or, *The Large*
Glass)
1915–23
Oil, varnish, lead foil, and dust
on two glass panels
PHILADELPHIA MUSEUM OF ART
BEQUEST OF KATHERINE S. DREIER, 1952
ACCESSION: 1952-98-1
© 2006 ARTISTS RIGHTS SOCIETY (ARS), NEW YORK /
ADAGP, PARIS / SUCCESSION MARCEL DUCHAMP
PHOTOGRAPH: GRAYDON WOOD

of sensual death had precedent in Pre-Raphaelite works, such as Sir John Everett Millais's *Ophelia,* 1852 (fig. 41), which the surrealists admired.

Man Ray and Duchamp collaborated directly and indirectly. Duchamp met Man Ray while in the early stages of conceiving the enigmatic masterpiece that would become one of his best-known works, *The Bride Stripped Bare by Her Bachelors, Even* (1915–23), also known as *The Large Glass* (fig. 42). In this large-scale piece, which took eight years to complete, Duchamp explored ideas of unfulfilled desire in a whimsical and intellectually labyrinthine construction. His copious notes about the sculpture, collected in a work known as *The Green Box* (1934), shed light on some of the eccentric motifs and themes.

Rendered in wire and other materials on glass, the work reflects Duchamp's fascination with optics and the human act of voyeurism. An abstract form representing the bride in the top pane is separated from the bachelors in the lower pane. Unable to consummate the love act, each bachelor grinds his chocolate — a French euphemism for masturbation — while the "oculist witnesses" look on. These oculist witnesses,

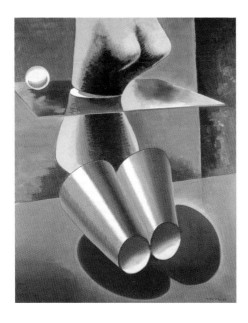

FIGURE 43
Man Ray
La jumelle
(The Twin)
1939
© 2006 MAN RAY TRUST / ADAGP (ARS) / TELIMAGE

·

This semi-abstract painting is one of many Man Ray works picturing sectioned female bodies.

in the middle of the lower right pane, were based on discs used by opticians at the time. They are not only spectators to the activities of the bride and the bachelors, but reminders to the viewer of his or her own act of looking. An intermediary piece from 1918, *To Be Looked At (from the Other Side of the Glass) with One Eye, Close to, for Almost an Hour,* was one of Duchamp's earliest works to investigate these themes.

After a significant amount of dust had accumulated on *The Large Glass,* Man Ray created the photograph "Dust Breeding" (1920), a magnified view of dust mounds resting on the artwork. The picture's title wittily points to the extremely long gestation of this work-in-progress, while also illustrating Man Ray's intimacy with Duchamp's studio. Much later, in a 1939 painting *La jumelle* (The Twin) (fig. 43), Man Ray portrayed an abstract female figure bisected at the waist by what appears to be a glass plate; her legs are replaced by a binocular-like motif. This imagery may well allude to both the materials and the theme of voyeurism in Duchamp's *Large Glass.*

·

When Man Ray moved to Paris in the summer of 1921, knowing virtually no French, Duchamp introduced him to artists and writers including André Breton, Paul Éluard, and Philippe Soupault, who gave him an exhibition at his bookstore, Librairie Six. That same year, Duchamp

FIGURE 44
René Magritte
Les marches de l'été
(The Marches of Summer)
1938–39
Oil on canvas
MUSÉE D'ART MODERNE DE LA VILLE DE PARIS, PARIS
© 2006 C. HERSCOVICI, BRUSSELS / ARTISTS RIGHTS SOCIETY
(ARS), NEW YORK
PHOTOGRAPH © PETER WILLI / BRIDGEMAN ART LIBRARY

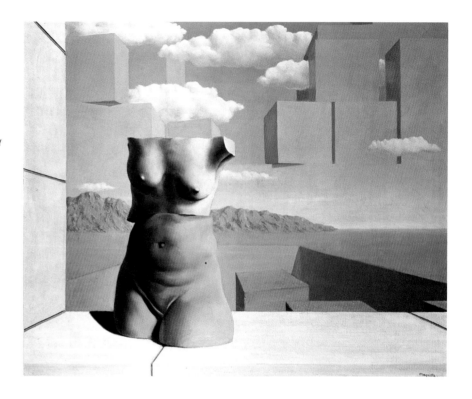

declared that his ambition was "to be a professional chess player," in a February 8 letter to the poet Tristan Tzara.

In Paris Man Ray largely supported himself by doing fashion photography. He also took hundreds of commissioned portraits of artistic and literary personalities, including James Joyce, Gertrude Stein, and Henri Matisse. His personal photography reveals radical uses of photographic technique, including solarization of images and his darkroom-generated Rayographs. Like Magritte and so many of his other surrealist colleagues, he also experimented with the artistic motif of sectioning the female body (figs. 26, 34, 35, and 44).[5]

His commercial work, some of it published in *Harper's Bazaar*, was revolutionary. He created images of women with fantastically elongated profiles, sometimes pictured alongside contemporary artworks or wearing

RIGHT: FIGURE 45
Man Ray
Nude female torso
ca. 1930
© 2006 MAN RAY TRUST / ADAGP (ARS) / TELIMAGE

LEFT: FIGURE 46
Man Ray
Lee Miller
1930
© 2006 MAN RAY TRUST / ADAGP (ARS) / TELIMAGE

African headdresses. In his personal photography, Man Ray photographed women with sculptures and composed pictures so that the women themselves appear to be works of art. *"Noire et blanche"* (Black and White), 1926 (fig. 96), portrays the head of his lover Kiki de Montparnasse as smooth and stylized as a sculpture, lying sideways, eyes closed, and juxtaposed with a dark African mask. In the photographic series of a nude female torso, circa 1930 (fig. 45), Man Ray photographed a model from the hips up wearing long black gloves, shadowed so that she comes across as an armless—though living—sculptural fragment. In a photograph from the series Lee Miller, 1930 (fig. 46), Miller appears nude from the hips up, with one arm oddly confined in a wire contraption. These pictures convey the elegance with which Man Ray manipulated women in his art, creating chic spectacles of their body parts. It was his great gift to combine compositional beauty with unsettling subject matter.

MAN RAY AND WOMEN

Man Ray's relationships with women were inextricably linked to his artworks. His photographs of Kiki de Montparnasse are some of his best known. Man Ray also used Kiki's own body as a canvas. Before they went

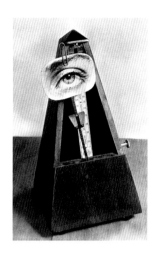

FIGURE 47
Man Ray
Object to Be Destroyed
1923
Modified metronome with photograph
© 2006 MAN RAY TRUST / ADAGP (ARS) / TELIMAGE

out at night, he would shave her eyebrows and repaint them as he wished, apply eye makeup, and dress her up. He claimed that the imprint of Kiki's lipstick on his collar was probably the inspiration for one of his paintings, *A l'heure de l'observatoire — Les amoureux* (Observatory Time — The Lovers), 1932–34, an enormous pair of lips floating in the sky, also resembling the shape of two entwined bodies. Other sources assert that the floating lips portray Lee Miller's and refer to the theme of the "devouring woman."[6]

In 1923, Kiki left Man Ray to try to establish a career as an actress in the United States. The year before, Man Ray had created the first version of an artwork that would in time become one of the icons of surrealism, *Object to Be Destroyed* (fig. 47). It was a metronome, and Man Ray attached a photograph of a woman's eye to the stem so that the eye swung back and forth as the metronome ticked.

A 1932 drawing of this object, with a photograph of Lee Miller's eye attached and titled *Object of Destruction,* was more charged. The breathtakingly beautiful Miller, Man Ray's assistant and lover since 1929, had recently broken up with him. Man Ray published the drawing in a 1932 issue of *This Quarter* with the instructions, "Cut out the eye from a photograph of one who has been loved but is seen no more. Attach the eye to the pendulum of a metronome and regulate the weight to suit the tempo desired. Keep doing to the limit of endurance." He added, in closing, "With a hammer well-aimed, try to destroy the whole at a single blow."[7]

MAN RAY AND THE MARQUIS DE SADE

Like other surrealists, Man Ray admired what he viewed as a pursuit of total liberty in the transgressive writings of the Marquis de Sade — writings that prompted Napoleon Bonaparte to send him to prison in 1801. An early artistic reference is Man Ray's photograph "Homage to

D. A. F. de Sade" (ca. 1929), published in the journal *Le surréalisme au service de la révolution* in 1930. This image of a woman's disembodied head under a glass bell jar reappears in his 1950 painting *Aline et Valcour* (fig. 48), titled after the story by Sade.

Some personal connections spurred Man Ray's curiosity about Sade during his Paris years. One of his neighbors in Paris was Maurice Heine, a scholar devoted to publishing Sade's uncollected works. Heine and Man Ray became friends, and Heine's own articles relating to Sade appeared in the surrealist magazine *Minotaure*. In 1936, the poet Paul Éluard, during a talk at the Burlington Gallery, noted that "we do not have a visual image of Sade," who "desired to give back to civilized man the full force of his primitive instincts."

That same year, Man Ray made sketches of Sade, published in *Les mains libres*, a book of Man Ray's drawings with accompanying poems by Éluard. In 1938, Man Ray made Sade the subject of an oil painting, showing him as a mountainous, sphinxlike figure made of stone.

While living in France, Man Ray photographed sadomasochistic scenarios that the writer and explorer William Seabrook had set up in a Montparnasse hotel suite, in a series titled The Fantasies of William Seabrook (fig. 49). Obviously posed, these photographs lack the refinement and imagination that typify most of Man Ray's work.

After Man Ray had settled in Los Angeles, he created second versions of some earlier pieces that he had left behind in Nazi-occupied France. Those renditions include *Le beau temps* (fig. 33) and the Sade portrait. Man Ray exhibited the new Sade painting frequently: at the Frank Perls Gallery in Hollywood in 1941, at his 1944 exhibition at the Pasadena Art Institute, and in 1945 at the Julien Levy Gallery in New York.[8] "I am not going to show it here again—It has been in 5 shows already," he wrote to his sister Elsie Siegler in an undated letter from 1944. "I did want to get it back to France where it would be better appreciated."[9]

FIGURE 48
Man Ray
Aline et Valcour
1950
Oil on canvas
© 2006 MAN RAY TRUST / ADAGP (ARS) / TELIMAGE

FIGURE 49
Man Ray
From the series *Les fantaisies de William Seabrook*
(The Fantasies of William Seabrook)
ca. 1930s
© 2006 MAN RAY TRUST / ADAGP (ARS) / TELIMAGE

In Los Angeles, he met Henry Miller, who had also lived in France, though the two didn't know each other there. Miller settled in Big Sur, California, in 1944. "The so-called pornography of his books reminded me of the banned writings of the Marquis de Sade," Man Ray reflected in *Self Portrait*. Miller had published his first book, *Tropic of Cancer*, in France in 1934. The book was banned in America and was not published in the United States until 1961. In correspondence, Miller encouraged Man Ray to write about Sade, with whom Miller was also fascinated.

"I cannot imagine a more noble role than to become the interpreter, officially accredited, for the Marquis de Sade," Man Ray wrote in notes from his L.A. years.[10] "You are the one to write about Sade, as I always say," Miller wrote to Man Ray in an undated letter. "I don't know of anyone who has your point of view on him, expresses it so clearly, or who is as enthusiastic," he wrote in another letter, dated February 8, 1946.

MAN RAY AND GEORGE HODEL

Man Ray made several photographs of George Hodel and his family during the 1940s. The intimate nature of some of these images suggests that the relationship was more than professional. His 1945 photograph of George and Dorothy Hodel's three young sons (fig. 50) is spontaneous, like a family snapshot, while his portrait of George Hodel seated in a UNRRA-issued trench coat next to a scroll of Chinese characters has a formal elegance (fig. 51). The picture was taken shortly after Hodel's return from China, where he served as Public Health Administrator. Hodel had developed a strong interest in Chinese art, shipping many pieces back to his Franklin Avenue home.

In 1946, Man Ray gave George and Dorothy Hodel the inscribed copy of the photographic self-portrait he made that year, with his face etched with vertical and horizontal lines (fig. 17).[11] Man Ray used the same image in the brochure for a 1948 solo exhibition at the Copley

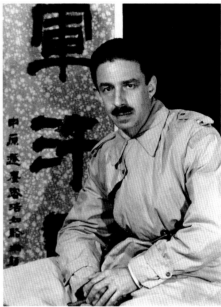

Galleries in Los Angeles and later chose it for the cover of *Self Portrait*, his 1963 memoir. The critic Roger Shattuck has called this picture a "modified and reversed replica" of Man Ray's 1933 photograph *"Monument à D. A. F. de Sade,"* showing a close-up of a nude backside superimposed with an upside-down cross.[12]

In a beautiful 1944 double portrait of Hodel's wife Dorothy with Juliet Man Ray (fig. 52), the women are portrayed almost like twins, positioned identically. Their faces are at equal angles to the camera, the outlines of their hair matches, and even the curve of their noses is the same.[13]

The two women also come across as different versions of the same archetype: Juliet, with the bold patterned shirt and vibrant flower, contrasted with Dorothy, wearing a tight, constricting dress with a high Asian-style collar. The double portrait is set up to convey an intimacy between the women—and perhaps, by extension, their male counterparts. It also suggests a shared outlook in terms of general aesthetics and perhaps in how Man Ray and Hodel preferred to view women. Another 1944 Man Ray portrait of Dorothy Hodel shows her in the same

LEFT: FIGURE 50
Man Ray
Portrait of Kelvin, Michael,
and Steven Hodel
1945
Signed and dated recto
COLLECTION OF STEVE HODEL
© 2006 MAN RAY TRUST / ADAGP (ARS) / TELIMAGE

RIGHT: FIGURE 51
Man Ray
Portrait of George Hodel
ca. 1946
Original signed recto on matte
FAMILY-OWNED COPYPRINT AFTER ORIGINAL —
COLLECTION OF STEVE HODEL
© 2006 MAN RAY TRUST / ADAGP (ARS) / TELIMAGE

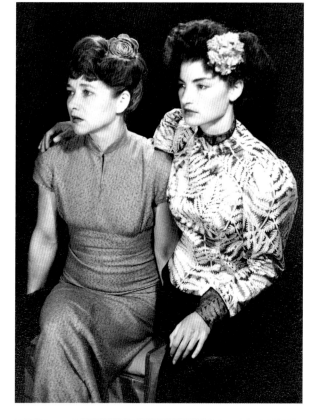

FIGURE 52
Man Ray
Portrait of Juliet Browner
[later Juliet Man Ray] and Dorothy Hodel
1944
FAMILY-OWNED COPYPRINT AFTER ORIGINAL —
COLLECTION OF STEVE HODEL
© 2006 MAN RAY TRUST / ADAGP (ARS) / TELIMAGE

FIGURE 53
Man Ray
Portrait of Dorothy Hodel
1944
Signed and dated recto
COLLECTION OF STEVE HODEL
© 2006 MAN RAY TRUST / ADAGP (ARS) / TELIMAGE

FIGURE 54
Photographer unknown
George Hodel with unidentified men,
Philippines
ca. 1985
COLLECTION OF STEVE HODEL
.

This original print with George Hodel's
handwriting was probably used to indicate
provenance when putting Man Ray's
The Oculist (hanging on the wall behind
George Hodel) up for auction.

The "oculist" and the "oculist witness"
were symbolic entry points into artistic
explorations of voyeurism, a theme taken up
by both Man Ray and Marcel Duchamp.

Objet de mon affection — "L'oculiste"
(also known as *The Oculist*) was created
in 1944 and exhibited at the Circle
Gallery in 1946. Man Ray gave the work
to George Hodel in 1948, one year after the
murder of Elizabeth Short.

dress, with her bracelets and two large flowers in her hair providing
focal points. The picture is similar to a photograph from George Hodel's
personal album that Steve Hodel believes portrays Elizabeth Short (fig. 88).

.

A sculptural work that tracks the relationship between Man Ray and
George Hodel is Man Ray's 1944 *Objet de mon affection — "L'oculiste"* (Object
of My Affection — "The Oculist," also known as *The Oculist*) (fig. 54), an
object portraying a large, single eye.[14] The piece can be viewed as a ref-
erence to Duchamp and the voyeuristic "oculist witnesses" that appear

in *The Large Glass.* Man Ray exhibited *The Oculist* at the Circle Gallery in Los Angeles in 1946 and then gave it to Hodel in 1948, the year after Elizabeth Short was killed. Though the gifting of the object proves little, it is interesting to observe, as the art historian Robert Pincus-Witten has, that this work echoes images of "the omniscient cosmic eye, the Masonic peak of the pyramid of the U.S. dollar bill." Pincus-Witten notes that such works imply a warning, too: "'I know that you know that I know that you know . . .'"[15]

Man Ray returned to Paris in 1951, a year after Hodel's incest trial, with his wife, Juliet, a dancer whom he married in Los Angeles in 1946.[16] Man Ray and Juliet sent Hodel a friendly postcard from Paris after they had settled into a new apartment there. "What to [*sic*] you want from Paris besides a *cocotte?*" it says in closing. "Love Julie & Man."[17]

The affectionate tone of the note, with its slang reference to a "tart," suggests that the pall of the incest trial had not fostered ill will between Hodel and the Man Rays. This informal postcard also raises the question of whether or not they associated George Hodel with the Black Dahlia murder.

The question will probably remain unanswered. But it is possible that Man Ray would have noticed parallels between the Black Dahlia crime-scene signatures and aspects of surrealism, including some of his own works. One photograph that he took in 1945 stands out.

That image shows Juliet lying on the couch in their home at 1245 Vine Street (fig. 55). She reclines languidly, with her arms arched upwards. Her artful pose recalls the posture of the woman in "Minotaur" (fig. 57). The artwork hanging above the sofa is Man Ray's repainted version of *Le beau temps* (fig. 33), whose central figure is a sectioned torso.

Conveying both reverie and death, the picture of Juliet, whose pose also resembles that in which Elizabeth Short was found (fig. 56), eerily prefigures the Black Dahlia murder by two years.

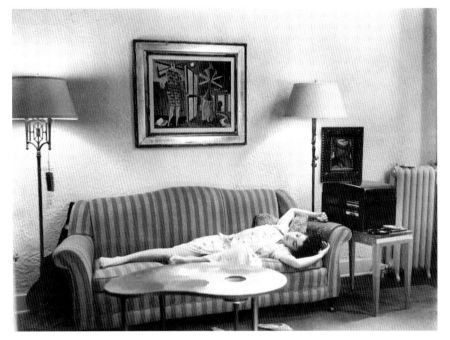

FIGURE 55
Man Ray
Juliet on the couch at 1245 Vine Street
ca. 1945
© 2006 MAN RAY TRUST / ADAGP (ARS) / TELIMAGE
•

In an image taken less than two years
before the murder of Elizabeth Short, Juliet
Browner lies supine with her arms above
her head in a position recalling Man Ray's
1935 photograph "Minotaur" (see fig. 57).
On the wall above her is Man Ray's second
version of *Le beau temps* (see fig. 33)
with a sectioned torso as its central figure.

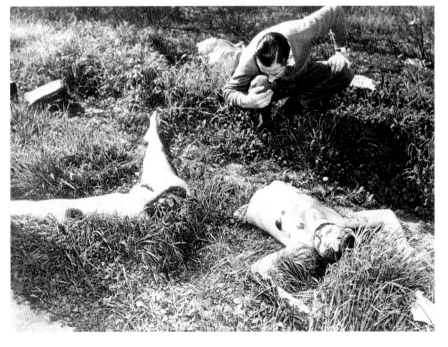

FIGURE 56
Crime-scene photograph—
Elizabeth Short murder
January 15, 1947
PHOTOGRAPH: DELMAR WATSON PHOTO ARCHIVE,
LOS ANGELES, CALIFORNIA
•

View from above, looking southwest.

Minotaur and *Minotaure*

*"If all the ways I have been along were marked on a map and
joined up with a line, it might represent a minotaur."*

—Pablo Picasso[1]

The photograph portrays the body of a slender young woman. Her chest cavity is deep in shadow; her ribs articulated. Her face, too, is in shadow, so she appears headless. Her arms are raised.

This circa 1933 photograph also alludes to the minotaur, the mythological creature that was half man, half bull. In the photograph, the woman's body optically doubles as the minotaur's face. Her raised arms allude to the curves of a bull's horns; her breasts become its eyes.

Steve Hodel suggested in *Black Dahlia Avenger* that his father may have posed Elizabeth Short's body with raised arms to mimic this photograph. What Hodel did not know is that Man Ray's picture is part of an overarching theme within surrealism, and just one of many artistic references to the minotaur. This figure was a metaphorical touchstone for surrealists, appearing regularly in writings and artworks in the years before and after the murder. In addition, figures with upraised arms are portrayed in other surrealist artworks — often appearing to reference the minotaur.

Writers as diverse as Jorge Luis Borges, Jean-Paul Sartre,[2] and James Joyce referred to the minotaur story in their works. Among artists, Giorgio de Chirico, Max Ernst, André Masson, Pablo Picasso, and Salvador Dalí portrayed aspects of the myth, investing in it a profound intellectual symbolism. In this narrative of irrational passion and violence, they found an ideal mascot — an alter ego for civilized man.

•

The story of the minotaur, from Greek mythology, involves the clash of civilization and primitive drives. Greed, love, and betrayal all play a part in the tale. It begins when Poseidon, the god of the sea, gives a white

FIGURE 57
Man Ray
***"Minotaure"* (Minotaur)**
ca. 1933

© 2006 MAN RAY TRUST / ADAGP (ARS) / TELIMAGE

FIGURE 58
Giorgio de Chirico
The Soothsayer's Recompense
1913
Oil on canvas
THE PHILADELPHIA MUSEUM OF ART
THE LOUISE AND WALTER ARENSBERG COLLECTION, 1950
© 2006 ARTISTS RIGHTS SOCIETY (ARS), NEW YORK / SIAE, ROME
PHOTOGRAPH © THE PHILADELPHIA MUSEUM OF ART /
ART RESOURCE

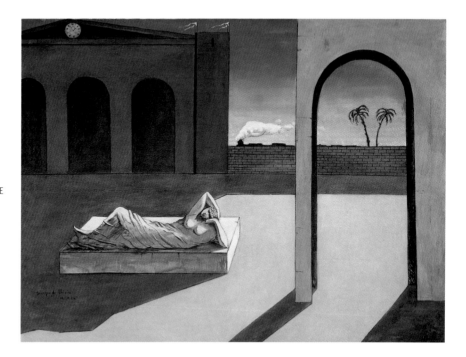

bull to Minos, the king of Crete, for sacrifice. Minos can't bring himself to kill the animal, so Poseidon punishes him by inducing Minos's wife, Pasiphaë, to fall in love with it. The result of their union is the minotaur, a creature with the body of a man and the head of a bull.[3]

The horrified Minos asks the architect and inventor Daedalus to make a structure that will contain this terrible being. Daedalus builds the labyrinth, an enormous complex of mazes from which the minotaur can never escape. Only Daedalus knows how to navigate it.

To satisfy the minotaur's appetite, Minos decrees that every nine years, seven young men and seven young women from Athens be sacrificed to the beast. Theseus, an Athenian hero, volunteers himself and secretly plans to kill the minotaur. Theseus then falls in love with Minos's daughter Ariadne, who, in return for a promise of marriage from Theseus, plans his escape. Ariadne gives Theseus a spool of golden thread, which he brings into the labyrinth and unwinds along the way. After killing the minotaur, Theseus navigates his way out by following the thread and leads the others to freedom.

Theseus then takes Ariadne and the thirteen youths to the island of Naxos. As Ariadne sleeps, however, Theseus abandons her and continues on to another island with the rest of the group.

Sigmund Freud viewed the labyrinth, the maze in which the minotaur was imprisoned, as a metaphor for the unconscious human mind. Psychoanalysis, he wrote, "supplies the thread that leads a man out of the labyrinth of his own unconscious." For the surrealists, so many of whom revered Freud, the minotaur symbolized instincts that lay beneath conventional behavior.

Artistic interpretations involving the minotaur story are varied. De Chirico, for example, was fascinated with Ariadne, portraying her in eight paintings from 1912 to 1913 (figs. 20, 58). He pictured Ariadne as a sleeping white statue in desolate courtyards. These paintings have been interpreted as conveying de Chirico's sense of personal melancholy during this time and also as referencing the Balkan Wars, in which Crete played a seminal role.

André Masson's many depictions range from a meditative drawing of a minotaur with the labyrinth superimposed on its chest to a rendering of the minotaur holding a dagger and cradling a woman as flames leap from its genitals (fig. 59).

The surrealists' fascination with the minotaur coincided with an international vogue for bullfighting, fueled in part by the writings of Ernest Hemingway and the artwork of Picasso.[4] The artist's passion for bullfighting—a sport strongly identified with Spanish culture—is well known. His representations of bulls and bullfighting ranged from the whimsical to the disturbing. *Tête de taureau* (Head of a Bull), 1942 (fig. 60), an assemblage built from a bicycle seat and handlebars, mimics the head and upturned horns of a bull. Its clever construction recalls the doubling effect that Man Ray used in his photograph "Minotaur." In the early 1930s, Picasso's etching *Minotauromachy* featured a more violent image of the

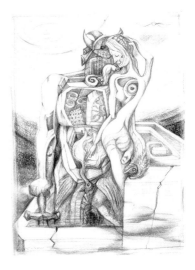

FIGURE 59
André Masson
Le secret du labyrinthe
(The Secret of the Labyrinth)
1935
Black lead and pastel on paper
MUSÉE NATIONAL D'ART MODERNE,
CENTRE GEORGES POMPIDOU, PARIS
© 2006 ARTISTS RIGHTS SOCIETY (ARS), NEW YORK /
ADAGP, PARIS
PHOTOGRAPH © PHOTO CNAC / MNAM DIST. RMN /
ART RESOURCE

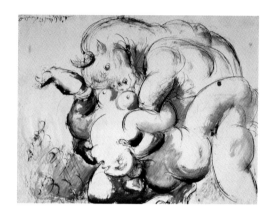

LEFT: FIGURE 60
Pablo Picasso
Tête de taureau
(Head of a Bull)
1942
Assemblage, bicycle seat and handlebars
MUSÉE PICASSO, PARIS
© 2006 ESTATE OF PABLO PICASSO / ARTISTS RIGHTS SOCIETY
(ARS), NEW YORK
PHOTOGRAPH: BEATRICE HATALA, © RÉUNION DES MUSÉES
NATIONAUX / ART RESOURCE, NY

RIGHT: FIGURE 61
Pablo Picasso
Minotaur Raping a Woman
June 28, 1933
India ink pen, wash drawing
MUSÉE PICASSO, PARIS
© 2006 ESTATE OF PABLO PICASSO / ARTISTS RIGHTS SOCIETY
(ARS), NEW YORK
PHOTOGRAPH: BEATRICE HATALA, © RÉUNION DES MUSÉES
NATIONAUX / ART RESOURCE, NY

minotaur, as did his 1933 *Minotaur Raping a Woman* (fig. 61). His most charged image in this vein is the figure that appears in the upper-left quadrant of *Guernica* (1937), the artist's masterpiece portraying the horrors of the Spanish civil war. Picasso's sketches for this figure show a hybrid half man, half bull. The humanoid bull in the final rendering, which looms over a woman cradling her dead child, has been read as a metaphor for the annihilating forces of Fascism.

Although Picasso never aligned himself with the surrealists, it was he who was invited to create the cover for the first issue of *Minotaure*,[5] the luxurious magazine published by Albert Skira between 1933 and 1939 (figs. 62, 67, 70, 72, 74). The many artistic interpretations of the minotaur— including Man Ray's—that appeared in the pages of this journal sealed the mythical creature's status as a surrealist icon.[6]

Thirteen issues of *Minotaure* appeared over the course of six years, with André Breton at the editorial helm for most of them. Skira insisted that the magazine be free of political and social commentary, so it became primarily a forum for intellectual and artistic ideas.[7] As such, it featured new art of the time, with reproductions of works by artists as diverse as Dalí, Bellmer (fig. 62), Ernst, Raoul Ubac, Manuel Alvarez Bravo, and Man Ray. The articles in *Minotaure* also featured art-historical and non-Western artworks, along with investigations into ethnology and criminality. *Minotaure* 8 published an imaginary dialogue among a group including Sade and Jack the Ripper. Essayistic contributors included Dalí, Benjamin Péret, Éluard, Paul Valéry, and Heine, among others.[8] Memorable covers were commissioned by artists such as Dalí, Magritte, and Duchamp.

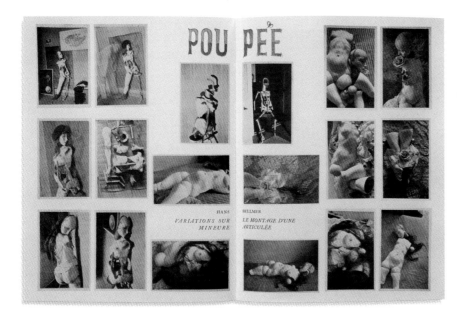

FIGURE 62
Magazine spread featuring Hans Bellmer's
"Poupée: Variations sur le montage
d'une mineure articulée"
(Doll : Variations on the Montage
of an Articulated Minor)
Minotaure
Issue 6
December 5, 1934
Published by Albert Skira, Geneva
PRIVATE COLLECTION
© 2006 ARTISTS RIGHTS SOCIETY (ARS), NEW YORK /
ADAGP, PARIS

Man Ray's "Minotaur" (fig. 57) was the magazine's dramatic frontis image in *Minotaure* 7, from 1935, and he contributed other photographs during the journal's run. *Minotaure* was no longer being published when Man Ray was living in Los Angeles, but he had copies of it while he was living there, as correspondence with his sister Elsie suggests. In a letter of July 25, 1941, Man Ray wrote, "Dear Elsie, Please excuse the delay — I received the *Minotaure* and *XXIe Siècle,* and am very pleased with them. You did well in selecting these numbers. However, that will do for the time being. I do not want to go to any more expense for the present, as I expect a friend to get me some other copies free."

Elsie, who lived in New Jersey, probably secured the copies through Julien Levy, the New York art dealer who distributed *Minotaure* in the United States and who was an early supporter of surrealist work. Levy had professional connections to Los Angeles as well. In the early 1940s, he traveled to California to sell a number of paintings that had not sold at his New York gallery.[9] In 1941, he organized a successful show of Dalí's paintings at Dalzell Hatfield Galleries in Los Angeles.[10] There, Levy also exhibited Dalí's jewelry designs and may have sold other surrealist ephemera,

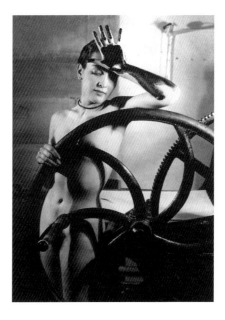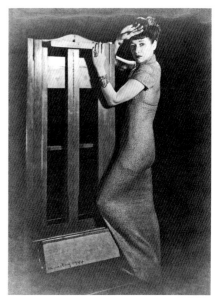

LEFT: FIGURE 63

Man Ray

From the series *Érotique voilée*

(Veiled Erotic)

[Meret Oppenheim]

1933

© 2006 MAN RAY TRUST / ADAGP (ARS) / TELIMAGE

RIGHT: FIGURE 64

Man Ray

Portrait of Dorothy Hodel

1944

Signed and dated recto

One of two variations taken in Man Ray's studio (one signed, one unsigned)

COLLECTION OF STEVE HODEL

© 2006 MAN RAY TRUST / ADAGP (ARS) / TELIMAGE

SEE ALSO SOTHEBY'S *PHOTOGRAPHS: NEW YORK, WEDNESDAY, APRIL 28TH, 1999*, P. 131 (LOT #231).

such as issues of *Minotaure*. If so, George Hodel would have had access to *Minotaure*, either from Man Ray or from a Los Angeles art venue.

The evidence here suggests not only that George Hodel knew of and read *Minotaure* but that he and Dorothy, collaborating with Man Ray, also made direct reference to the magazine's imagery and themes in photographs in the years before the Black Dahlia murder. Two articles in particular from *Minotaure* suggest that the Hodels were familiar with the magazine — both its imagery and the themes conveyed in its pages.

The articles relate to photographs by Man Ray of George and Dorothy Hodel, carefully composed images in which photographer and subjects seem to participate in allegorical role playing. Domination and submission, sex and sexual power, and the idealized masculine and feminine personae all seem to play parts in this photographic exchange among like-minded friends.

Among the illustrations accompanying Breton's article "Beauty Shall Be Convulsive," from *Minotaure* 5 (1934), is Man Ray's photograph from the series *Erotique voilée* (Veiled Erotic), 1933 (fig. 63). Part of a series featuring the painter Louis Marcoussis and the Swiss artist Meret Oppenheim, the picture shows Oppenheim and a large etching press. Man Ray's picture illustrates the broader surrealist fascination with

LEFT: FIGURE 65
Man Ray
From the series *Érotique voilée*
(Veiled Erotic)
[Louis Marcoussis and Meret Oppenheim]
1933
© 2006 MAN RAY TRUST / ADAGP (ARS) / TELIMAGE

RIGHT: FIGURE 66
Man Ray
T-Square
1943
Brush and ink on paper
© 2006 MAN RAY TRUST / ADAGP (ARS) / TELIMAGE

juxtaposing the human body and machines; in this case, the curved and serrated wheel of Marcoussis's press is paired with Oppenheim's nude body, its form echoed by the black band circling her neck. In the *Minotaure* photograph, Oppenheim's hand rests against her forehead; her palm, coated in black ink, faces out.[11] Other pictures from the series point to a more complex narrative, with Marcoussis and Oppenheim behind the large wheels, Marcoussis appearing to tie Oppenheim's hands behind her back (fig. 65).

Man Ray's 1944 photograph of Dorothy Hodel (fig. 64) bears parallels to the Oppenheim photo from *Minotaure*. Man Ray poses Dorothy Hodel with a large easel. Dorothy also has a hand against her forehead, her palm positioned outwards. One knee bends in toward the picture frame, its slim contour visible through her translucent dress. While Oppenheim's expression is beatific, Dorothy Hodel's appears haunted. Both photographs suggest that these sylphlike women are instruments—accoutrements of the mechanisms next to them. As Oppenheim later recalled of the photo shoot with Man Ray, "He told me he wanted to photograph me against a kind of machine. . . . Man Ray gave the directions and I followed them."[12] Indeed, both pictures imply an erotic pairing of sensual photographic subjects and artistic apparatus.

FIGURE 67
Magazine spread featuring *"Eritis Sicut*
Dii . . . ," **an essay by Maurice Heine**
Minotaure
Issue 11
May 15, 1938
Published by Albert Skira, Geneva
PRIVATE COLLECTION

•

This *Minotaure* spread features Tibetan
deities including the Buddhist Yamantaka
(Sanskrit: "Conqueror of Yama, Lord of
Death"). The accompanying article by
Maurice Heine — Man Ray's neighbor in
Paris — equates the Yamantaka with the
minotaur.

According to Buddhist mythology, a holy
man meditating in a cave had nearly reached
nirvana when two thieves with a bull
entered the cave and killed the animal.
They then beheaded the holy man, who put
on the bull's head and transformed into
Yama, a ferocious deity with a thirst for
human blood.

After an appeal from the people, the
Bodhisattva Mañjuśrī assumed the form of
the fierce, virile Yamantaka, also often
portrayed with a bull's head, and powerful
enough to slay Yama.

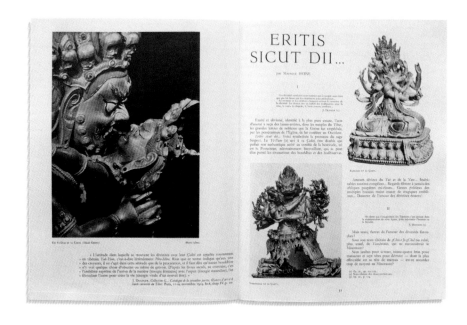

Man Ray's 1943 brush-and-ink drawing *T-Square* (fig. 66) highlights
this surrealist view of women as both artistic muses and artistic tools.
The image shows the silhouette of a woman whose body, forming the
T-square's head, is bisected by its blade. Man Ray's original inscription
on this artwork, erased but still faintly legible, reads: "To make of the
head of the T-square — a body. The first step necessary to a liberation
from rectangular rules. The hand that [illegible word] this body may
be induced to use it as effectively as if the hand uses a straight edge."

•

An even more revealing connection between George Hodel and *Minotaure*
is evident in an article by Maurice Heine, *"Eritis Sicut Dii"* (fig. 67), from
issue 11, published in 1938. Here, Heine writes about sculptures from
Tibetan temples, including the Yamantaka, in relation to surrealism. The
Yamantaka is the fearsome destroyer of Yama, the lord of death. In sculp-
tural portrayals, this many-headed creature is usually shown with the
central head of a bull and in sexual union with a consort.[13] In this magi-
cal being, Heine wrote, "who does not recognize the minotaur?"

FIGURE 68
Man Ray
Portrait of George Hodel
ca. 1946
Signed recto
FAMILY-OWNED COPYPRINT AFTER ORIGINAL —
COLLECTION OF STEVE HODEL
© 2006 MAN RAY TRUST / ADAGP (ARS) / TELIMAGE

In this portrait by Man Ray, George Hodel appears with a small statue of Yamantaka. The photograph may well reference a four-page article featuring Yamantaka that appeared in the May 1938 issue of *Minotaure* (fig. 67). Sculptural variations of the Yamantaka often picture the deity engaged in sexual union with a consort.

A circa 1946 photograph by Man Ray shows Hodel, again wearing the UNRRA trench coat, touching a small statue of the Yamantaka (fig. 68). His face is inches from the creature's many arms and heads. It is notable that, of the numerous art objects Hodel shipped back to the United States under diplomatic immunity, Hodel chose to be photographed with this work.[14]

In *Black Dahlia Avenger,* Steve Hodel notes that the photograph of George Hodel with the Yamantaka illustrates his father's tendency to identify with symbols of sexual potency. To consider this image in the context of the *Minotaure* essay is to realize that Hodel may have also identified with the minotaur itself.

Heine's illustrated article *"Martyres en taille-douce"* (Martyrs in Copper-Plate Engraving) appeared in *Minotaure* 9 (fig. 70). This piece featured art-historical etchings portraying saints being tortured and killed, including

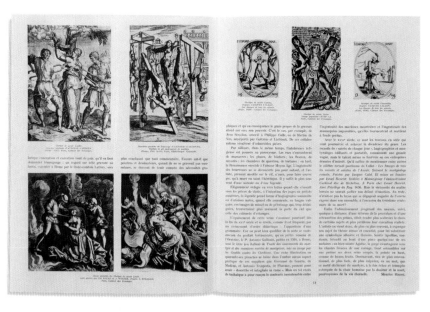

FIGURES 69, 70
Magazine spread, *"Martyres en taille-douce"* (Martyrs in Copper-Plate Engraving), an essay by Maurice Heine
Minotaure
Issue 9
October 15, 1936
Top-left-page detail:
Antoine Lafrery
Martyre de Sainte Agathe
(The Martyrdom of Saint Agatha)
1567
Published by Albert Skira, Geneva
PRIVATE COLLECTION

Antoine Lafrery's *Martyre de Sainte Agathe,* 1567 (fig. 69), a rendering of Agatha's breasts being severed—punishment, according to legend, for refusing to marry or submit to sexual advances. *Minotaure* 11 included an essay by Paul Recht, illustrated with fifteenth-century panels by Sandro Botticelli. Titled *The Story of Nastagio degli Onesti: The Disembowelment of the Woman Pursued,* 1483–87 (fig. 71), these panels portray the grisly fate of a phantom woman who turned down a marriage proposal. Her punishment was to be hunted down by her suitor and his dogs in a forest and killed—only to return to life and be hunted again in perpetuity.

These narratives—ancient stories of women tortured for defending their virtue—might have a strong impact on someone already predisposed to violence against women. The images and the stories tell of women who men thought deserved to be killed for fending off male advances. In the symbolic case of Agatha, she loses her breasts for refusing to give up her virtue.

Dalí's essays for *Minotaure* ranged in subject from *"Le surréalisme spectral de l'éternel féminin Préraphaélite"* (The Spectral Surrealism of the

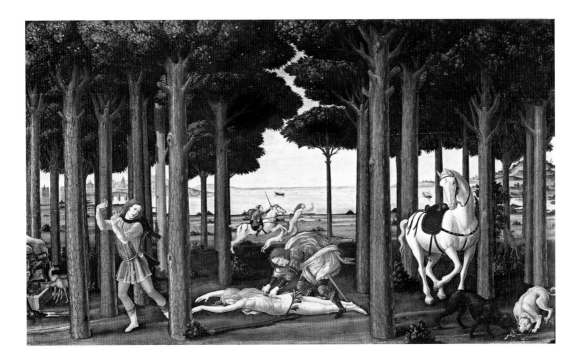

FIGURE 71
Sandro Botticelli
The Story of Nastagio degli Onesti:
The Disembowelment of the
Woman Pursued
1483–87
Oil on panel
COLLECTION MUSEO NACIONAL DEL PRADO, MADRID
PHOTOGRAPH © GIRAUDON / BRIDGEMAN ART LIBRARY

.

Featured in the essay "Botticelli et la
peste" (Botticelli and the Plague),
by Paul Recht, *Minotaure*, issue 11,
May 15, 1938.

Eternal Pre-Raphaelite Woman) in *Minotaure* 8, illustrated with works including John Everett Millais's painting *Ophelia* (fig. 41) and W. Holman Hunt's *The Hireling Shepherd,* to *"Les nouvelles couleurs du 'Sex-Appeal spectral'"* (The New Colors of "Spectral Sex Appeal") in *Minotaure* 5. In the latter article, Dalí described two female types, the "phantom" and the "specter."

As an example of the fleshy "phantom," Dalí described "Mae West's round and salivary muscles, terribly glutinous with biological after-thoughts." Dalí's preferred spectral woman could be easily taken apart and inspected section by section. He wrote, "The 'dismantle-able body' is the aspiration and verification of feminine exhibitionism, which . . . permits each piece to be isolated and separately consumable."[15] In this way, Dalí offered an explanation for so many of his own representations of women, shown in parts or layers (figs. 23, 28, 34, 72).

Dalí created the cover for *Minotaure* 8, published in 1936 (fig. 72). It shows a woman's body with the head of a bull, whose tongue hangs between its sharp, grinning teeth. The anatomical cutaways include an orifice in her stomach, from which a lobster protrudes, and sectioned

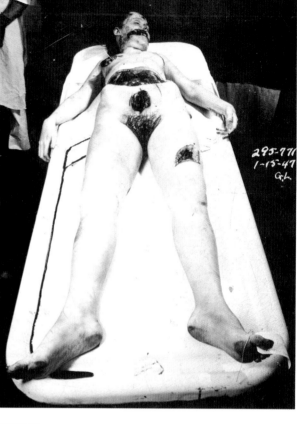

FIGURE 72
Salvador Dalí
Magazine cover
Minotaure
Issue 8
June 15, 1936
Published by Albert Skira, Geneva
PRIVATE COLLECTION
© 2006 SALVADOR DALÍ, GALA-SALVADOR DALÍ FOUNDATION /
ARTISTS RIGHTS SOCIETY (ARS), NEW YORK
•

The figure on Dalí's cover for a 1936 issue
of *Minotaure* has the head of a bull and
the sinewy female body typical of Dalí's
works. The cutaways in the thighs and
abdomen bear parallels to the damage done
to the body of Elizabeth Short.

FIGURE 73
Dissecting table photograph —
Elizabeth Short murder
January 15, 1947

FIGURE 74
René Magritte
Magazine cover
Minotaure
Issue 10
Winter 1937
Published by Albert Skira, Geneva
PRIVATE COLLECTION
© 2006 C. HERSCOVICI, BRUSSELS /
ARTISTS RIGHTS SOCIETY (ARS), NEW YORK

•

On the left side of this *Minotaure* cover by René Magritte, a segmented female figure lifts her arms in a gesture mimicking the horns on the skeletal minotaur in the foreground. These two surrealist motifs — the sectioned female body and upraised arms — visually correspond to the crime-scene signatures of the Black Dahlia murder.

areas in her thighs. A Magritte cover for *Minotaure* 10, from the winter of 1937, also shows a central figure with a bull's head, in this case a horned skull (fig. 74). In the background, pieces of a woman's hollow body nest together, like a stacking doll, echoing the sectioned female torsos found elsewhere in surrealism. The top figure has upraised arms in the posture associated with the minotaur. Taken together, motifs from these two covers call to mind the slain body of Elizabeth Short (figs. 56, 73).

MINOTAURS AFTER *MINOTAURE*

By 1939 much of Europe was in a financial crisis, and the magnitude of Hitler's ambition had become frighteningly apparent. Cultural institutions lost their funding or closed because of wartime disruptions. So it was with *Minotaure*. But this did not end the artistic preoccupation with the minotaur figure, which continued to appear in art, in print, and elsewhere.

Into the 1940s, expatriate artists including Max Ernst and Jacques Lipchitz created variations of the minotaur—Lipchitz going so far as to equate the beast with Adolf Hitler.[16] (The filmmakers Albert Lewin and Hans Richter also drew comparisons between the Third Reich and the minotaur story.) The British surrealist painter Conroy Maddox portrayed a seated minotaur in a jacket and tie, holding a top hat. Dalí created set designs for the Ballet Russe's performance of *Labyrinth*, a dance chronicling the minotaur tale, performed at New York's Metropolitan Opera House in 1941 and covered in *Time* magazine.[17]

As the war continued through the 1940s, *View*, an American magazine published by Charles Henri Ford, succeeded *Minotaure* as the leading avant-garde art journal. A competing journal, *VVV*, initiated by André Breton, lasted from 1942 to 1944.[18] *View* was a more populist endeavor, covering art, literature, film, and music.

Thirty-two issues appeared between 1940 and 1947. Writers who published in *View* ranged from Paul Bowles to William Carlos Williams to Albert Camus, whose novel *The Stranger* was excerpted in a 1946 issue.[19] Henry Miller's writings also appeared in the magazine, along with those of Man Ray.[20] John Huston's film *The Maltese Falcon* (1941) was covered in a lengthy essay, as was his stage production of Sartre's *No Exit*, which he directed in New York in October 1946.[21] Of course, Huston, Man Ray, and Miller were all celebrities in their own right by this point. But the fact that George Hodel was close to all of them makes it likely that he read *View*.

FIGURE 75
Magazine spread featuring an ad for a Picasso exhibit at the Pierre Matisse Gallery, New York
View
Series 3, No. 4 (pp. 126–27)
December 1943
Published by Charles Henri Ford
© 2006 ESTATE OF PABLO PICASSO / ARTISTS RIGHTS SOCIETY (ARS), NEW YORK
PHOTOGRAPH: RESEARCH LIBRARY, THE GETTY RESEARCH INSTITUTE, LOS ANGELES

•

Picasso's drawing shows the minotaur with upraised arms. In a stanza of the poem on the page opposite, Charles Henri Ford writes:
"The sinister is saved by a sense of humor, But love is lost. Who could love Ophelia After she went mad? It was not her death That was tragic, death was her due."

Though Ford's relationship with expatriate surrealists was sometimes contentious, he devoted entire issues of *View* to both Max Ernst and Marcel Duchamp.[22] The minotaur also had a presence in *View*. The December 1943 issue featured Picasso's 1935 drawing *Le minotaure* in an ad for his exhibit at the Pierre Matisse Gallery (fig. 75). Picasso's minotaur has upraised arms, similar to the posture in Man Ray's "Minotaur" photograph. An article in the summer 1944 issue by Ossip Zadkine, "The Minotaur Lost and Found," describes the minotaur as a "being luminous with melancholy mystery" with whom man could identify.

New artistic takes on the minotaur continued to emerge at least into the late 1940s. It was, then, not only the image of the minotaur, as represented in Man Ray's photograph and a host of other artworks, but the murderous spirit of the minotaur, a prevalent theme in surrealism, that may have informed the Black Dahlia murder.

Dreams of Love and Death

"What a curious sensation! To caress the figures of my madness!
Then there is no longer any sanity in me."

—Ben Hecht, *Fantazius Mallare: A Mysterious Oath*

A delusional man kills a beautiful woman who he imagines is an extension of himself. It turns out that the murder itself was a delusion. The woman is still alive, and the man finds her more alluring than before. He tries to kill her again, but it is unclear if he succeeds—and if the second act of violence takes place in a dream or in reality.

This dreamlike narrative comes from *Fantazius Mallare: A Mysterious Oath* (fig. 77), the florid and disturbing first novel by Ben Hecht, written in 1922. In later years, Hecht, a prolific Hollywood screenwriter as well as novelist, would count Alfred Hitchcock's *Spellbound* (1945) and *Notorious* (1946) among his best-known screenplays.[1] In those thrillers, dreams and the unquiet human mind also play starring roles.

Hecht's development as a writer occurred in tandem with the advent of surrealism, and the rapidly expanding and profound influence of Sigmund Freud's writings. Freud's *Interpretation of Dreams,* first published in 1900 and translated into English in 1913, ignited an international fascination with dream analysis. Literary masters from Virginia Woolf to Thomas Mann incorporated Freud's ideas into their works. The surrealists, also picking up on Freudian theory, were obsessed with the idea that dreams might bring buried thoughts and desires to light. They were especially intrigued by the dark recesses of the unconscious.

Dreamlike imagery was ubiquitous in surrealist art (Dalí's melting clocks and Magritte's enigmatic scenes providing the best-known examples), and the surrealists also portrayed the dream state in a cavalcade of images showing people with closed eyes (figs. 18, 19, 21, 24, 26, 39, 45, 55, 87, 89–92, 97, 98, 99, 140, 145).[2]

FIGURE 76
Man Ray
"Séance de rêve éveillé – groupe surréaliste"
(Waking Dream Séance – Surrealist Group)
1924
Oil on canvas
© 2006 MAN RAY TRUST / ADAGP (ARS) / TELIMAGE

LEFT: FIGURE 77
Ben Hecht
Fantazius Mallare: A Mysterious Oath
Illustrated by Wallace Smith
September 1922
Published in an edition of 2,025 copies
by Covici-McGee, Chicago
PRIVATE COLLECTION

RIGHT: FIGURE 78
Ben Hecht
*The Kingdom of Evil: A Continuation
of the Journal of Fantazius Mallare*
Illustrated by Anthony Angarola
1924
Published in an edition of 2,000 copies
by Pascal Covici, Chicago
PRIVATE COLLECTION

Hecht's productions were part of a loose genre of books, films, and artworks from the 1920s through the 1940s that involved dreams of violent eroticism. These themes also held a fascination for George Hodel and provide a meaningful backdrop against which to consider the Black Dahlia murder.[3]

Whoever killed Elizabeth Short, we maintain, was someone familiar with the art and ideas of surrealism — including the surrealists' preoccupation with psychoanalysis and dreams. The murderer may have crossed the line from expressing sadistic fantasies through artistic works to expressing them in real acts of aggression. George Hodel's interest in dream states and psychoanalysis was evident in his taste in fiction, film, and art. His recreational activities as a photographer and hypnotist also betrayed an interest in dreams, and his later professional work — as a psychiatric consultant to the Hawaii prison system and a psychiatrist in the Philippines — shows an ongoing engagement with the field.[4]

GEORGE HODEL AND BEN HECHT

Through his books, films, and personal relationships, Ben Hecht was associated with both George Hodel and the Black Dahlia murder by one degree of separation. A literary magazine that Hodel published in 1925, *Fantasia* (figs. 79–82), bears a connection to dreams and surrealism in both its title — an apparent direct reference to Hecht's *Fantazius Mallare* — and its stated devotion to "the portrayal of bizarre beauty in the arts," a description that calls to mind Breton's notion of "convulsive beauty." The journal's title also recalls Fantômas, the pulp-literature antihero who was so admired by the surrealists.

Fantasia featured a review by Hodel of Hecht's 1924 sequel to *Fantazius Mallare, The Kingdom of Evil: A Continuation of the Journal of Fantazius Mallare* (fig. 78). Madness is also at the center of this book, which is set in a nightmarish imaginary kingdom ruled by the evil Piltendorf, who fashions an army of "mannikins" he controls with strings.

Fantazius Mallare, the story of an artist retreating into a world of hallucination, was deemed obscene by the U.S. government, and Hecht and the illustrator, Wallace Smith, were convicted and fined $1,000 each.[5] In the passage in which Mallare kills the woman he imagines is his "phantom," Hecht conjures imagery that calls to mind the crime-scene signatures left on the body of Elizabeth Short: "There was something more to give him. She would remove something of herself — her arms, her breasts, her white thighs. . . . She listened and wished to die in his hands. . . ."

•

Ben Hecht wrote a screenplay with Rowland Brown, who was Dorothy Hodel's lover in the 1940s. Hecht was a supporter of the composer Ernst Krenek,[6] who married a woman who roomed at the Franklin Avenue house, the composer Gladys Nordenstrom. These connections make it probable that Hecht knew Hodel. In addition, Hecht was close with Will Fowler,

Fantasia

Published monthly
at sixty-five twelve Monterey
South Pasadena, California

Two dollars fifty the year
Twenty-five cents the issue

G. Bishop Pulsifer George Hill Hodel

Editors

Registration as second-class matter pending

A Dedication

T^O the portrayal of bizarre beauty in the arts, to the delineation of the stranger harmonies and the rarer fragrances, do we dedicate this, our magazine.

S^{UCH} beauty we may find in a poem, a sketch, or a medley of colors; in the music of prayer-bells in some far-off minaret, or the noises of a city street; in a temple or a brothel or a gaol; in prayer or perversity or sin.

AND ever shall we attempt in our pages the vivid expression of such art, wherever or however we may find it—ever shall we consecrate our magazine to the depiction of beauty anomalous, fantasial.

"As the tremendous stalk wilts, toppling into an ever deeper and more sinister arc, its walls blaze with a continual sunset. Phosphorescent seas appear to run down its broken sides. The flames and banners of decay creep out of its roots and spread in slow and ghostly conflagrations toward its summit. Daily the spectacle of its dissolution increases. Alkaline pinks and excremental yellows, purples and lavenders like tumerous shadows; browns that float like colossal postules through seas of lemon; reds that ferment into wavering islands of cerise and salmon, that erupt into ulcerous hills of scarlets and magentas—these revolve about the walls, mounting into vast patterns and dissolving one into the other. Slowly death postures in its coquettish shrouds."

Recurring in persistent refrain throughout "The Kingdom of Evil" is seen Ben Mecht's phallic symbolism—sometimes exhausting the sexual vocabulary in lecherous blatancy, sometimes shrouded in veils of obscure yonic characterization.

The black-and-white illustrations by Anthony Angarola, which accompany the text, are massive and gauntly superb, though they are obviously forced in order to harmonize with the grotesque theme of the fantasy.

With almost animate pigments has Hecht painted this monstrous dream of Mallare's, and with delicate and meticulous craftsmanship has he fashioned its cadaverous and perverse beauty.

George Hill Hodel.

the reporter who was among the first to arrive at the crime scene after the murder, as well as with Will's father, the reporter and screenwriter Gene Fowler. In the mid-1920s, Hecht and Gene Fowler had the same publisher, Pascal Covici, who also published early English translations of works by the Marquis de Sade.[7] It is noteworthy that a man whose writings may have influenced the killing of Elizabeth Short also had ties to one of the reporters at the Black Dahlia murder scene.

On February 1, 1947, Hecht published an article in the *Los Angeles Herald Express* providing a detailed profile of who he thought the Black Dahlia killer was: a thin lesbian with a thyroid imbalance. At the end of the improbable characterization, however, Hecht revealed that his description was a ruse. He then claimed he *did* know who the real killer was — but he would not reveal that person's identity.[8]

SPELLBOUND

Hecht's screenplay for *Spellbound* (fig. 83) may also have influenced George Hodel. In a story that echoes *Fantazius Mallare*, *Spellbound* concerns a man who believes he has murdered someone. He then undergoes psychoanalysis and hypnosis to retrieve repressed memories that prove his innocence. Hecht's script was based on a 1927 book by Frances Beeding, *The House of Dr. Edwardes*, a gothic novel set in a lunatic asylum in France. But Hecht departed from the novel by moving the action to a psychiatric facility in Vermont and playing up the role of Freudian psychoanalysis in the plot.

In *Spellbound* — whose tagline was "The Maddest Love That Ever Possessed a Woman" — Gregory Peck plays Anthony Edwardes, a doctor who comes to work at a psychiatric facility where Constance Petersen, a psychiatrist played by Ingrid Bergman, is on staff.[9] Petersen falls in love with Edwardes, while also realizing that he is an imposter who, because of amnesia, does not know who he really is. The only thing he is convinced

OPPOSITE PAGE: FIGURES 79–82
Magazine cover and interior pages
Fantasia
G. Bishop Pulsifer and George Hill Hodel, editors
1925
•

The dedication to this short-lived periodical reads: "Ever shall we consecrate our magazine to the depiction of beauty anomalous, fantasial." Inside is George Hodel's review of *The Kingdom of Evil: A Continuation of the Journal of Fantazius Mallare*, Ben Hecht's sequel to his hallucinatory, violent first novel, *Fantazius Mallare: A Mysterious Oath*. Hodel praised Hecht for his "delicate and meticulous craftsmanship" in fashioning the book's "cadaverous and perverse beauty."

FIGURE 83

Gregory Peck (as Dr. Anthony Edwardes) and Ingrid Bergman (as Dr. Constance Petersen) in a publicity shot for Alfred Hitchcock's film *Spellbound*
1945

© SELZNICK INTERNATIONAL PICTURES
PHOTOGRAPH: SELZNICK INTERNATIONAL PICTURES / PHOTOFEST

FIGURE 84

Publicity shot featuring Salvador Dalí's dream sequence in Alfred Hitchcock's film *Spellbound*
1945

© SELZNICK INTERNATIONAL PICTURES
PHOTOGRAPH: SELZNICK INTERNATIONAL PICTURES / PHOTOFEST

Dalí's famous dream sequence in *Spellbound,* featuring de Chirico-like landscapes populated by surreal figures, provides the clues that enable Dr. Constance Petersen, a psychiatrist played by Ingrid Bergman, to solve the mystery. A portion of this sequence, in which a man cuts an eye with a pair of scissors, is an homage to Dalí's earlier film collaboration with Luis Buñuel, *Un chien andalou* (see fig. 85). According to Steve Hodel, *Spellbound* was one of George Hodel's favorite movies.

of is that he has killed the real Dr. Edwardes, a delusion reinforced by a dream. "I kept thinking while I was dreaming that all this meant something. There was some other meaning in it that I ought to find out," Peck's character says. As he and Dr. Petersen fall in love, she tries to uncover the truth as he hypnotically recounts the dream and repressed childhood memories.

Spellbound was high on the list of George Hodel's favorite films, according to Steve Hodel. He particularly admired the dream sequence in the film, based on imagery by Salvador Dalí. An homage to the subconscious mind, Dalí's segment includes faceless, de Chirico–like figures,

a surreal gambling salon, and a scene in which Peck's character sees a person fall off a rooftop. Another sequence shows a curtain decorated with a giant eye being cut by a pair of scissors (fig. 84), Dalí's reference to an earlier work of his own: the notorious depiction of a woman's eye being slit open[10] in the surrealist movie *Un chien andalou,* 1929 (fig. 85), which the artist cowrote with the director Luis Buñuel.

THE DREAM DEFENSE

It is Edwardes's confusion of dream with reality that bears the most relevance here. George Hodel was interested in dream states from a young age. His pensive photographic self-portrait as a teenager, inscribed "Portrait of a Chap Suddenly Aware of the Words of Sigmund Freud" (fig. 8), reveals a newfound fascination with the study of the unconscious mind.

Hodel was known to have hypnotized women at his house, according to a December 20, 1949, *Los Angeles Times* article in which a woman named Corrine Tarin "declared that she had been hypnotized" by "Dr. Hodel in his Franklin Ave. Home." Hodel's interest in hypnosis had catastrophic consequences at a 1949 gathering where Tarin was present.[11] It was during that event that he was alleged to have hypnotized a guest, Barbara Sherman, before having sexual intercourse with his fourteen-year-old daughter, Tamar Hodel.[12]

Police who searched Hodel's home reported that they found "a large collection of photographs of nude girls in the doctor's home, together with several objects of obscene art," according to a *Los Angeles Daily News* article from October 6, 1949 (fig. 86).

Interviewed for the same article, Hodel said, "Everything is a dream to me. I believe someone is trying to hypnotize me. I want to consult by [*sic*] psychiatrist but I don't trust him. He might find something wrong with me." Amazingly, Hodel continued, "If this is real and I am really here, then these other things must have happened."

OPPOSITE PAGE, BOTTOM RIGHT: FIGURE 85

Still from Luis Buñuel and Salvador Dalí's film *Un chien andalou* (An Andalusian Dog) 1929

PHOTOGRAPH: PHOTOFEST, NY

.

Among the most iconic surrealist images is this frame from *Un chien andalou,* in which a woman's eye is sliced open by a razor (a cow's eye was substituted to create the effect). Buñuel and Dalí's second film collaboration, *L'âge d'or* (The Golden Age), mocked the Catholic church by equating Jesus Christ with the Count of Blangis, the murderous rogue in Sade's *120 Days of Sodom*. Henry Miller—a mutual acquaintance of both George Hodel's and Man Ray's in the 1940s—was among Buñuel's most ardent public supporters, and his most famous works, such as *Tropic of Capricorn* (1934), were influenced by his admiration of these films' nonlinear structure and perceived blasphemy.

Girl accuses Hollywood doctor father

Accusations of a 14-year-old girl that she had been subjected to incestuous and perverted acts by her father today brought formal charges against Dr. George H. Hodel, 38, Hollywood physician.

Formal complaints charging one count of incest and one of sexual perversion were issued by the district attorney's office, disclosing Dr. Hodel's arrest yesterday at his home, 5121 Franklin avenue.

Chief Dep. Dist. Atty. S. Ernest Roll announced the physician's daughter, Tamar, a sophomore at Hollywood High school, had told him she had shared sexual relations with her father since she was 11.

She also told the chief prosecutor she was given intoxicants and participated with Dr. Hodel, another man and two women in a series of perverted acts in the Franklin-avenue home last July 15.

The girl further charged her father had encouraged her to have relations with other men, and gave investigators the names of 19 youths with whom she had shared such interludes. All were being sought for questioning.

From Dep. Dist. Atty. William Ritzi it was learned the case may implicate "at least one other Hollywood doctor" and a number of motion picture personalities.

"My father reeks of sex," the young girl told Roll and Ritzi. "He is a nut on sex." She said he had attempted to hypnotize her but had been unsuccessful.

Dr. Hodel's arrest followed by five days a missing person report he filed on his daughter last Friday. She was picked up Sunday night and questioning by Georgia Street juvenile officers brought to light her sordid story.

Dr. Hodel has been three times married and divorced, the girl told authorities.

District attorney's aides said the physician, a reputed authority in the treatment of venereal diseases, told them both he and his daughter "at an early age manifested a desire for the study of love."

"Everything is a dream to me," they quoted him. "I believe someone is trying to hypnotize me. I want to consult by psychiatrist but I don't trust him. He might find something wrong with me.

"If this is real and I am really here, then these other things must have happened."

Hodel was lodged last night in Hollywood jail and was to be arraigned today on the charges of incest and perversion.

Police who made the arrest reported they found a large collection of photographs of nude girls in the doctor's home, together with several objects of obscene art.

His postulation that an incident recalled in a dream "must have happened" recalls the blurring of illusion with reality evident in both *Spellbound* and *Fantazius Mallare*. "My hands fought with a phantom . . . how did I know that my hands fight?" asks Mallare of his imagined murder. "Because I remember them striking. Yet that may have been an illusion. . . . I don't know anything." In *Spellbound*, too, Gregory Peck's character wrestles with the conviction that a dream proves him guilty of murder.

SURREALIST DREAMS

In addition to representing dream imagery, the surrealists were fascinated with portraying the dream state. A 1929 cover for *La révolution surréaliste* 12 featured René Magritte's photomontage *Je ne vois pas la [femme] cachée dans la forêt* (fig. 87). The image was made of small photographs of sixteen male surrealists, all with closed eyes, surrounding a rendering of a nude woman, also with closed eyes. The image accompanied an "Inquiry on love" published in the same issue, thematically linking dreams with eros.[13] Prominent surrealists also undertook pseudoscientific examinations of dreams. Breton and Francis Picabia staged dream séances in their studios in 1922 and 1923, transcribed what people said, and published the results. Man Ray photographed a staged portrayal of one such session, "*Waking Dream Séance*," 1924 (fig. 76), which appeared on the cover of the first issue of *La révolution surréaliste*, in December 1924; accounts of dreams were published inside.[14]

Two dreaming figures in the surrealist mode turn up in a personal photograph album that belonged to George Hodel. The photographs, presumably taken by Hodel, portray women with their eyes closed. In one soft-focus image, the woman appears with bare shoulders and a relaxed arm resting behind her head (fig. 88). The other picture shows a woman with closed eyes and two large flowers in her hair, posing next to a sculpture of a horse (fig. 93).

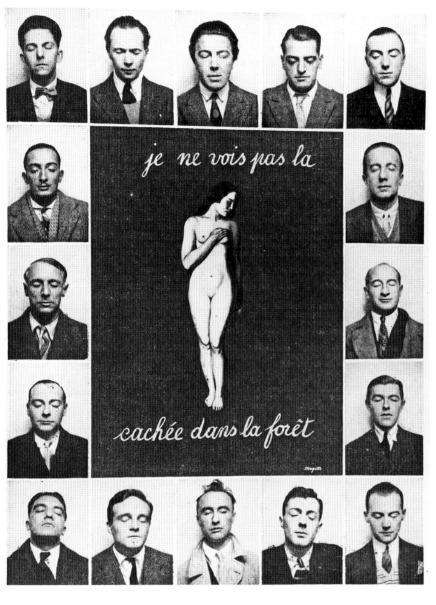

OPPOSITE PAGE: FIGURE 86

"Girl Accuses Hollywood Doctor Father"
Los Angeles Daily News, October 6, 1949
.

One of several articles on Geoge Hodel's incest case that appeared in the Los Angeles newspapers—the *Los Angeles Times,* the *Los Angeles Evening Herald and Express,* and the *Los Angeles Mirror*—from the time of his arrest on immorality charges in October of 1949 through his trial and acquittal in December of that year. This one features George Hodel's statement "Everything is a dream to me. . . . If this is real and I am really here, then these other things must have happened."

FIGURE 87

René Magritte
Je ne vois pas la [femme] cachée dans la forêt
(I Do Not See the [Woman] Hidden in the Forest)
Collage with photographs by Man Ray—an illustration from *La révolution surréaliste,* **issue 12**
1929
BIBLIOTHÈQUE LITTERAIRE JACQUES DOUCET, PARIS
© 2006 C. HERSCOVICI, BRUSSELS / ARTISTS RIGHTS SOCIETY (ARS), NEW YORK
© 2006 MAN RAY TRUST / ADAGP (ARS) / TELIMAGE
PHOTOGRAPH: © ARCHIVES CHARMET / BRIDGEMAN ART LIBRARY

As Steve Hodel writes in *Black Dahlia Avenger,* it was his discovery of these pictures in 1999 that initially raised his suspicions that his father might have had something to do with the Black Dahlia murder. Though the identity of the women in the pictures has been disputed, it is significant that the images appear to borrow surrealist motifs. May Ray himself took many pictures of women with closed eyes from the 1920s onward. The woman with flowers and the sculpture recalls Man Ray's 1944

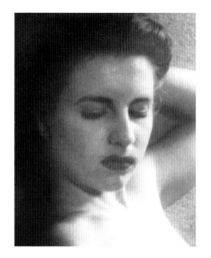

FIGURE 88

Unattributed, presumed by George Hodel
Date unknown

COLLECTION OF STEVE HODEL

•

Steve Hodel believes that the woman in
this image from George Hodel's personal
photo album is Elizabeth Short. Regardless
of her identity, the picture suggests Hodel's
familiarity with surrealist archetypes,
particularly the "dream state" images
produced by Man Ray.

CLOCKWISE FROM TOP LEFT:

FIGURE 89

Man Ray
Juliet Browner
[later Juliet Man Ray]
ca. 1945

FIGURE 90

Man Ray
Charlotte Heytum (solarized)
1943

FIGURE 91

Man Ray
"Portrait ancien et moderne"
(Ancient and Modern Portrait)
[Juliet Man Ray]
1950

FIGURE 92

Man Ray
Mrs. Tony Duquette
[Elizabeth Duquette]
1948

FIGURES 89–92 © 2006 MAN RAY TRUST /
ADAGP (ARS) / TELIMAGE

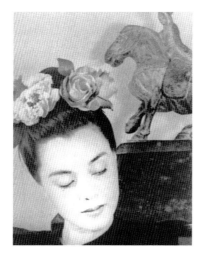

FIGURE 93
Unattributed, presumed by George Hodel
Date unknown
COLLECTION OF STEVE HODEL
.

This portrait of an unidentified woman in George Hodel's personal photo album seems to be informed by Man Ray's signature compositions in which women appear submissive to sculptural objects.

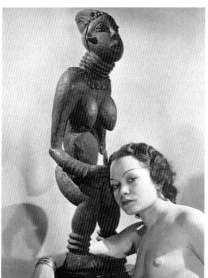

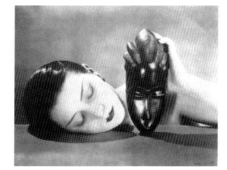

CLOCKWISE FROM UPPER LEFT:

FIGURE 94
Man Ray
Woman with *Objet désagréable*
(Unpleasant Object) by Alberto Giacometti
1931

FIGURE 95
Man Ray
Woman with plaster cast of Man Ray's head
Date unknown

FIGURE 96
Man Ray
"*Noire et blanche*"
(Black and White)
[Kiki de Montparnasse]
1926

FIGURE 97
Man Ray
"Helena's Statue 'The Bangwa Queen'"
1937

FIGURES 94–97 © 2006 MAN RAY TRUST / ADAGP (ARS) / TELIMAGE

photograph of Dorothy Hodel, which shows her, too, with downcast eyes and a pair of flowers in her smoothly coiffed hair (fig. 53). Indeed, it seems to be a more amateurish take on the same composition.

The portrayal of the woman with the sculpture also links this photograph from Hodel's album to several similar compositions by Man Ray (figs. 89–92 and 94–97).

Just as some of Hodel's other photographs emulate artistic styles, these images appear to be trying for a surrealist effect. Here the dreaming woman plays on the surrealist trope that is linked to desire and, sometimes, to death.

DREAMS THAT MONEY CAN BUY

On December 2, 1946, *Life* magazine published a feature about *Dreams That Money Can Buy* (figs. 98, 99), a film then in production and directed by the German expatriate filmmaker Hans Richter. The movie, an arthouse film reflecting, as *Spellbound* did, a vogue for dream interpretation and psychoanalysis, was alternately humorous and disturbing, engaging and tedious. Centered on a dream salesman styled after a psychiatrist, it includes short segments created by Man Ray, Max Ernst, Fernand Léger, Marcel Duchamp, Alexander Calder, and Richter himself. John Cage and Paul Bowles provided some of the scores, and the folk and blues singer Josh White and the Broadway star Libby Holman sang the song accompanying Léger's segment.

Though created by artists, *Dreams That Money Can Buy*, released in 1947, was intended to attract a crossover audience. "Movie-goers leery of surrealism need not shy away from *Dreams*," the *Life* article stated. "'The movie is good,'" Richter is quoted as saying. "'You don't have to understand it to enjoy it.'"

A recurring presence in the film is a photograph of Man Ray's eyes. The image, which appears to be a greatly enlarged and cropped version

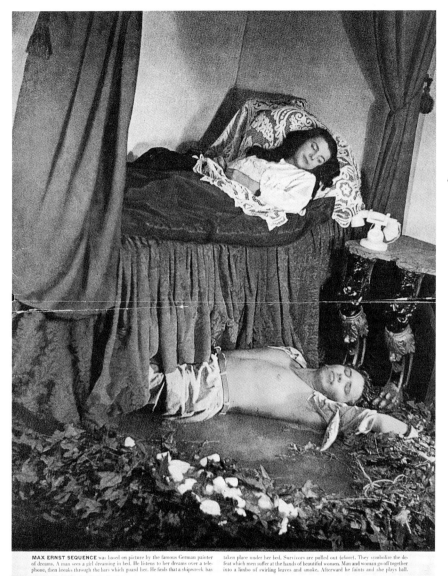

MAX ERNST SEQUENCE was based on picture by the famous German painter of dreams. A man sees a girl dreaming in bed. He listens to her dreams over a telephone, then breaks through the bars which guard her. He finds that a shipwreck has taken place under her bed. Survivors are pulled out (*above*). They symbolize the defeat which men suffer at the hands of beautiful women. Man and woman go off together into a limbo of swirling leaves and smoke. Afterward he faints and she plays ball.

CONTINUED ON NEXT PAGE

FIGURE 98

Magazine page featuring a publicity shot for Hans Richter's film *Dreams That Money Can Buy*, photographed by Sun Studio, to accompany the article "Surrealist Movie: Six Ultramodern Artists Supply Dreams for New Film"
Life
December 2, 1946 (pp. 86–88)

PHOTOGRAPH: RESEARCH LIBRARY, THE GETTY RESEARCH INSTITUTE, LOS ANGELES (930027)
CAPTION © 1946 LIFE, INC. REPRINTED WITH PERMISSION. ALL RIGHTS RESERVED.

·

During 1945 and 1946 Man Ray corresponded with director Hans Richter about *Dreams That Money Can Buy*, a film featuring short scenarios by Max Ernst, Marcel Duchamp, Alexander Calder, Fernand Léger, Richter, and Man Ray. Released in 1947, *Dreams* won the special prize at the Venice Film Festival that year. The film opened in Los Angeles in July 1948 (see fig. 107). This image from *Dreams* appeared in a December 1946 spread about the film in *Life* magazine, six weeks before the murder of Elizabeth Short. *Life*'s accompanying caption reads in part: "Max Ernst sequence was based on a picture by the famous German painter of dreams.* A man sees a girl dreaming in bed. He listens to her dreams over a telephone, then breaks through the bars that guard her. He finds that a shipwreck has taken place under her bed. Survivors are pulled out (above). They symbolize the defeat which men suffer at the hands of beautiful women . . ."

*THE PICTURE REFERRED TO IS IN ERNST'S 1934 COLLAGE NOVEL, *UNE SEMAINE DE BONTÉ* (A WEEK OF KINDNESS).

of Man Ray's 1946 "Self-Portrait," hangs behind the desk of the dream salesman. Man Ray gave George Hodel a version of this same "Self-Portrait" in 1946.

Considering this gift, it seems likely that George Hodel would have sought out the *Life* feature. In addition, Hodel admired Josh White's music and had probably met White himself, because Hodel dated the Haitian dancer Josephine Premice, who performed with White onstage.

Tamar Hodel, too, admired White's music, and her associations with it are noteworthy: Her father had played her his recordings of White's music, and she claims she found the strength to endure the stress of the trial by replaying Josh White's songs in her head. During this time, Tamar developed an imagined kinship with White, whom she had not met. Remarkably, the two did meet and later became romantically involved.[15]

Man Ray's participation in the film would also have been interesting to Hodel—particularly since Man Ray gave Hodel a version of the "Self-Portrait" so prominently featured in the movie.

Man Ray's segment of *Dreams That Money Can Buy*, which makes fun of audiences' sheeplike ardor for Hollywood films, was an adaptation based on his written sketch "Ruth, Roses, and Revolvers," which appeared in *View* magazine in 1944. Man Ray's correspondence with Richter while the film was in production reveals the tension that arose as Richter tried to reshape Man Ray's writings for the screen.[16] "I agree completely that the best way to make a script is to drop it in a slot machine and get a finished product at the bottom," Richter wrote to Man Ray in a letter of December 3, 1945. "Just try to help me understand you, and try to understand me, friendly, with more patience and less revolver."

Léger's narrative, "The Girl with the Prefabricated Heart," concerns a love story between two machine-made mannequins in which the woman and bride-to-be, a modern-day, mass-produced Venus, ultimately rejects her partner. Describing this artificial goddess, the accompanying lyrics explain, "Her chromium nerves and her platinum brain / Were chastely encased in cellophane / And to top off this daughter of science and art / She was equipped with a prefabricated heart."

The Richter sequence focuses on a contemporary Narcissus, played by a man in a brown suit with a blue face, though it also alludes to the minotaur myth. Early in Richter's narrative, Narcissus follows a piece of string and finds a woman at the end of it—a reference to the golden

SEX lies waiting at the end of the long blue ribbon of intuition which he has followed. Girl offers Narcissus some cherries to eat and he debates briefly between kissing the girl and cutting her throat, an implication that all love is very close to hatred.

FIGURE 99

Detail of a magazine page featuring publicity shots for Hans Richter's film *Dreams That Money Can Buy,* **photographed by Sun Studio, to accompany the article "Surrealist Movie: Six Ultramodern Artists Supply Dreams for New Film"**
Life
December 2, 1946 (p. 86–88)

PHOTOGRAPH: RESEARCH LIBRARY, THE GETTY RESEARCH INSTITUTE, LOS ANGELES (930027)
CAPTION © 1946 LIFE, INC. REPRINTED WITH PERMISSION. ALL RIGHTS RESERVED.

Hans Richter's own scenario, one of seven in his film *Dreams That Money Can Buy,* was a surrealist mixing of mythological references including Narcissus (a favorite of Dalí) and the labyrinth. During 1953 and 1954, Richter elaborated on aspects of his *Dreams* scenario, planning to use them in another film, *Minotaur,* for which he had written a script in 1948 but never made. Richter said that he had read "one hundred and twenty different versions of the Theseus story" for this project, which alluded to the Third Reich.

thread that Theseus uses to find his way out of the minotaur's labyrinth. Later on, a woman lounging in a hammock seductively offers Narcissus cherries. As the *Life* caption (fig. 99), published just six weeks before the murder, describes, "He debates briefly between kissing the girl and cutting her throat, an implication that all love is very close to hatred."

The Exquisite Corpse: A Literal Reenactment?

"There is every reason to believe that [surrealism] acts on the mind very much as drugs do; like drugs, it creates a certain state of need and can push man to frightful revolts."

—André Breton, "Manifesto of Surrealism"[1]

"On one of those idle, weary nights which were quite numerous in the early days of surrealism—contrary to what is so often fancied in retrospect—the Exquisite Corpse was invented," recalled Simone Kahn, André Breton's first wife, of the game's origins. Based on an old parlor game, Exquisite Corpse began as an exercise with language. On a piece of paper, the poet Jacques Prévert put down three words—*le cadavre exquis* (the exquisite corpse). Without seeing what he had written, others completed the sentence. The result was a wisp of accidental poetry: "The exquisite corpse will drink the new wine."

So emerged the first Exquisite Corpse—a witty description of a beautiful cadaver imbibing alcohol. Breton shouted with joy at how these randomly abutting words produced such an image and others just as odd. As Kahn describes, "The suggestive power of those arbitrary meetings of words was so astounding, so dazzling, and verified surrealism's theses and outlook so strikingly, that the game became a system, a method of research, a means of exaltation as well as stimulation, and even, perhaps, a kind of drug."[2]

The game produced delirium in its next incarnation as well.[3] One night, someone suggested playing with drawings instead of words. The first person created a drawing on the top third of a piece of paper, where the head and upper part of a human body would be, and then folded the paper to conceal the image. Another drew imagery in the torso region and folded the paper again. The third completed the picture. Such hybrid images, Kahn wrote, were "creatures none of us had foreseen, but which we ourselves had nonetheless created."[4]

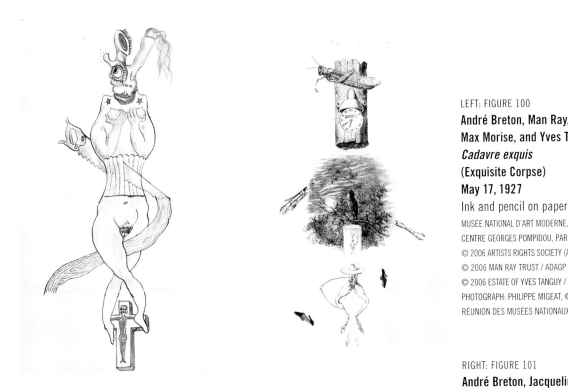

LEFT: FIGURE 100
André Breton, Man Ray,
Max Morise, and Yves Tanguy
Cadavre exquis
(Exquisite Corpse)
May 17, 1927
Ink and pencil on paper
MUSÉE NATIONAL D'ART MODERNE,
CENTRE GEORGES POMPIDOU, PARIS
© 2006 ARTISTS RIGHTS SOCIETY (ARS), NEW YORK / ADAGP, PARIS
© 2006 MAN RAY TRUST / ADAGP (ARS) / TELIMAGE
© 2006 ESTATE OF YVES TANGUY / ARTISTS RIGHTS SOCIETY (ARS)
PHOTOGRAPH: PHILIPPE MIGEAT, © CNAC / MNAM / DIST.
RÉUNION DES MUSÉES NATIONAUX / ART RESOURCE, NY

RIGHT: FIGURE 101
André Breton, Jacqueline Lamba,
and Yves Tanguy
Cadavre exquis
(Exquisite Corpse)
1938
Collage: engraved illustrations
and photographs on graph paper
MUSÉE NATIONAL D'ART MODERNE,
© 2006 ARTISTS RIGHTS SOCIETY (ARS), NEW YORK / ADAGP, PARIS
© 2006 ESTATE OF YVES TANGUY / ARTISTS RIGHTS SOCIETY (ARS)
CENTRE GEORGES POMPIDOU, PARIS
PHOTOGRAPH © CNAC / MNAM / DIST. RÉUNION DES
MUSÉES NATIONAUX / ART RESOURCE, NY

Exquisite Corpse was one of many activities that served, for Breton, as an initiation rite for and character assessment of people in the group. It was related in spirit to automatic writing and drawing—processes of creating without premeditation. The shared idea was that words and images flowed directly from the unconscious, without influence or forethought. Other surrealist games included the Truth game, in which players were required to provide truthful answers to provocative questions asked by other players, and Decalcomania, an exercise in creating and interpreting Rorschach-like blots.[5] Exquisite Corpse remains the best known, perhaps because many of the artworks were collected, exhibited, and published.

There were no rules governing the type of imagery that went into these artworks, but the pictures often included motifs associated with death and violence. As the art historian Sidra Stich has observed, "The recurring inclusion of images pointedly allied with death as integral body parts (e.g., skulls, a gun, a bottle of poison) locate destruction within the very core of the figure."[6]

Many surviving Exquisite Corpse artworks, rendered in a variety of materials, illustrate this phenomenon. A 1927 drawing by André Breton, Man Ray, Max Morise, and Yves Tanguy (fig. 100) shows a female form with a one-eyed head sprouting sporelike forms — and a saw cutting through her midsection. A 1938 picture by Breton, his wife at the time, Jacqueline Breton (the former Jacqueline Lamba), and Yves Tanguy portrays a gun where a head would be located on a human body. In a 1938 work by Breton, Nusch Éluard, Paul Éluard, and Valentine Hugo, two skulls appear in place of the feet. More whimsically, a work by Breton, Jacqueline Lamba, and Tanguy from 1938 (fig. 101) portrays an owl in a moonlit landscape for the midsection, frog's legs at the bottom, and a cricket and clock for the head.

•

Literally and figuratively, Exquisite Corpse resonated with all those who called themselves surrealists. While the game itself was popular, it also served as a metaphor for the surrealist fascination with jumbled anatomy and random additions.[7] Salvador Dalí was particularly skilled at the game, given his expert draftsmanship and strong imagination, as Michael R. Taylor has noted. In one collaboration, Dalí depicted a firing squad execution in the middle of the artwork. Dalí also used Exquisite Corpse drawings in his magazine and poster work during the 1930s, bringing the idea into more public view.[8] He fabricated a three-dimensional Exquisite Corpse, which he displayed at his Dream of Venus pavilion at the New York World's Fair in 1939.[9]

A 1934 Exquisite Corpse drawing by Breton, Nusch Éluard, Paul Éluard, and Valentine Hugo (fig. 102) bears startling parallels to Elizabeth Short's body as it was discovered on January 15, 1947 (figs. 103–106).

Itself an amalgam of surrealist motifs, the drawing, when compared with the condition of Short's body, reveals how the killer may have employed, to dreadful effect, a similar array of surrealist imagery.

In the delicate crayon-on-paper rendering of a woman's body, the figure has upraised arms and, in place of breasts, circular shapes that enclose asymmetrical triangles. The upper body is bent softly at the neck, and a fantastical instrument-like image takes the place of the face. A yellow vertical impression appears near the genital area. The circular shapes in place of the breasts on the figure in the drawing are echoed in the circular area where Short's right breast was removed, as revealed in the crime-scene photographs. These photographs also show a triangular shape[10] incised next to Short's left breast, echoing the artwork's triangular motifs. The vertical incision above Short's genital area corresponds with the yellow mark in this Exquisite Corpse picture. Her head is turned to the side, and her upraised arms resemble the position of the arms in the drawing.

Some writers maintain that, because of the differing ways in which the body was manipulated, the Black Dahlia murder was the work of more than one killer.[11] This raises the gruesome specter that whoever killed Elizabeth Short was playing a surrealist game — Exquisite Corpse — with a real human being.

Someone familiar with surrealism, inspired by the strains of the uncanny and of violent eroticism that run throughout surrealist art, may have tried to create a horrific masterpiece from the body of a young woman. In keeping with the general idea of Exquisite Corpse, multiple assailants may have taken turns with the body, inscribing their signatures on the victim's legs, torso, breasts, and face.

It is conceivable that someone (or more than one person), seeking the heady state of surrealist exaltation — the almost druglike state of delirium experienced by those participating in the Exquisite Corpse games — could have found this state in killing Elizabeth Short.

Thus inspired, they would have created what they viewed as the most exquisite corpse of all.

FIGURE 102

**André Breton, Nusch Éluard,
Paul Éluard, and Valentine Hugo**
Cadavre exquis
(Exquisite Corpse)
1934
Crayon on paper

COLLECTION MUSÉE D'ART ET D'HISTOIRE,
SAINT-DENIS, FRANCE
© 2006 ARTISTS RIGHTS SOCIETY (ARS), NEW YORK / ADAGP, PARIS
PHOTOGRAPH © ARCHIVES CHARMET /
BRIDGEMAN ART LIBRARY

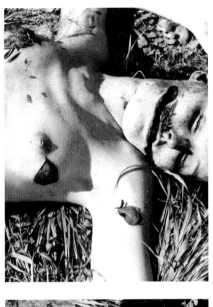
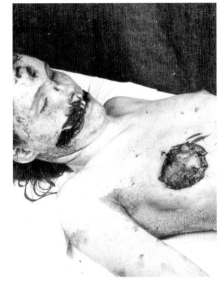
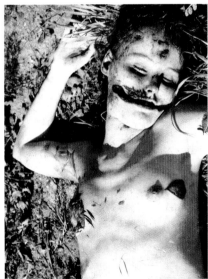
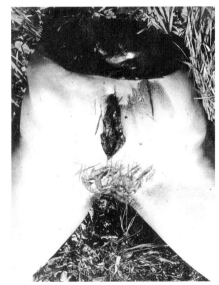

Crime-scene and dissecting table
photographs — Elizabeth Short murder
January 15, 1947

PART II: **ART IMITATES DEATH**

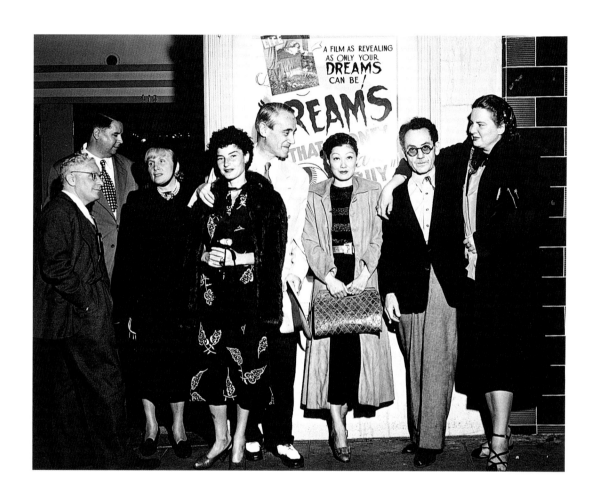

After the Murder

The previous chapters have shown that Elizabeth Short's killer may have been someone with an intimate knowledge of surrealist art—someone on the inside of the Los Angeles art world or connected peripherally. The murder may itself have been a surrealist act—perhaps even a session of the Exquisite Corpse game, entwining eroticism and death in the killer's misinterpretation and distortion of artistic ideals. In other words, death imitated art.

In the years after the killing, art appears to have imitated death. More specifically, people intimate with the Los Angeles art scene during the 1940s may have referred to the murder in their later art—and even, possibly, to the killer himself.

If the murder of Elizabeth Short bears a surrealist imprint, then it follows that someone versed in the arts committed it. Someone seeking to impress or upstage more prominent artists could have imagined that artistic motifs displayed in the killing would be understood as such.

Additionally, if the killer was someone known to the Los Angeles art world, that might also explain why artists remained focused on the murder years later. The murder would have been all the more compelling for those who suspected the identity of the killer.

If someone in this milieu did have an idea of who the killer was, it was kept private. In 1947, the same year as the murder, the House Un-American Activities Committee (HUAC) was investigating in Hollywood. HUAC, chaired by J. Parnell Thomas, subpoenaed forty-one witnesses to testify about their ties to Communism or to identify others suspected of Communist activity.

Left-leaning artists had good reason to be concerned in this political climate. Indeed, many artists, including surrealists, had an open association with Communism. André Breton, Louis Aragon, and Paul Éluard had all been members of the French Communist Party. Picasso had joined the French Communist Party in 1944. Diego Rivera's Communist

FIGURE 107

Photographer unknown
Premiere of *Dreams That Money Can Buy,*
Esquire Theater, Los Angeles
July 16, 1948
PHOTOGRAPH: RESEARCH LIBRARY, THE GETTY RESEARCH INSTITUTE, LOS ANGELES (930027)

•

Left to right: Albert Lewin, unidentified man, Mildred Lewin, Juliet Man Ray, the film's director, Hans Richter, unidentified woman, Man Ray, unidentified woman

sympathies were well known. American artists associated with any of these others may have wanted to keep a low profile.

By 1951, contemporary art itself was essentially declared blacklisted in Los Angeles. The Los Angeles City Council "legally decreed modern art as Communist propaganda and banned its public display in the area," according to the art historian Naomi Sawelson-Gorse.[1]

For these and other reasons, artists who had suspicions about the killing would not have disclosed them in public form, we believe. For an avant-garde artist in particular to openly comment on a surrealist-style murder in Los Angeles would have been close to an act of folly. The risk of incrimination by association would have been too great.

Exchanges concerning the crime may have appeared in veiled form, through artistic motifs comprehensible only to others in the know. It wasn't until the 1960s—long after the Black Dahlia murder had disappeared from the headlines, the political atmosphere had shifted, and surrealists were no longer the darlings of the art world—that more pointed references to the murder appear to have been made.

The L.A. Art Scene

"Los Angeles was just stirring with its first interest in art. The movement was like the murmur of a giant in sleep. Museum directors, gallery owners and the elite of the art world often met at the Arensbergs'."

— Beatrice Wood[1]

As a city and cultural milieu, Los Angeles at the time of the murder had already forged a unique identity, largely determined by the city's climate, its geography, and the fact that it was a boomtown built on the film industry. Angelinos, culturally and geographically distant from centers such as Paris and New York, were for the most part slow to accept modernist art. The Los Angeles County Museum, now one of the premier art institutions in the country, was known as the Los Angeles County Museum of History, Science, and Art. Most Californian art buyers preferred nineteenth-century landscapes and the contemporary Eucalyptus school of painting, focusing on picturesque Southern California scenes.[2]

Those who supported avant-garde art formed a small group of disparate characters, from film industry insiders to European artistic and intellectual expatriates connected by their shared passion for art. The actor Vincent Price, who spearheaded the short-lived Modern Institute of Art in the 1940s and later sat on the boards of the UCLA Arts Council and the Los Angeles County Museum, once said, "You can sell 'em sin and you can sell 'em sex but when you try to peddle 'culture' you run smack into a solid wall of stupid ignorance."[3]

Pre-Columbian art and artifacts, however, were very much in vogue among Los Angeles collectors. Mexico's proximity made these ancient objects easy to obtain, and the lax border controls made smuggling into the United States a common occurrence. Among the Hollywood set, Price (fig. 108), John Huston, and the actress Paulette Goddard were drawn to pre-Columbian objects. (Huston was rumored to have smuggled pre-Columbian pieces back from Mexico while shooting the 1948 film

FIGURE 108
Photographer unknown
Vincent and Mary Price
August 18, 1950
PHOTOGRAPH © ASSOCIATED PRESS

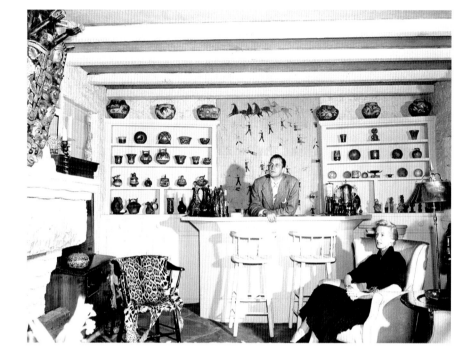

FIGURE 109
Photographer unknown
Billy and Queta Pearson
March 5, 1952
PHOTOGRAPH © ASSOCIATED PRESS

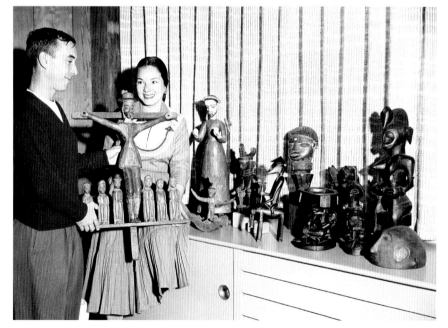

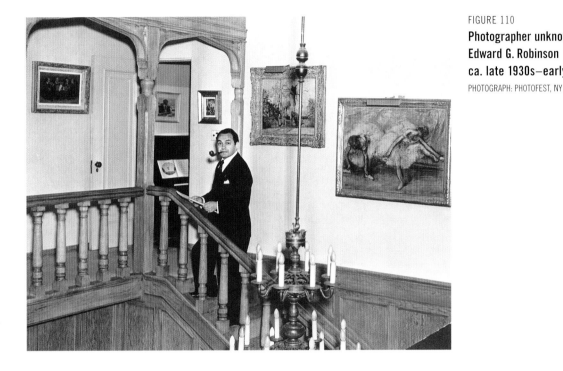

FIGURE 110
Photographer unknown
Edward G. Robinson
ca. late 1930s–early 1940s
PHOTOGRAPH: PHOTOFEST, NY

The Treasure of the Sierra Madre.)[4] The jockey and bon vivant Billy Pearson (fig. 109), a friend of Huston's, spent much of his income on pre-Columbian artifacts. Pearson purchased most of George Hodel's art collection in 1950. South of the border, Pearson traded works with the artists Diego Rivera and Miguel Covarrubias, both of whom collected pre-Columbian pieces themselves.[5] Back in Los Angeles, the gallery owner Earl Stendahl was a principal dealer in pre-Columbian art. Referring to rumors of Stendahl's illicit dealings in this arena, Vincent Price said in an interview, "I always say that the next war is going to be between Stendahl and the country of Mexico."[6]

The arrival of many European expatriates before and during the war years brought a new cosmopolitan flavor to Los Angeles. Creative personalities from the Russian-French composer Igor Stravinsky to the German art dealer Galka Scheyer brought with them an enthusiasm for the avant-garde, including modern art. Much of European modernism

referenced "primitive" objects, and those Angelinos who were drawn to pre-Columbian works felt intellectual affinities with newcomers also interested in non-Western and ritualistic pieces.

Edward G. Robinson (fig. 110) and Fanny Brice were part of a group of Hollywood insiders whose passion for contemporary art dovetailed with their commitment to the city's cultural well-being. In 1939, Hollywood elite including Bette Davis, Dashiell Hammett, and Fritz Lang, along with Robinson, Walter and Louise Arensberg, Galka Scheyer, and dozens of others, sponsored Earl Stendahl's efforts to bring Picasso's *Guernica*—then traveling to a few U.S. cities—to Los Angeles.[7] Picasso's grim portrayal of the consequences of Fascism during the Spanish civil war had garnered international notice, but when the monumental canvas was exhibited in Los Angeles, the turnout was poor.[8] However, the city's overall indifference to avant-garde art during the 1940s made the associations among those who were supporters even closer.

THE ARENSBERG CIRCLE

One place where avant-garde works *did* receive a strong showing was in the Hillside Avenue home of Walter and Louise Arensberg (fig. 111), the collectors and surrealist patrons who had moved to Los Angeles from New York in 1921 and settled there permanently in 1927. In the years since their relocation to the West Coast, they had assembled one of the nation's preeminent collections of pre-Columbian and modern masterpieces. Man Ray, Max Ernst, and Marcel Duchamp all benefited from their zeal for collecting.

The Arensbergs, Marcel Duchamp's patrons for more than thirty years, had hung their collection unconventionally. Modern and pre-Columbian artworks were mixed together and displayed salon-style, cheek by jowl (fig. 113).[9]

TOP LEFT: FIGURE 111
Beatrice Wood
Louise Arensberg, Walter Arensberg,
and Marcel Duchamp
1936
Gelatin silver print
PHILADELPHIA MUSEUM OF ART: GIFT OF JACQUELINE,
PAUL, AND PETER MATISSE IN MEMORY OF THEIR MOTHER,
ALEXINA DUCHAMP
© 2006 BEATRICE WOOD CENTER FOR THE ARTS

TOP RIGHT: FIGURE 112
Photographer unknown
Man Ray and Duchamp with rue de la
Vieille Lanterne sign, Los Angeles
1949
Gelatin silver print
PHILADELPHIA MUSEUM OF ART: GIFT OF JACQUELINE,
PAUL, AND PETER MATISSE IN MEMORY OF THEIR MOTHER,
ALEXINA DUCHAMP

·

Man Ray and Marcel Duchamp pose
together on a Hollywood film set.
Man Ray wears a shoelace in place
of a necktie, an iconoclastic fashion
statement that Gloria de Herrera mentions
in her 1961 poem "The Myth of MAN RAY"
(fig. 143).

FIGURE 113
Floyd Faxon
Walter and Louise Arensberg home,
Hollywood, California (View 12)
ca. 1948
Gelatin silver print
PHILADELPHIA MUSEUM OF ART: ARENSBERG ARCHIVES

Many people who knew the Arensbergs also knew the Hodels. Indeed, George and Dorothy Hodel were often linked to the Arensbergs by one degree of separation (see endpapers and pages 154–161, Los Angeles 1935–1950: A Web of Connections). The people who had contact with both families include Henry Miller, Man Ray, Billy Pearson, Edward G. Robinson, and the poet Kenneth Rexroth. The artist Andrée Rexroth, Kenneth's first wife, who died in 1940, likely painted Dorothy Hodel's portrait.[10]

The architect Lloyd Wright, who designed Hodel's house on Franklin Avenue (figs. 114, 115, 121, 122), was well acquainted with the Arensbergs. Wright designed and made structures for Earl Stendahl, the artist Beatrice Wood, and the art dealer Jake Zeitlin (all of whom were friends of the Arensbergs).

Others within the Arensberg circle had acquaintances in common with George Hodel. The art dealer Galka Scheyer coordinated the purchase of Duchamp artworks by the Arensbergs. A note written by Dorothy Hodel in 1943 indicates the Hodels' contact with Scheyer about "children's pictures," possibly referring to photographic portraits (fig. 116).

Walter Arensberg was born into a wealthy family from Pittsburgh, where his father was the president of a steel company. His wife, the former Mary Louise Stevens, was an heiress to a textile fortune.[11] In New York during the 1910s, the Arensbergs' lifestyle, along with their intellectual and aesthetic enthusiasms, had a formative impact on the development of modernism. Their libertine, all-night salons attracted guests such as the poet William Carlos Williams, the artists Charles Sheeler, Mina Loy, and Man Ray, and many others. Duchamp was often the unofficial star of the show. In her memoir, *I Shock Myself,* the artist Beatrice Wood recalls falling asleep on a bed at one of the Arensbergs' parties with a number of other people, including Duchamp, with whom she, like many other young women, was romantically infatuated.[12]

FIGURE 114
Photographer unknown
George Hodel in the study of his
Franklin Avenue home
ca. 1950
FAMILY-OWNED COPYPRINT AFTER ORIGINAL —
COLLECTION OF STEVE HODEL

FIGURE 115
Photographer unknown
George Hodel's collection of Chinese
artifacts in his study
ca. 1950
FAMILY-OWNED COPYPRINT AFTER ORIGINAL —
COLLECTION OF STEVE HODEL

The Arensbergs' move to Los Angeles created a geographical and social remove from the goings-on in the New York art world. The salons for which they had been famous became more formal and their influence as art patrons was now evident in other ways. Though private collectors, the Arensbergs opened their doors to the public, receiving most visitors interested in seeing their collection. Servicemen and school groups were among their guests, as well as art enthusiasts.[13] Works by de Chirico, Duchamp, Constantin Brancusi, and Dalí covered their walls in almost every space of the house, including the bathrooms. In a city without many formal venues for displaying avant-garde art, their home, with some fifteen hundred works on display, was a remarkable anomaly.

During these years, Walter Arensberg, who was elected class poet at Harvard and, after graduation, focused on writing poetry before turning to collecting,[14] became increasingly obsessed with proving that works attributed to Shakespeare were in fact written by Francis Bacon. This project would lead him to publish several books on the subject and to found the Francis Bacon Foundation in Claremont, California, a research institute associated with his cause. Among those who became involved in the Bacon/Shakespeare debate were Henry Miller and Kenneth Rexroth (whom Miller called "the only scholar" he knew).[15] Rexroth and Miller were both friendly with George Hodel.

The Arensbergs had been among Duchamp's main patrons when they lived in New York, and their relationship persisted after they moved to Los Angeles, despite the geographical distance between them. The artist had stated in the early 1920s that he was no longer going to make art and would devote his time to playing chess instead. The Arensbergs continued to buy earlier works by Duchamp, and they also appointed him curator of their collection. Between 1930 and 1936, Duchamp arranged their purchase of works by Brancusi, Ernst, Léger, and Joan Miró, among others. At one point, the Arensbergs discussed

building a museum in California with Duchamp's works as the focal point, a scheme that never panned out.

In 1948, fearful that the Arensbergs would will their collection to a museum outside California, Vincent Price, Fanny Brice, and Edward G. Robinson rallied the cultural elite and founded the Modern Institute of Art. Arensberg had told Price that if Price could create a museum of modern art, he would loan his artworks for display. Arensberg even suggested that he might donate his collection to such an institution.[16]

Located in Beverly Hills, the Modern Institute of Art had an annual attendance of forty thousand and put on ten shows, including exhibitions of French Impressionist artists' and Paul Klee's works, as well as a show drawn from the Arensbergs' holdings. Nonetheless, it closed within two years because it lacked adequate financial support.

In December of 1950, working closely with the Arensbergs, Duchamp orchestrated the gift of their collection to the Philadelphia Museum of Art, which agreed to their condition that the collection be kept separate from the museum's other holdings. This move ensured Duchamp not only prominent display but a permanent position within the modern art-historical canon.

Duchamp, famous for earlier works such as *Nude Descending a Staircase* (1912), which the Arensbergs owned, and *The Fountain* (1917), made newspaper headlines when he visited the Arensbergs in Hollywood in 1936. During his later visits, in 1949 and 1950, he stayed at their home and socialized with artists and colleagues in Los Angeles, including Man Ray, Beatrice Wood, and the art dealer and artist William Copley.[17]

While the Arensbergs' relationship with Duchamp was for the most part steady, their friendship with Man Ray came to an end sometime in the late 1940s. When Man Ray had first arrived in Los Angeles, the Arensbergs had welcomed him into their West Coast circle, facilitating personal and professional connections. At a dinner party at their house in 1940, Man Ray

OPPOSITE: FIGURE 116
Calendar page with Dorothy Hodel's handwriting from November 7, 1943
COLLECTION OF STEVE HODEL

·

This misspelled November 1943 entry in George and Dorothy Hodel's calendar notes, "Gelka Scheyer for children's pictures." The German expatriate Galka Scheyer was a major force in introducing modernism to Los Angeles in the 1930s and 1940s. An artist's agent representing the "Blue Four"—Alexei Jawlensky, Lyonel Feininger, Paul Klee, and Wassily Kandinsky—she occasionally acted as an intermediary for Walter Arensberg when he wished to purchase works from Marcel Duchamp.

The calendar highlights the small interconnecting artistic circles in Los Angeles at the time—linking Duchamp, the Arensbergs, and the Hodels by one degree of separation.

FIGURE 117
Man Ray
Portrait of Albert Lewin
ca. 1945
© 2006 MAN RAY TRUST / ADAGP (ARS) / TELIMAGE

FIGURE 118
Lilliane Montevecchi in a publicity shot
for Albert Lewin and René Cardona's
film *The Living Idol*
1957
© MGM / PHOTOGRAPH: MGM/PHOTOFEST

met Albert Lewin, the filmmaker who became a friend and patron throughout his Hollywood years (fig. 117). Lewin's interest in art and the dark side of the creative mind was evident in his films, including *The Private Affairs of Bel Ami* (1947) and *The Moon and Sixpence* (1942). Like many of Lewin's films, these touched on complex and troubled relations between men and women. In addition to buying art by Man Ray, Lewin commissioned him to both photograph and paint a picture of Ava Gardner for his 1951 film *Pandora and the Flying Dutchman*, whose imagery contained references to Man Ray's art. The painting was not used in the final cut, but Lewin did incorporate the photograph as well as a chess set that he had designed.[18]

Several years later, Lewin's fascination with art and anthropology was still evident in *The Living Idol* (1957), in which an excavation at a Mayan pyramid sets off a series of ominous events. In the film, an anthropology professor delivers a lecture on the history of ritual sacrifice, showing slides of Mayan maidens (fig. 118), the minotaur, and Hitler with a parade of German troops.[19]

The Arensbergs were still on friendly terms with Man Ray in October of 1946, when he and Juliet Browner married in a double wedding ceremony with Max Ernst and Dorothea Tanning. After the wedding, the two couples were feted in serial celebrations at the homes of the Stendahls, the Arensbergs, and the Lewins. Florence Homolka, a friend and protégé of Man Ray's, took pictures of the event (fig. 119).

FIGURE 119
Florence Homolka
"Double Wedding Portrait (Man Ray, Juliet
Man Ray, Max Ernst, Dorothea Tanning)"
Los Angeles
October 25, 1946
THE J. PAUL GETTY MUSEUM, LOS ANGELES
REPRODUCED COURTESY OF THE ESTATE OF FLORENCE
HOMOLKA

Florence Homolka took this photograph of Man Ray and Juliet Man Ray with Max Ernst and Dorothea Tanning on the occasion of their double wedding. Homolka, a friend and protégé of Man Ray, published her own book of photographic portraits, *Focus on Art,* in 1962, portraying many of the intellectuals, Hollywood insiders, and European expatriates in Los Angeles during the 1940s. A variation of this image appears in that book, along with portraits of Hodel's friends John Huston and Edward G. Robinson.

By the time of Duchamp's second visit to Los Angeles in April of 1949, however, the relationship between Man Ray and Walter Arensberg had soured. Man Ray was no longer welcome at the Arensbergs' home, and Duchamp made excuses to leave their house in order to socialize with him.[20]

The origin of the rift has been attributed to the fact that the Arensbergs expressed little interest in Man Ray's art. And, earlier that year, Man Ray had titled a group of paintings he showed at the Copley Galleries Shakespearean Equations, which may have been intended as a mockery of Arensberg's Francis Bacon project.

It is a believable enough cause for cutting off ties. However, it is also conceivable that Man Ray's friendship with George Hodel was a factor. The murder of Elizabeth Short, in which Hodel became a suspect, took place two and a half months after Man Ray's wedding and not long before his thirty-year relationship with the Arensbergs terminated. These were years in which Man Ray was friendly with and photographing Hodel. Hodel might have earned a reputation by then as someone of dubious, perhaps even criminal, character. His personal secretary, Ruth Spaulding, had died of a barbiturate overdose in 1945, and he had been at her home the

had been indexed for filing. It is now estimated that these reports will be indexed and filed by Thursday morning, November 3, 1949. These records and reports deal primarily with the investigation of suspect Dillon. It was further found that there were approximately two thousand two hundred documents being records, reports and statements and correspondence of the Homicide Division which had been filed in order and indexed. However, due to the fact that the Homicide Division and Sgt. F. A. Brown could not secure the assistance of any stenographers and filing clerks, no indexing or filing had been done on these documents since December, 1948. These documents number approximately five hundred and twenty eight and have yet to be indexed and filed. It is estimated by Sally Scott, a file clerk, that it would take approximately six more weeks to complete the work on these five hundred and twenty eight documents.

On October 26, 1949 Chief of Police William A. Worton assigned two stenographers to assist this file clerk in indexing. It seems that hundreds of police officers have worked on this case and as a result some of these officers did not bring to a conclusion some of the loose ends of their investigations. There has been a tremendous amount of investigation work done on this case as reflected by the officers reports, statements and correspondence. Captain Harry Elliott in charge of the Homicide Division stated that there has been more work done on this case than any other murder case in the history of the LAPD. Sgt. F. A. Brown and Sgt. Harry Hanson have done most of the work on this investigation having been assigned ever since the case of the murder and in spite of their being handicapped by the lack of clerical assistance and lack of expense money with which to travel they have kept their records in fair order and have made a comprehensive investigation and as indicated by their reports they brought most of their check-outs on suspects and investigations to a conclusion as nearly as possible. However, due to the lack of coordination of effort and the lack of proper correlation of records, reports, statements and correspondence on the part of the Administrative Division of the LAPD it appears that there is much work yet to be done on this case and at least fifty persons remain that should be interviewed and t here are at least twenty-five more persons that should be requestioned. There have been three hundred and sixteen supects fifty of whom have been arrested, (Not always charged with murder.) and later released. On the date of this report there are one hundred and seven remaining possible suspects after a definite elimination of two hundred and nine suspects. There have been nineteen suspects who have confessed to the murder of Elizabeth Short.

AFter examination of the files and evidence it appears that the investigative effort should be continued and concentrated on the following suspects:

Leslie Dillon -- Mark Hanson -- Carl Balsiger -- Glen Wolfe -- Henry Hubert Hoffman -- Dr. George Hodel --

FIGURE 120

Page 3 of Frank Jemison's report to the grand jury October 28, 1949

.

The Los Angeles County district attorney lieutenant's report on the Black Dahlia murder recommended that the investigation be concentrated on six prime suspects, including George Hodel.

night she died. In October of 1949, he was indicted on charges of improper relations with his daughter Tamar. That same month, he was identified as one of six prime suspects in the Black Dahlia murder (fig. 120).[21]

It is likely that the Arensbergs knew or at least knew of George Hodel because of his art-world connections. In addition to his activities as a collector and amateur photographer, he, too, had a possible link to Albert Lewin. Marion Herwood Keyes, one of Hodel's two secretaries at the Los Angeles County Health Office, worked as an associate costume designer for Lewin's *The Picture of Dorian Gray* (1945) shortly after leaving

front entrance approach

view of West Wing

For Sale: SHANGRI—LA ... in Los Angeles

views of Library

... *a uniquely beautiful and luxurious modern home, by* Lloyd Wright

THIS UNUSUAL AND DISTINGUISHED STUDIO RESIDENCE is considered one of the finest examples of the architectural genius of Lloyd Wright. It is located in the exclusive De Mille tract (Laughlin Park), on the lower Los Feliz hillside, conveniently close to both Hollywood and Los Angeles. The new Hollywood Parkway now being completed brings it within a few minutes of downtown Los Angeles. THIS UNIQUE HOME IS BEING OFFERED, FOR QUICK LIQUIDATION, AT A REMARKABLY LOW PRICE.

The house is built around a large central patio (27 by 72 feet), with sunken pool (not a swimming-pool). There are 5 master bedrooms, 2 servants' bedrooms, and 4 baths. If fewer bedrooms are needed, they may readily be used for other purposes, since there are primarily separate studios, opening onto the patio. All rooms are on one level, although the front entrance to the house is from a lower level. A rear driveway also enters into the house, on the upper level, with a two-car built-in carport which also opens onto the patio. Besides, there are two large and beautiful studio living-rooms, one at the north end of the patio, 20 x 25 feet, and another at the south end, 20 x 27 feet. Both studios have 25-foot ceilings and massive glass-panel doors which slide back to open directly onto the central patio (see photos). The north studio is on a slightly raised level, making it suitable for use as a private stage or concert room.

view of South Studio

THE TWO LARGE STUDIO LIVING-ROOMS, the dining-room, and 3 of the master bedrooms face the patio, with sliding glass panel doors opening onto it. The bedroom sliding doors have massive decorative Venetian blinds, affording either privacy or full sun exposure, as desired. Another master bedroom has its own small private walled-in sun patio. One bedroom is finished in Chinese gold papering on walls and ceilings; another has strikingly rich tropical hardwood panelling. There are six large overhead skylights, with amber-gold glass giving warm interior lighting through the day, and diffuse electric lighting at night (see photo above).

TYPE OF CONSTRUCTION: Central portion is reinforced pre-cast concrete, on heavy concrete slab foundation. Large basement. Outer wings of house are concrete and stucco. Heavy steel reinforcing throughout. There is no filled ground. Roof is slate (Johns-Manville) over studio wings, and composition elsewhere. Large kitchen; butler's pantry. New (1940) 11-cubic-foot Frigidaire; Bendix home laundry. Service porch has capacious built-in incinerator. Two automatic hot-water heaters. Unit heat.

ORIGINAL COST: $68,000 (1927). Cost of lot (75' x 175') was $12,500. 2-1 zone (Laughlin Park, De Mille tract). Estimated present reproduction cost: $95,000. Building is 63' x 125'; total enclosed area (exclusive of central patio) is 6250 square feet. Taxes are only $477.49 (1940 - 50).

APPRAISAL VALUE: $60,500 (fire insurance underwriters, 1940). INSURANCE COVERAGE: $60,500. SELLING PRICE: $44,500, for quick liquidation. COURTESY TO BROKERS. VIEWING: by appointment only. Inquire through: Henry C. Rohr, Esq., Trustee; 650 S. Spring St., Los Angeles 14 (TU-6331). THIS IS A UNIQUE OPPORTUNITY TO ACQUIRE A LARGE AND DISTINGUISHED STUDIO HOME, AT VERY LOW COST: $16,000 UNDER ITS STANDARD MARKET VALUATION.

FIGURES 121, 122

Photographer and designer unknown
"For Sale: Shangri-La ... in Los Angeles"
ca. 1950

COLLECTION OF STEVE HODEL

·

A real estate brochure that George Hodel used to sell his house at 5121 Franklin Avenue describes a "uniquely beautiful and luxurious modern home" being offered "for quick liquidation." Hodel sold the house and many of his possessions and artworks after his 1949 incest trial. He relocated to Hawaii and then the Philippines.

Hodel's employ. Herwood Keyes had been friends with Ruth Spaulding. In addition, Hodel preferred to rent rooms in his Franklin Avenue house to artists, according to the 1950 D.A. transcripts. His friend the artist Fred Sexton had an inaugural show at the Stendahl Art Galleries, whose owner, Earl Stendahl, was close with the Arensbergs.[23] Edward G. Robinson and John Huston collected Sexton's works, as did Paulette Goddard and the Hollywood patron Ruth C. Maitland.[24] Sexton was also a participant in the 1949 incident involving Tamar Hodel that led to the incest trial.

Marcel Duchamp and the *Étant donnés*, Part I

"The idea of a breast is a very good one and feasible I think."

— Marcel Duchamp in a letter to Man Ray, November 8, 1948[1]

Shortly after the period in which Elizabeth Short's death was dominating national newspaper headlines, Marcel Duchamp began the sketches and studies that would, over time, evolve into his final masterpiece, *Étant donnés: 1 la chute d'eau, 2 le gaz d'éclairage* (Given: 1. The Waterfall, 2. The Illuminating Gas), figure 134. Known as the *Étant donnés*, this enigmatic, three-dimensional tableau has been an object of fascination for art historians and museumgoers since it was first publicly seen at the Philadelphia Museum of Art in 1969.

Early studies for the nude figure in the *Étant donnés* were based on Duchamp's lover at the time, the Brazilian sculptor Maria Martins. Duchamp met the vivacious Martins, the wife of the Brazilian ambassador Carlos Martins, sometime in the early 1940s. She lived in Washington, DC, with her family but also kept a New York studio on Park Avenue and Fifty-eighth Street. Martins exhibited at the Valentine Gallery in New York during the 1940s, showing there with Piet Mondrian in 1943.[2]

Her involvement in early versions of the *Étant donnés* was intimate, as letters from Duchamp to her reveal. Duchamp called his ever-changing artwork "our" sculpture and also referred to it as "N. D. des désires" ("our lady of desires").[3] Duchamp was so taken with Martins that, as the art historian Francis Naumann has speculated, her activities as an artist may have influenced Duchamp's own creative production. Naumann compares the *Étant donnés* figure to two of Martins's sculptures of female nudes from 1942 and 1944, both rendered without heads and lying on their backs.[4]

Despite the intense bond between Martins and Duchamp, she would not leave her family for him, though it appears that the famously aloof bachelor wished her to do so. In a letter, he urged Martins to rent

FIGURE 123
Mark Kauffman
Portrait of Marcel Duchamp
1965
PHOTOGRAPH: MARK KAUFFMAN / TIME LIFE PICTURES / GETTY IMAGES
.

Marcel Duchamp, photographed behind his early masterwork *The Large Glass* at the Philadelphia Museum of Art. In front of his left shoulder are the three "oculist witnesses," represented in three circular forms. It is widely held that *The Large Glass* relates thematically to the *Étant donnés*, unveiled after Duchamp's death.

an apartment in his building: "You could isolate yourself with me there and *no one* would know about this cage outside of the world."[5] She did not take the apartment, so he rented it himself, using it as the studio where he worked on the *Étant donnés*.[6] Their affair continued until 1950, when Martins moved to Brazil with her family; their final written correspondence was in 1951. Martins and Duchamp met for the last time in 1966, two years before Duchamp died.[7]

In the fall of 1951, Duchamp, Max Ernst, and Dorothea Tanning spent a weekend with Alexina ("Teeny") Matisse at her country house in Lebanon, New Jersey.[8] Teeny Matisse was the former wife of the dealer Pierre Matisse, Henri Matisse's eldest son. They had divorced two years earlier, and she had three children, two of whom were in college.

Duchamp and Teeny became romantically involved and soon moved in together, subleasing Max Ernst and Dorothea Tanning's New York apartment until 1959. (The nameplate read MATISSE-DUCHAMP-ERNST).[9] They married on January 16, 1954, and Duchamp became a naturalized U.S. citizen the following December.[10]

As Duchamp continued to develop the *Étant donnés,* some of his alterations reflected Teeny's presence in his life. He modeled the figure's hand after hers and changed the wig on the model to one the color of Teeny's hair.

Teeny, however, did not share Duchamp's zeal for the *Étant donnés.* She "reportedly found the subject distasteful," Naumann notes. Nonetheless, she assisted him with it, helping him gather the twigs and leaves that would be part of the final work from around her Lebanon house.[11]

After two decades of working on the *Étant donnés* in relative secrecy, Duchamp finally unveiled it privately in his studio in 1968, shortly before his death. As he wished, it was posthumously reconstructed and installed at the Philadelphia Museum of Art near *The Large Glass* and his works from the Arensberg collection.

The completed work reveals a ghostly pale sculpture of a nude woman sprawled in the bed of long twigs. The left leg is bent awkwardly, exposing the gashlike form that appears in place of her genitals (fig. 134).

As Duchamp had specified, museum staff installed the tableau behind a rough-hewn wooden door set in a brick edifice (fig. 146). The door and bricks both came from Cadaqués, Spain, where Marcel and Teeny spent their summers.[12]

Viewers can see the work only by looking through one of two peepholes in the door. Thus, it is easy to miss the interior of the *Étant donnés* entirely, unless one knows to approach the holes.

While Martins and Teeny Matisse provided some of Duchamp's inspiration, it is generally believed that this unsettling masterwork refers to much more than these two women. Scholars have cited a range of influences, from the artworks of Gustave Courbet and Hans Bellmer, to alchemy, Victorian pornography, stereoscopy, and nineteenth-century salon paintings.

Many have interpreted the *Étant donnés* as a more straightforward version of the concepts in *The Large Glass*—as overt in its representation of voyeurism and sex as *The Large Glass* was arcane.[13] While *The Large Glass* presents a confounding narrative that can be seen from several vantage points, the *Étant donnés'* construction forces the viewer to adopt a voyeuristic position that specifically directs one's gaze directly to the prone, unclothed figure's genital area. As the art critic Calvin Tomkins has noted in comparing the *Étant donnés* with the female figure in *The Large Glass*, "The bride has been stripped bare at last."[14]

Some people who knew Duchamp at the time concur. "I don't know what this great mystery is," the painter Robert Barnes, who procured a pigskin for use in Duchamp's work in progress, said in a 2001 interview. In his opinion, "It is the bride fleshed out and it is the appropriate final production that Duchamp created."[15]

LEFT: FIGURE 124
**Dissecting table photograph —
Elizabeth Short murder
January 15, 1947**

RIGHT: FIGURE 125
Marcel Duchamp and Enrico Donati
Prière de toucher
(Please Touch)
**Cover of the deluxe edition of the
exhibition catalog for "Le Surréalisme en
1947," on view at Galerie Maeght, Paris
July–August 1947**
Hand-painted foam-rubber breast
with felt, mounted on board
© 2006 ARTISTS RIGHTS SOCIETY (ARS), NEW YORK / ADAGP,
PARIS / SUCCESSION MARCEL DUCHAMP
PHOTOGRAPH: RESEARCH LIBRARY, THE GETTY RESEARCH
INSTITUTE, LOS ANGELES

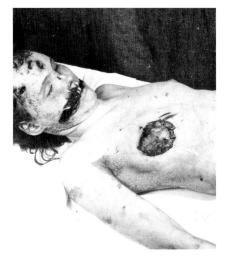

Others see something more straightforward. "A large part of the *Étant donnés* is about irony and humor," says William Copley's son, the artist Billy Copley. "In my opinion, Duchamp kept it a secret because he had made a broad statement that he had finished making art. But he really needed to go to work every day. So he created something for himself to do."

"There was a perception that everything he did was a great intellectual exercise, but the meanings were based on the most ordinary human endeavors," in Copley's view. "As much as the intellectuals would make of it, the *Étant donnés* is based on day-to-day life, life and death, and life between the sexes."[16]

In surrealism, as we have seen, life and love between the sexes were often laced with the implication of violence. So it may have been with the *Étant donnés*.

•

Whatever else shaped Duchamp's conception of the *Étant donnés*, the Black Dahlia murder must also be considered. Completed, Duchamp's

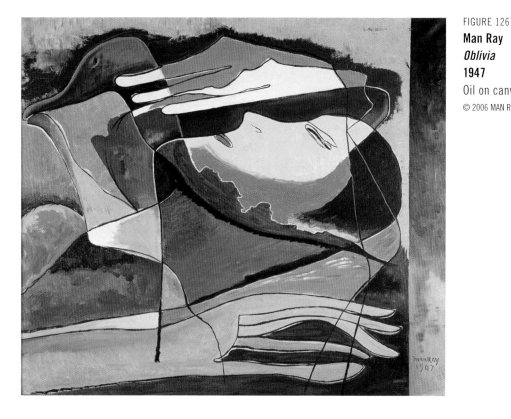

FIGURE 126
Man Ray
Oblivia
1947
Oil on canvas
© 2006 MAN RAY TRUST / ADAGP (ARS) / TELIMAGE

unusual diorama shows clear similarities to crime-scene photographs of Elizabeth Short's body (fig. 135).

With this in mind, it is useful to consider some events surrounding the development of the *Étant donnés*, as well as Duchamp's other artistic activities, alongside the story of the Black Dahlia murder as it began unfolding in early 1947.[17]

While on vacation in the summer of 1946, Marcel Duchamp photographed a small waterfall at Chexbres, Switzerland. The original purpose of the photograph is not known, but it ultimately provided the background for the *Étant donnés*.[18]

Duchamp returned to his New York home on January 22, 1947—just seven days after Elizabeth Short was killed. Newspaper articles and photo-

LEFT: FIGURE 127

Marcel Duchamp
Étant donnés: Maria, la chute d'eau et le gaz d'éclairage
(Given: Maria, the Waterfall and the Illuminating Gas)
December 1947
Black lead pencil

MODERNA MUSEET, STOCKHOLM
© 2006 ARTISTS RIGHTS SOCIETY (ARS), NEW YORK / ADAGP, PARIS / SUCCESSION MARCEL DUCHAMP
PHOTOGRAPH © MODERNA MUSEET, STOCKHOLM

•

This pencil drawing by Marcel Duchamp, of his lover, the sculptor Maria Martins, is the first image that relates to the three-dimensional figure in his final work, *Étant donnés*.

RIGHT: FIGURE 128

Marcel Duchamp
Étude pour *Étant donnés: 1 la chute d'eau, 2 le gaz d'éclairage*
(Study for Given: 1. The Waterfall, 2. The Illuminating Gas)
ca. 1947
Collage

PRIVATE COLLECTION
© 2006 ARTISTS RIGHTS SOCIETY (ARS), NEW YORK / ADAGP, PARIS / SUCCESSION MARCEL DUCHAMP
PHOTOGRAPH © CAMERAPHOTO ARTE VENEZIA / BRIDGEMAN ART LIBRARY

•

This small collage by Duchamp begins to suggest the ideas he would bring to fruition in the final *Étant donnés*. It incorporates a figure similar to his earlier drawing of Maria Martins (fig. 127) with photographs he took of a waterfall at Chexbres, Switzerland.

graphs conveyed the principal facts about the murder, but the full extent of what happened was accessible only through word of mouth by people in the know. Duchamp would have had immediate access only to the greatly modified crime-scene photos that appeared in the mainstream press.

In July of 1947, Duchamp collaborated with the artist Enrico Donati to create 999 handmade covers for the deluxe editon of *"Le surréalisme en 1947,"* the catalog accompanying the Exposition Internationale du Surréalisme at Galerie Maeght in Paris (fig. 125). Alongside the words *"Prière de Toucher"* (Please Touch), the covers featured a three-dimensional, foam rubber sculpture of a breast surrounded by black velvet. A more affordable edition of the catalog had a photograph of the same breast by the French photographer Rémy Duval, reproducing the image from the deluxe version.

It is in line with Duchamp's subversive sense of humor that someone reading the catalog *has to* touch the breast while holding the book. It is virtually impossible not to cradle the breast in one's hand. The more the book is handled, the dirtier the breast gets.

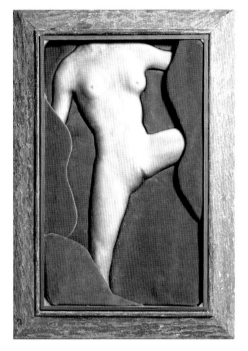

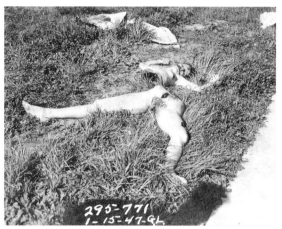

When asked in 1966 if the cover had any significance to him, Duchamp replied, "No, it was just another idea. I had seen these sponge-rubber 'falsies' they sell in stores. I had to finish them, because, since they were meant to be hidden, the manufacturers hadn't bothered with the details. So I worked on making little breasts, with pink tips."[19] It is noteworthy, however, that Duchamp's image of a single breast appeared just months after Elizabeth Short's body, absent her right breast, was discovered (fig. 124).

The catalog cover and the *Étant donnés* can be seen as pieces of the same puzzle. They are both tableaux of cool eroticism—one filling a small room; the other compact enough to hold in the hand—and may contain separate references to the same event, the murder of Elizabeth Short.

In a letter from November 1947, Duchamp wrote to Man Ray, "The idea of a breast is a very good one and feasible I think." Francis Naumann and the writer Hector Obalk Ludion have noted that the letter refers to the deluxe catalog cover, with the foam breast.[20] However, since the

FIGURE 129
Marcel Duchamp
Étude pour *Étant donnés: 1 la chute d'eau,*
***2 le gaz d'éclairage* (Study for Given:**
1. The Waterfall, 2. The Illuminating Gas)
1948–49
Painted leather on plaster, velvet
COLLECTION: MODERNA MUSEET, STOCKHOLM, SWEDEN
© 2006 ARTISTS RIGHTS SOCIETY (ARS), NEW YORK / ADAGP, PARIS / SUCCESSION MARCEL DUCHAMP
PHOTOGRAPH: © CAMERAPHOTO ARTE VENEZIA / BRIDGEMAN ART LIBRARY

FIGURE 130
Crime-scene photograph—
Elizabeth Short murder
January 15, 1947

Exposition Internationale du Surréalisme had already taken place, the chronology does not appear to correspond. The letter may pertain instead to a photograph that Man Ray took of the cover — or to one he took of a construction that resembled it.[21] Either way, it is clear that Man Ray and Duchamp continued some sort of dialogue about "a breast" *after* Duchamp had created the catalog.

·

If the *Surréalisme en 1947* catalog or aspects of the *Étant donnés* contain veiled references to Elizabeth Short's death, there remains the question of why Duchamp took an interest in this criminal act. A straightforward answer suggests itself. Duchamp would have been interested if he had a personal connection to the killing. That connection could have been his friendship with Man Ray, who himself may have realized that the murder resembled aspects of some of his own photographs, such as "Minotaur" (fig. 57), and his photograph of Juliet on the couch at 1245 Vine Street (fig. 55). If Man Ray took a particular interest in the killing, or had a personal connection to it, the crime might well have intrigued Duchamp by association.

In 1947, the year of the Black Dahlia murder, Man Ray completed the painting *Oblivia* (fig. 126), portraying a woman's face, her eyes closed, and her oversized hands resting on either side of her head. The title and imagery revisit the familiar surrealist themes of dreams and desire, perhaps accompanied by an air of death. In general, Man Ray's art did not receive a felicitous reception while he was in Los Angeles, but this appears to have been an exception. In an undated letter Man Ray received, the correspondent wrote, "Dear Man Ray and Julie, 'Oblivia' is a tremendous success — Ted Bocker [sp?] hung and framed it well and it is a sensation." The note appears to refer to a collector who had happily displayed the painting in his home.

FIGURE 131
Marcel Duchamp
Feuille de vigne femelle
(Female Fig Leaf)
1950/1961
Bronze, cast after 1950
plaster original, 1961.

FIGURE 132
Marcel Duchamp
Objet-dard
(Dart Object)
1951/1962
Bronze, cast after 1951
plaster original, 1962.

FIGURE 133
Marcel Duchamp
Coin de chasteté
(Wedge of Chastity)
1954/1963
Bronze and plastic, cast after
1954 plaster original, 1963.

FIGURES 130–32: TATE GALLERY, LONDON
PURCHASED WITH ASSISTANCE FROM THE NATIONAL LOTTERY
THROUGH THE HERITAGE LOTTERY FUND, 1997
© 2006 ARTISTS RIGHTS SOCIETY (ARS), NEW YORK / ADAGP,
PARIS / SUCCESSION MARCEL DUCHAMP
PHOTOGRAPH © TATE GALLERY, LONDON / ART RESOURCE, NY

During December of that year, in his New York studio, Duchamp completed the pencil drawing of Martins (fig. 127), writing "Given: Maria, la chute d'eau et le gaz d'éclairage" (Given: Maria, the Waterfall and the Illuminating Gas) on the front. He would work with variations on this image for the next several years. The drawing portrays Martins's legs, torso, and breast; her sinewy left leg is raised high to one side.

A collage study (fig. 128) combined a variation on the 1947 drawing of Martins with the earlier imagery from Duchamp's photograph of the waterfall at Chexbres. The waterfall appears in the background on the lower-right side of the picture, a detailed rocky landscape. The study also portrays the body with the left leg and arm covered by a large swath of greenery. That motif, in particular, bears a resemblance to one of the Black Dahlia crime-scene photographs, in which grass obscures part of the victim's left leg and arm.[22]

In a collage work from 1948–49, made of painted leather on plaster and velvet, Duchamp began to flesh out the image dimensionally (fig. 129). In this version, showing mainly the torso area in isolation, the gash-like form that ultimately appears in the *Étant donnés* genital area is clearly visible. In addition, as the figure developed through various studies, it appeared more deathlike, recalling descriptions of the ivory-white corpse of Elizabeth Short.

In 1950, Duchamp created an unusual small sculpture, *Feuille de vigne femelle* (Female Fig Leaf), figure 131. This work, semi-abstract in appearance, was the first of many erotic objects Duchamp created during

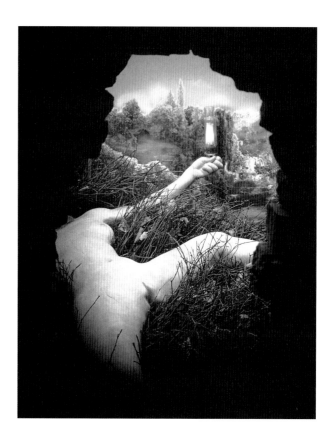

FIGURE 134

Marcel Duchamp

Étant donnés: 1 la chute d'eau,
2 le gaz d'éclairage
(Given: 1. The Waterfall,
2. The Illuminating Gas)
[Interior view, through peephole in door]
1946–66

Mixed-media assemblage: wooden door,
bricks, velvet, wood, leather stretched over
an armature of metal, twigs, aluminum,
iron, glass, Plexiglas, linoleum, cotton,
electric lights, gas lamp (bec Auer type),
motor, etc.

PHILADELPHIA MUSEUM OF ART
GIFT OF CASSANDRA FOUNDATION, 1969
ACCESSION: 1969-41-1
© 2005 ARTISTS RIGHTS SOCIETY (ARS), NEW YORK / ADAGP,
PARIS / SUCCESSION MARCEL DUCHAMP

the early 1950s, including *Objet-dard* (Dart Object), 1951 (fig. 132), and *Coin de chasteté* (Wedge of Chastity), 1954 (fig. 133), which he gave to Teeny as a wedding present.[23] *Female Fig Leaf* was cast from a sculptural study for the female figure in the *Étant donnés*.[24] More specifically, it was an impression made from the genital area of this study.

In its final form, the *Étant donnés* featured a pale figure made of leather over a metal armature. The head, or lack of it, is obscured by the wig in Teeny's hair color. Duchamp wrote the title of the piece on the figure's right shoulder.

·

One of the first people Duchamp called in to view *Étant donnés* after its completion was a person who was present during many key events described in these pages.

He was an art-world figure who had been in Los Angeles when the murder occurred and who became lifelong friends with Man Ray and Duchamp during that time. He was immersed in surrealism profession-

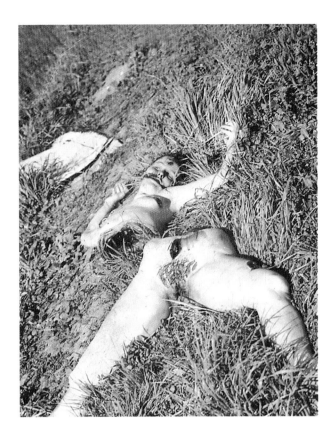

FIGURE 135
**Crime-scene photograph—
Elizabeth Short murder
(detail, rotated 45 degrees)
January 15, 1947**

ally as an art dealer and as an artist. In his own paintings begun during his time in Los Angeles, he portrayed the themes of envy, eroticism, and murder.

Why would Duchamp choose this person to be the first to see his long-hidden work? Perhaps because the man in question was a longtime personal friend and financial supporter who would ensure that the *Étant donnés* would join Duchamp's other masterpieces in the Philadelphia Museum of Art. He was also someone who, five years earlier, had made a painting that may itself have referred to Elizabeth Short's killing—and may even have hinted at who the Black Dahlia murderer was.

The man Duchamp invited to his studio that day was Wiliam Copley.

William Copley: Surrealist Confidant

*"I was very young when I opened my gallery in Los Angeles. It was 1948,
and to me the Surrealists were gods descended straight from Mount Olympus."*
— William Copley[1]

The adopted son of a wealthy San Diego newspaper family, William Copley arrived in Los Angeles in 1946, shortly after his military service during World War II had ended.[2] Soon after his arrival, he walked into the Stendahl Art Galleries wearing his Army uniform and sandals, and purchased a Picasso portrait of Dora Maar for $2,500. This impulsive act quickly put him in the public eye of the art world in Los Angeles.

If the Arensbergs epitomized the elite avant-garde in Los Angeles in the 1940s, entertaining intellectual and artistic luminaries as they fine-tuned their world-class art collection, Copley, equally passionate about art and ultimately quite influential, was in character and conduct at the opposite end of the spectrum. He was a young man who had come to Los Angeles with few art-world connections. Though relatively unknown, Copley quickly ingratiated himself with the artists he admired by the force of his personality and by the promise of exposure at his new gallery. In short order, he became a dealer, collector, and artist. Copley was a humorous and irreverent person who, at least in his writings, recalled his five years in Los Angeles, and his financially disastrous stint as an art dealer there, as a breezy adventure.

Copley took up painting a year after he arrived in Los Angeles, in 1947, and exhibited internationally until his death in 1996. Though his cartoonish style, featuring bare-breasted women and clothed men, had little resemblance to surrealist art, Copley felt a fierce spiritual connection with the movement as a young man and overtly referenced its themes in his own work. He recalled how his life changed when his then-brother-in-law, John Ployardt, a Disney animator, taught him about surrealism. "Surrealism made everything understandable: my genteel family, the war,

FIGURE 136
Photographer unknown
William Copley, Juliet Man Ray, Man Ray,
and Gloria de Herrera, visited by Marcel
Duchamp on board the S.S. ***De Grasse,***
before their departure for Paris
March 12, 1951
PHOTOGRAPH: RESEARCH LIBRARY, THE GETTY RESEARCH
INSTITUTE, LOS ANGELES (980024)
REPRODUCED COURTESY OF JAMES B. AND BARBARA BYRNES

FIGURE 137
Man Ray
Portrait of William Copley
ca. 1960
© 2006 MAN RAY TRUST / ADAGP (ARS) / TELIMAGE

and why I attended the Yale Prom without my shoes," Copley wrote. "It looked like something I might succeed at."

As Man Ray noted of Copley in *Self Portrait*, "He began to collect paintings at the same time that he began to paint discreetly, without being influenced by the work of others, except by a general iconoclastic quality of the Dadaists and Surrealists. His undisciplined technique and harsh humor were too disrespectful of any school. It conformed to my repeated declaration that art was the pursuit of liberty and pleasure."

Copley and Ployardt decided to open a gallery in Los Angeles, despite the fact that "the place was an intellectual desert," in Copley's words, and not receptive to contemporary art. "No one in their right mind would have considered trying to open a surrealist gallery in the California environment, which, of course, is what we decided to do late one whiskied evening," Copley later wrote.[3]

After six months of preparation, the Copley Gallery hosted its first show, a Magritte exhibition, on September 9, 1948. Copley sold a few paintings at the opening show, which the buyer paid for but never picked up. Over the next six months, the gallery's opening parties attracted people from the Hollywood film industry. He spent about $87,000 to mount shows during this time — by Joseph Cornell, Roberto Matta, Yves Tanguy, Man Ray, and Max Ernst — before closing up shop.

During that time, Copley bought many works for himself, amassing what would become a valuable personal collection. Later, he maintained that the gallery's failure didn't have to do with a lack of money in Los Angeles. Rather, it failed because collectors of surrealism went to New York to buy art.

Man Ray was among the first artists Copley approached about showing at his gallery. At the time, Man Ray was becoming disillusioned by the lukewarm reception that his works were getting in Los Angeles. In offering him an exhibition, Copley provided Man Ray with exposure and

FIGURE 138
William Copley
Birth of Venus
1953
Oil on canvas
© 2006 THE ESTATE OF WILLIAM N. COPLEY
REPRODUCED COURTESY OF THE ESTATE OF WILLIAM N.
COPLEY AND NOLAN / ECKMAN GALLERY, NEW YORK
PHOTOGRAPH: DOROTHY ZEIDMAN
•

William Copley often referred to surrealists whom he admired in his paintings, giving his works titles such as *Hommage à Magritte* (Homage to Magritte) and *Breton Revisited.* He also used visual motifs referencing surrealist artworks (including urinals and chessboards, both nods to Duchamp). In this painting, Copley's imagery alludes to Man Ray's photographic series *Érotique voilée* (see figs. 63, 65).

moral support, if not financial gain. The show, entitled "To Be Continued Unnoticed," was on view during December of 1948. Copley sold only one work during the exhibition, to Albert Lewin; he bought another himself. In the catalog, Man Ray published criticism of his last four shows, favorable and unfavorable, including one written in the absurdist style of Lewis Carroll's "Jabberwocky."

Copley exhibited his own paintings in an inaugural show in January of 1951, at Royer's Book Shop on North Robertson Boulevard in Los Angeles. From the onset of his career, Copley used the signature "CPLY" on his paintings. The Royer's catalog listed twenty paintings from the previous few years, some loaned by Man Ray and Ernst.

Dorothea Tanning wrote a short poem, titled "On the Paintings of BILL COPLEY," for the exhibition brochure (fig. 139). "Astonished nudes waiting for murder," the poem opens, "Naked as a clinic and staring like glass." Tanning also wrote that "all who know this man / Avow him the soul of kindness," and she concluded, "Listen. He is laughing gently at the whores and the mountebanks."

These early themes—prostitutes and naked women with clothed men, portrayed in boldly graphic surroundings—continued in Copley's art for close to fifty years (fig. 138). As the curator Walter Hopps wrote,

On the Paintings of BILL COPLEY

Astonished nudes waiting for murder,
Naked as a clinic and staring like glass.
Is tomorrow a home?

Avow him the soul of kindness)
Box-springs, cries another, have replaced the
* wooden horse*
In this irrevocable town (what a town!)

r deities will do us the honor—
phone. Yes,
d again, he's walking the rope,
poseful.
his agonized bouquet of paper flowers?
ised like a face on a tomb?
laughing gently at the whores and the
nks.

DOROTHEA TANNING, Dec. 22, 1950

"From the outset, among CPLY's key images and subjects one invariably finds naked nymphs and an overdressed male protagonist who disport themselves in chases, embraces, guilts, in an ongoing narrative dance of joys and sorrows. A thoroughly recognizable human comedy of sexual fetishism and bravado invariably pervades the work."[4]

While pursuing his own art, Copley was continuing to expand his gallery stable. He asked Man Ray to provide an introduction to Duchamp, then living in New York. An appointment was arranged for Copley and Ployardt to meet the artist in New York early in 1948.

Accounts of the meeting differ slightly, but Copley recalls the setup as mysterious and exciting—"all very Arabian Nights."[5] Man Ray had told him to send a telegram to Duchamp's studio on West Fourteenth Street when he arrived, which he did; Duchamp responded with a postcard instructing him to meet him in the lobby of New York's Biltmore Hotel. It turned out that the Biltmore had several lobbies, and they eventually found Duchamp in one of them, reclining on a large sofa and smoking a pipe. Duchamp commented that he often came to the hotel just to ride the elevators.

They went to lunch and then visited Duchamp's studio, where they discovered nothing but a bathtub, some clothesline, a chess table, clocks, a crate and a chair, tobacco, and matches.

Much about this meeting reveals Duchamp's eccentricities, but one thing in particular stands out. Duchamp specified that they meet in the lobby of the Biltmore Hotel—a hotel of the same name as the one in Los Angeles where Elizabeth Short was thought to have been last seen alive. A flyer printed by the Los Angeles Police Department and circulated around Los Angeles, requesting any information about Short, noted that she was last seen at the Biltmore Hotel. Given Duchamp's love of word games and double entendres, this choice may well have been more than coincidence.

FIGURE 139
William Copley
Exhibition brochure for "CPLY: Paintings by William N. Copley" at Royer's Book Shop, 465 N. Robertson Boulevard, Los Angeles
January 15–30, 1951
Oil on canvas
PRIVATE COLLECTION
REPRODUCED COURTESY OF THE ESTATE OF WILLIAM N. COPLEY
•

This small pamphlet for William Copley's first show of paintings includes a poem by Dorothea Tanning dated December 22, 1950, and titled *On the Paintings of BILL COPLEY.* It begins: "Astonished nudes waiting for murder, Naked as a clinic and staring like glass."

FIGURE 140
Max Ernst
Portrait of Gloria de Herrera at
Capricorn Hill with starched blue jeans
1950
© 2006 ARTISTS RIGHTS SOCIETY (ARS), NEW YORK /
ADAGP, PARIS
PHOTOGRAPH: RESEARCH LIBRARY, THE GETTY RESEARCH
INSTITUTE, LOS ANGELES (980024)
REPRODUCED COURTESY OF JAMES B. AND BARBARA BYRNES
•

Photographs in Gloria de Herrera's photo album, taken when she and William Copley visited Max Ernst and Dorothea Tanning at their home in Sedona, Arizona, show the friends playfully interacting with a pair of stiff blue jeans. The vacant pants and de Herrera's cropped body humorously imply the surrealist motif of bisection, while de Herrera's closed eyes also reference the surrealist preoccupation with the dream state.

Around the time of the meeting, Duchamp's studies for the *Étant donnés* were beginning to bear similarities to the posture of Elizabeth Short's slain body. It is conceivable that Man Ray not only set up the meeting between Copley and Duchamp, but also arranged for Copley to give Duchamp a package at that time — containing newspaper articles about the murder, or perhaps even crime-scene photographs. As the art historian Jonathan Wallis has suggested, Man Ray may also have provided Duchamp with images of the crime scene during a weeklong visit he made to New York in 1947.

"With his lifelong fascination with sado-masochism, Man Ray would certainly have taken an interest in the particulars of this crime," Wallis writes. "As a photographer of such repute," he continues, "Man Ray might have been able to obtain one of the many hundreds of crime-scene photographs taken by reporters that circulated through the Hollywood community."[6] If Man Ray wanted to get this material to Duchamp, a hand delivery by himself or a trusted friend would have been a more attractive proposition than sending it through the U.S. mail.

A comparison of Duchamp's December 1947 drawing of Maria Martins with subsequent studies — the collage in which the figure's left

FIGURE 141
Photographer unknown
Gloria de Herrera, Saint-Martin d'Ardèche,
France
ca. early 1950s
PHOTOGRAPH: RESEARCH LIBRARY, THE GETTY RESEARCH
INSTITUTE, LOS ANGELES (980024)
REPRODUCED COURTESY OF JAMES B. AND BARBARA BYRNES

·

Gloria de Herrera poses beneath a minotaur-like figure in this photograph, taken at Max Ernst's former home in Saint-Martin d'Ardèche, France. Ernst lived there until 1941, when he fled Nazi-occupied France and settled in the United States. The picture was taken in the early 1950s, after de Herrera relocated to France with William Copley, Man Ray, and Juliet Man Ray.

arm and leg are partially obscured by grass, and the final work, with its pale hue — show stylistic shifts that seem to support the theory that Duchamp gained access to Black Dahlia crime-scene photographs sometime in late 1947 or early 1948.

·

Copley remained in Los Angeles for a few more years before moving to France with his girlfriend Gloria de Herrera (figs. 140, 141) — his marriage to Ployardt's sister having begun to disintegrate — along with Man Ray and Juliet Man Ray. Man Ray had been saying for a few years that he wanted to return to France, and the postwar situation there had stabilized enough by the late 1940s that he was eager to go.

Man Ray felt that a kind of pall had fallen over Los Angeles. "The pace of what was to be my last two years in Hollywood became accelerated, as if a crisis was approaching," he wrote in *Self Portrait*. In part, Man Ray may have been referring to the shadow of McCarthyism, which, for a Jewish artist associated with known Communists, would have been ominous.[7] Man Ray wrote, "Households broke up and familiar faces disappeared, new faces came upon the scene in quick succession."[8]

One household that broke up during this time was that of George Hodel, who had sold his house and left the country and his family after the incest trial.

Copley, de Herrera, and the Man Rays traveled to New York and then continued on to Paris by boat, leaving on the S.S. *de Grasse* in March of 1951 (fig. 136). Before the ship departed from New York, Duchamp came on board and gave Man Ray a gift — *Feuille de vigne femelle* (Female Fig Leaf), figure 131, the small object that was an inverse impression of the genital area of his study for the figure in the *Étant donnés*. As a token of Duchamp's friendship with Man Ray, the gift of the *Female Fig Leaf* may simply reflect the artists' shared interest in things erotic. The two artists were especially close and had a history of referring to each other's artworks in their own. Man Ray, after all, was the only person ever to see Duchamp dressed as his female alter ego, Rrose Sélavy, in person. More recently, Man Ray had photographed the cover of Duchamp's *Le surréalisme en 1947* exhibition catalog, or a similar assemblage featuring a single breast.

Alternately, since Duchamp had publicly declared that he was no longer making art, his gift of the *Female Fig Leaf* may have been his way of bringing Man Ray in on the long-term *Étant donnés* — serving as an early souvenir of the work in progress that would be Duchamp's final masterpiece. (Man Ray's photograph "Dust Breeding" had signified his intimacy with Duchamp's other great work *The Large Glass,* which took Duchamp eight years to complete.) As William Copley observed, Duchamp's "claiming he was no longer painting allowed him to buy time. . . . This gave him all the freedom in the world."[9]

·

If Duchamp was already envisioning that the final *Étant donnés* would bear some resemblance to Elizabeth Short's body, his gift of the *Female Fig Leaf* would have had more charged symbolism, as Wallis has suggested.[10]

Perhaps it related to crime-scene photographs of the gash in Elizabeth Short's lower abdomen. Duchamp's sculpture would signal a shared knowledge between Man Ray and Duchamp that the murder was related to surrealism — and possibly that they both knew who the killer was. If both artists suspected that the crime was surrealist in nature, then *Female Fig Leaf* and the *Étant donnés* might also be viewed as corresponding works.

During the voyage to France, Man Ray began to write his autobiography, *Self Portrait*, as well as an essay on the function of the artist in society. "The artist is his own most severe judge," he wrote, reiterating a theme that appears in many of his writings. ". . . His mistakes cannot hurt any other member of society, and at the worst retard his own progress."

This defense of art as essentially harmless, as divorced from real-life consequences, is echoed in a humorous statement about art by Copley, relating to the critical response to surrealism. "The surrealists have a number one rule," Copley wrote. "Never submit a work to a juried show. This person is judging your drawing. Your drawing has committed no crime so why should it be judged."[11] He also acknowledged, "If people knew what was going on inside our heads, we'd all be put in jail."[12]

It is telling that Man Ray worked on both his essay about the function of the artist in society and his autobiography — in many ways a highly censored version of his life — immediately after leaving Los Angeles. The often witty *Self Portrait* contains only one reference to the Marquis de Sade and scant mention of Lee Miller, one of the great loves of Man Ray's life. Nor is there much mention of the violent undertones in many of his own works. Did events in Los Angeles move him to begin rewriting his own history at that moment — along with an essay on the innocence of art, his own included?

Copley, Man Ray, and Duchamp remained close personally and professionally after Copley and Man Ray moved to France. Man Ray was

FIGURE 142

Man Ray

Man Ray, William Copley, Noma Copley, and Juliet Man Ray in the rue Ferou studio

December 31, 1953

Inscribed and dated verso by Juliet Man Ray: "My friend Noma on the day she married Bill. She is Mrs. Copley—Man and I were matron of honor and best man— picture taken in our studio 2 bis, Rue Férou. Dec. 31—1953."

© 2006 MAN RAY TRUST / ADAGP (ARS) / TELIMAGE
REPRODUCED COURTESY OF THE ESTATE OF WILLIAM N. COPLEY AND NOLAN / ECKMAN GALLERY, NEW YORK

the best man at Copley's 1953 wedding to his second wife, Noma (fig. 142), and the two men attended a costume party together as Tweedledee and Tweedledum. Continuing to work as an artist in France, Copley, with Noma, also set up a philanthropic organization, later known as the Cassandra Foundation. Copley showed his admiration for Duchamp in particular through financial support over the years.

While Man Ray was receiving increasing recognition as an artist, he was working on *Self Portrait*, often writing in the company of friends. He worked on the book while visiting Duchamp in Cadaques in 1961, and later that year, when visiting Copley at his house near Paris. It was finally published in 1963.

In 1961, Gloria de Herrera wrote a poem she titled "The Myth of MAN RAY" (fig. 143). De Herrera had been friendly with Man Ray in Los Angeles; she had bought artworks from him, and he had also given her a few.

The Myth of MAN RAY

MAN RAY, the arrogant, the egocentric, the little
 man with a shoelace for a necktie who can
 utter no intelligible words but only spout venom.

MAN RAY, the strange creature with a black prism for
 a heart and dice floating in acid for a brain.

MAN RAY? 'Oh, yeah, wasn't he one of those crazy French
 artists who painted ants and made 'things' out
 of gears and clock guts?'

MAN RAY, who hates picasso, hates gertrude stein, hates
 james joyce; the MAN who plays chess with
 himself so he will never lose.

MAN RAY? I thought he died years ago.

FIGURE 143
Gloria de Herrera
"The Myth of MAN RAY"
1961
PHOTOGRAPH: RESEARCH LIBRARY, THE GETTY RESEARCH
INSTITUTE, LOS ANGELES (980024)
REPRODUCED COURTESY OF JAMES B. AND BARBARA BYRNES

De Herrera wrote this poem, calling Man
Ray "arrogant" and "egocentric," the
same year that her former lover William
Copley created his painting *Il est minuit
Dr. _____* (fig. 145).

In addition, according to some who knew de Herrera, she bore a physical
resemblance to Lee Miller. In Paris, de Herrera worked in art conservation
and later became an activist in the Algerian struggle for independence.
Some of de Herrera's art-world friends spurned her because of her polit-
ical involvement.[13]

The 1961 poem was a personal diatribe against Man Ray, whom she
called "the arrogant, the egocentric . . . who can utter no intelligible words
but only spout venom. MAN RAY, the strange creature with a black prism
for a heart and dice floating in acid for a brain." It may be that de Herrera

FIGURE 144

Ed van der Elsken

René Magritte, Marcel Duchamp,
Max Ernst, and Man Ray at the opening
of William Copley's exhibition at the
Stedelijk Museum, Amsterdam
1966

© ED VAN DER ELSKEN / NEDERLANDS FOTOMUSEUM,
ROTTERDAM
REPRODUCED COURTESY OF THE ESTATE OF WILLIAM N.
COPLEY AND NOLAN / ECKMAN GALLERY, NEW YORK

FIGURE 145

William Copley
Il est minuit Dr. _____
(It Is Midnight Dr. _____)
1961

Oil on canvas

PRIVATE COLLECTION
© 2006 THE ESTATE OF WILLIAM N. COPLEY
REPRODUCED COURTESY OF THE ESTATE OF WILLIAM N.
COPLEY AND NOLAN / ECKMAN GALLERY, NEW YORK
·

Copley was living in France and in frequent contact with Man Ray and Duchamp when he created this work. The painting shows a doctor surrounded by a scalpel, saws, and other tools. A reclining nude fills in the lower part of the canvas.

wanted to set the record straight on Man Ray's character—at least from her own point of view—while he was describing himself in more sanguine terms in *Self Portrait*.

That same year, as Man Ray was nearing completion of *Self Portrait*, Copley created a significant artwork. Like many of his other paintings, *Il est minuit Dr. _____* (It Is Midnight Dr. _____), 1961 (fig. 145), portrays a nude woman and a fully clothed man.[14] The male figure appears at the upper left, holding a medical bag. The woman reclines near the bottom of the canvas like an odalisque. It is a classical pose, reminiscent of Ariadne and so many other nudes in art history. She has closed eyes, a hint of a smile, and one hand resting on her forehead. Above her is an array of instruments, including a scalpel and two saws. It suggests that Copley, distanced from the crime scene by fourteen years and thousands of miles, had not forgotten it.

Marcel Duchamp and the *Étant donnés*, Part II

"Il vaut mieux être deux pour soulever délicatement le nu et le placer exactement *aux 3 points d'impact."* ("It's better *to have two people* in order to delicately raise the nude and place it *exactly* on the three points of impact.")

—Marcel Duchamp[1]

In 1962, Copley left Paris and, after a brief stay in Los Angeles, settled in New York, where Duchamp was also living. Copley continued to make art, creating paintings including *Death of the Unknown Whore* (1965) and *Tomb of the Unknown Whore* (1965), incorporating his by then signature imagery and themes.

In 1965, when Duchamp had nearly completed the *Étant donnés,* he had to move from his Fourteenth Street studio. He dismantled and reconstructed the entire *Étant donnés* in a smaller room on East Eleventh Street. The next year, Duchamp finished and signed the piece, dating it 1946–1966. In 1967 he crafted detailed instructions for its care.[2]

At some point before the summer of 1968, Duchamp invited Copley in to see the finished *Étant donnés.* Duchamp wanted Copley to buy the work and give it to the Philadelphia Museum of Art — which he did, purchasing it for about $60,000 through the Cassandra Foundation. There, it would join Duchamp's other works, including *The Large Glass,* in the Arensberg galleries.

Duchamp died that fall. Throughout his career, he had been more interested in intrigue than personal gain, and he ensured that a sense of mystery would pervade the *Étant donnés* for many years after his death.

According to Duchamp's instructions, the *Étant donnés* was dismantled in his studio by his stepson Paul Matisse and Philadelphia Museum staff and then taken to Philadelphia. Its presence there remained a secret until it was reinstalled and opened to the public on July 7, 1969.

The final work was not photographed for fifteen years, per instructions from Copley and Teeny Duchamp.[3] During that time, any written

description of the *Étant donnés* could only be accompanied by an image of the door.

Looking beyond the woman's body, one sees a serene landscape with a small waterfall near a lush array of trees beneath a light blue sky. Despite the slack posture of the figure, her left arm is upraised, holding a lamp. At once animate and limp, she presents an odd specter indeed. The *Étant donnés* was an intentionally posthumous artwork—mysterious and highly provocative. As Billy Copley notes, "I'm sure he was fascinated with the fact that this work was going to contradict his statements that he had stopped making art. But that's what he was about, contradictions and keeping everyone off balance. It was part of the game of life as he saw it. That was the poetry of it."[4]

The one thing that seems clear is that the *Étant donnés* carries clues to a larger story concerning Duchamp's life, his earlier works and those of his fellow artists—and, perhaps, a crime that was never solved.

FIGURE 146
Marcel Duchamp
Étant donnés: 1 la chute d'eau,
2 le gaz d'éclairage
(Given: 1. The Waterfall,
2. The Illuminating Gas)
[Exterior view]
1946–66
Mixed-media assemblage: wooden door, bricks, velvet, wood, leather stretched over an armature of metal, twigs, aluminum, iron, glass, Plexiglas, linoleum, cotton, electric lights, gas lamp (bec Auer type), motor, etc.
PHILADELPHIA MUSEUM OF ART
GIFT OF CASSANDRA FOUNDATION, 1969
ACCESSION: 1969-41-1
© 2005 ARTISTS RIGHTS SOCIETY (ARS), NEW YORK / ADAGP, PARIS / SUCCESSION MARCEL DUCHAMP

Afterword

One Sunday morning in May of 2003, my wife, Brigid, and I sat down at a café in Brooklyn to enjoy our morning coffee and our copy of the *New York Times*. Inside was David Thomson's review of Steve Hodel's recently published *Black Dahlia Avenger*. I read it with the sort of bemusement brought on by a dose of laughing gas at the dentist's office. You know the feeling, the airy light-headedness that directly precedes the drilling?

"Can this be possible?" I wondered, before reading it aloud to Brigid. She, too, was intrigued, and we discussed the review briefly before setting off for the day's activities. Neither of us could have known then how much our lives would be changed by those few moments that Sunday.

On the way home I bought the book, and, over the next two days, read it quickly—gripped by the narrative, yet only casually attending to the details. I remember breezing through entire chapters that I thought were overreaching. Still, I was astonished by the book generally, and even more amazed that I had never heard of Elizabeth Short or the Black Dahlia murder. As a designer for museums and galleries, I have spent most of my professional life engaged with art, so it was the relationship between George Hodel, the alleged killer, and Man Ray that intrigued me most. Fascinated, I did what many people now do after reading their first book on a new topic: I Googled it. I revisited the basic facts, studied the grainy, low-resolution crime-scene photographs online, and tried to make sense of the various competing theories about the murder.

Thinking my curiosity had been satisfied, I was about to shelve the book when I remembered a footnote in a publication I had recently designed for the Philadelphia Museum of Art. The note itself turned out to be slightly off-topic, but it did confirm for me what I was beginning to intuit: that there was more to the surrealism angle on the murder than Steve Hodel had realized, and that I had something to contribute. I began to revisit the many books on surrealism that I already owned, and spent all of my spare moments tracking down others.

In the earliest stages of my research, I concentrated on a basic idea—that the damage done to Elizabeth Short's body closely resembled artistic motifs in surrealist depictions of women. I grouped these motifs into general categories that I called, for lack of better words, "formal antecedents." These included the raised positioning of the arms; the fixation on, and representation of, the female reproductive organs; the geometric cutaways—commonly from the breasts and legs—and, most important, the lateral sectioning of the female torso. I prepared a dozen or so elaborate hand-made charts to cross-reference artists with these antecedents and soon established that the antecedents, even when stylistically specific to an individual artist, were part of a common artistic language, spoken and understood by like-minded colleagues through art.

Concurrently, I began working on the ideas that now form the web of connections and the chronology in the book, putting a special emphasis on Marcel Duchamp and his masterpiece *Étant donnés*, which I thought looked somewhat like the crime scene itself.

Early in July of 2003, a curator I know put me in touch with Jonathan Wallis—an art historian who had given an academic paper on the topic in 2001, two years before *Black Dahlia Avenger* was published. In that paper, Wallis had speculated on a relationship between the *Étant donnés* and the Black Dahlia.

Jonathan and I decided to join forces in December 2003 and soon began sharing research. Together we contacted Steve Hodel and invited him to Philadelphia, where we introduced him to the *Étant donnés* and where Steve, in turn, shared with us his remarkable family history and parts of his family archive.

By the time of Steve's visit in November 2004, I had been researching this material for more than a year and a half. I returned to a closer reading of *Black Dahlia Avenger*, then in its second (and much more convincing) edition. My initial curiosity and somewhat haphazard start had developed

into a more methodical practice of tracking facts and organizing the myriad subjects that now populate this book: the individual lives and works of Man Ray, Marcel Duchamp, Salvador Dalí, and the other surrealists; the life of George Hodel; and the rich history of the closely knit Los Angeles art scene, in which Hodel undoubtedly participated.

By January of 2005, I had collected enough relevant material—most significantly, a new understanding of the life and work of William Copley—to make a convincing case for a relationship between art and the crime. It was the discovery of Copley's painting *Il est minuit Dr. _____* that provided the strongest argument for continuing to explore the idea that Marcel Duchamp's *Étant donnés* was at least partially modeled on the murder of Elizabeth Short.

Still, I felt that I needed a coauthor, someone to bring fresh perspective and a singular voice to the narrative that was building in my head and on my computer. In New York I connected with Sarah Bayliss, a journalist and contributing editor at *ARTnews.*

At this point the project gained momentum. Together Sarah and I spent dozens of hours researching original documents in museum libraries: exhibition invitations from the 1940s, artists' correspondence, poems, yellowed magazine articles. We sifted through hundreds of artifacts and were delighted when particularly relevant pieces rose to the surface.

Among the countless questions that Sarah and I wrestled with was what to make of the information and materials we received from Steve Hodel. His family history is one of the most remarkable that either of us has ever encountered. Even the most gifted fiction writer could not begin to describe the variations of human dysfunction so creatively. The Hodel family story includes cross-generational incest, concealed interracial adoption, public scandal, and suspicious deaths. Its historical nexus occurred at a time of unbridled American optimism, in a city that, through its major cultural export—the movies—literally photographed

itself maturing. It is a family history populated by some of the major celebrities of the twentieth century, and it is inextricably linked to one of the most riveting crimes in American history. In this book we have only skimmed the surface.

The richness of the Hodel material, especially the photographs and documents linking George Hodel to Man Ray, undoubtedly imbue this book with an implicit relationship to *Black Dahlia Avenger.* However, we have made every effort to view Steve's assertions objectively, challenging him when necessary. Neither Sarah nor I believe, for instance, that the unidentified women pictured in his father's photo album are Elizabeth Short. Steve Hodel's attribution to his father of the murders of many other women, with little presented evidence, is provocative but highly questionable, in our view. This is not, however, to downplay the generosity and invaluable contributions of information and material that we have received from Steve Hodel. Without him, no book.

Together, Sarah and I struggled with the open display of gruesome crime-scene and autopsy photographs. However, we concluded that it was the only accurate way to make our major points. This book contains the *least* graphic of the photographs that have come into our possession.

It has been said that there is no perfect crime — that all crime leaves a trace. If that is true, then perhaps this book is a small testament to the power of art as a keeper of record. As much as art pleases or challenges, is beautiful or is not, perhaps simply its existence defines its most important task: to leave a hint of its maker; of the time, or place, or reason for which it was made.

— *Mark Nelson, New York City, 2006*

Acknowledgments

The subject matter of this book called for strong stomachs, steady nerves, and considerable patience from those who surrounded and supported us. We would like to express our gratitude to the following individuals for the time, effort, and attention that they brought to the process.

At Bulfinch Press, we thank Jill Cohen for her early interest and enthusiasm, Michael Sand for his unfailing editorial insight at every step, and Pamela Marshall for her attentive copyediting. We also tip our hats to Pamela Schechter, who expertly facilitated the production of this book.

We thank Steve, Tamar, and Fauna Hodel for generously sharing their personal memories, photographs, and documents with us.

For their perceptive contributions and feedback along the way, we thank Jane Avrich, Maureen Bray, Doug Clouse, Billy Copley, Marijane Moosoolian, Francis Naumann, Robert Pincus-Witten, Ezra Shales, Michael R. Taylor, and Josh White Jr. We are grateful to Jonathan Wallis, whose initial research was invaluable to this book.

The following people and organizations were generous in allowing us access to their resources and in answering our many queries: Jennifer Belt and Humberto DeLuigi, Art Resource, New York; Amy Berman, the Art Institute of Chicago; Pierre-Yves Butzbach, Telimage, Paris; James B. and Barbara Byrnes; Joanna Cook, the Menil Collection, Houston; the Estate of William N. Copley; Francine Della Catena, the Los Angeles Times, the Estate of Marcel Duchamp; Regina Feiler, Life, Inc.; Holly Frisbee, the Philadelphia Museum of Art; Laurence Goux and Sylvie Gonzalez, Musée d'art et d'histoire, Saint-Denis; Laurence Homolka, the Estate of Florence Homolka; Caroline Jennings and David Savage, the Bridgeman Art Library, New York; Eric Le Roy, Les films de l'équinoxe-fonds photographique Denise Bellon; the Los Angeles Public Library; Magnus Mamros, Moderna Museet, Stockholm; Ron Mandelbaum, Photofest, NY; the research librarians at the Museum of Modern Art Library, New York; David Nolan and Martin Bland, the Nolan/Eckman Gallery; Yaelle Pazzy, Getty Images; Carolien Provaas, Nederlands Fotomuseum, Rotterdam; Marcia L. Schiff, Associated Press; Julio Sims and Rani Singh, the Getty Research Institute for the History of Art and the Humanities, Los Angeles; Laura Straus and Janet Hicks, the Artist Rights Society; the Delmar Watson Photography Archive, Los Angeles; the Beatrice Wood Center for the Arts, Ojai.

We are indebted to the following people for their support and understanding: Tom Burris, Nicole Cadoret, William Eggleston III, Anthony McCall, Roberta McCreary, Jason Ring, Mike Tower, and the infinitely patient David Zaza.

For their encouragement and love, we thank our families, especially our spouses, Brigid and Michael.

Appendix I
Los Angeles 1935–1950: A Web of Connections
(SEE ENDPAPERS)

LOUISE AND WALTER ARENSBERG
From 1914 until their deaths in 1953 and 1954, respectively, Louise and Walter Arensberg amassed one of the most important private collections of modern and pre-Columbian art in the United States. Their New York salons during the 1910s, attended by writers and artists including William Carlos Williams, Wallace Stevens, Man Ray, and Marcel Duchamp, made a lasting contribution to American modernism. They moved to Los Angeles in 1921, and their collection (ultimately including some forty works by Duchamp) expanded rapidly while their home became the epicenter of the cultural elite. Given that George and Dorothy Hodel can be connected directly or indirectly to many associates of the Arensbergs' (Man Ray, Henry Miller, Edward G. Robinson, Kenneth Rexroth, and Galka Scheyer), that the two families lived less than three miles apart, and that the Arensberg home was open to anyone who wanted to see the collection, it seems likely that the Hodels and the Arensbergs were at least casually acquainted.

FANNY BRICE
A legendary comedian, singer, and entertainer, Brice became famous for headlining at the Ziegfeld Follies during the 1920s. For much of her life Brice lived in Los Angeles, where she was an ardent collector and patron of the arts. She joined Edward G. Robinson, Vincent Price, and others to initiate the Modern Institute of Art in 1948.

ROWLAND BROWN
Brown, who cowrote a film script with Ben Hecht in the 1930s, was Dorothy Hodel's lover in the 1940s.

WILLIAM COPLEY • GLORIA DE HERRERA
The wealthy adopted son of a newspaper publisher and former congressman, Copley moved to Los Angeles in 1946 after four years of military service. With his brother-in-law, John Ployardt, a Walt Disney artist, Copley opened an art gallery dedicated exclusively to surrealism and became friendly with many in the arts community. The gallery was a commercial failure, but during its short run Copley managed to show the work of Joseph Cornell, Max Ernst, Man Ray, René Magritte, Roberto Matta, and Yves Tanguy. Along the way he established an extensive personal collection of surrealist artworks. He introduced himself to Man Ray in 1946 or 1947 and to Marcel Duchamp in 1948, and his personal history became entwined with theirs. He supported them financially and they, in turn, encouraged his artistic endeavors. Copley and his girlfriend Gloria de Herrera relocated from Los Angeles to Paris with Man Ray and Juliet Man Ray in 1951.

SALVADOR DALÍ

Salvador Dalí was the most commercially successful and well known of the surrealist painters. An international celebrity, Dalí lived in California with his wife, Gala, in the 1940s, during which time he famously created the dream sequence for Alfred Hitchcock's *Spellbound* (1945). His contact with fellow artists Max Ernst, Marcel Duchamp, and Man Ray was limited during his Los Angeles years, but he did correspond with Man Ray during the 1940s. Dalí knew the writer Henry Miller, with whom he had spent the summer at the Virginia home of the poet and publisher Caresse Crosby in 1941.

MARCEL DUCHAMP

One of the most influential artists of the twentieth century, Marcel Duchamp, like Pablo Picasso, was an artist whose public appeal was equal to his great critical acclaim. He rocketed to fame in 1913 when his *Nude Descending a Staircase* was shown at the Armory Show in New York City. In the decades that followed, his created or numerous "found" pieces counted among the century's most influential works of art. Duchamp's visits to Los Angeles — in 1936, 1949, 1950, and 1963 — are well documented. The main purpose of the trips in 1949 and 1950 was to assist his patron Walter Arensberg in securing a museum home for his massive art collection, but Duchamp found time to socialize as well during his visits. He spent a good deal of time with his close friend Man Ray and his then-new acquaintance William Copley. Duchamp was well acquainted with Albert Lewin, Beatrice Wood, and others, and he also socialized with the architect Lloyd Wright.

MAX ERNST • DOROTHEA TANNING

The married surrealist artists Max Ernst and Dorothea Tanning lived in Sedona, Arizona, during the latter part of the 1940s and visited Los Angeles a number of times. Their friends in the Los Angeles art community included Walter Arensberg, Earl Stendahl, William Copley, and Albert Lewin, who featured Ernst's 1945 painting *The Temptation of Saint Anthony* in his 1947 film *The Private Affairs of Bel Ami.* Ernst was close to fellow artists Man Ray and Marcel Duchamp.

CHARLES HENRI FORD

A novelist, poet, and filmmaker, Charles Henri Ford cowrote *The Young and the Evil* (1932), an early gay novel, with the writer and film critic Parker Tyler. They later collaborated on publishing and editing *View,* an American magazine that covered avant-garde culture and surrealist art and ran from 1940 through 1947. Ford was acquainted with Marcel Duchamp, Max Ernst, Man Ray, Henry Miller, and John Huston, whose works all appeared or were reviewed in the pages of *View.* Ford's sister, the actress

Ruth Ford, posed for Man Ray photographs and appeared in John Huston's October 1946 stage production of Jean-Paul Sartre's *No Exit.*

PAULETTE GODDARD
Goddard, who starred in dozens of feature films, was an avid collector and patron of pre-Columbian and modern art. She was close to John Huston and Evelyn Keyes, to whom Huston was married in the 1940s.

BEN HECHT • WILL FOWLER • ERNST KRENEK • GLADYS NORDENSTROM
A prolific author of screenplays and novels, Hecht had indirect ties to the Black Dahlia murder and to George Hodel. He was friends with Gene Fowler and his son, Will Fowler, who was among the first reporters at the Black Dahlia crime scene. Hecht helped the composer Ernst Krenek find work in Hollywood. Krenek married the composer Gladys Nordenstrom, a roomer at Hodel's Franklin Avenue house. George Hodel reviewed Hecht's nightmarish novel *The Kingdom of Evil: A Continuation of the Journal of Fantazius Mallare* in *Fantasia,* a short-lived literary magazine he copublished as a young man. Hecht also wrote an article for the *Los Angeles Herald Express* on February 1, 1947, in which he claimed to know, but did not reveal, who killed Elizabeth Short.

DOROTHY HARVEY HODEL
Dorothy Jeanne Harvey married John Huston on October 17, 1926, and they divorced in 1933. She married George Hodel on December 7, 1940. Though the Hodels divorced in 1944, they reconciled on several occasions and sometimes lived together, remaining in close contact until 1950, when George Hodel left Los Angeles for Hawaii. According to Steve Hodel, Dorothy's friends included the actor Sam Jaffe, Kenneth Rexroth, the film director Dudley Murphy and his wife, Virginia, the composers George and Ira Gershwin, the actor Johnny Weissmuller, and Henry Miller, whom the Hodels visited at his home at Big Sur. She had four sons by George Hodel: Michael, twins Steven and John (the latter died shortly after birth), and Kelvin.

GEORGE HODEL
A successful physician living in Los Angeles, George Hodel was a prime suspect in the murder of Elizabeth Short.

FLORENCE HOMOLKA
A friend and protégé of Man Ray's, Florence Homolka photographed many of the intellectuals, European expatriates, and Hollywood luminaries who populated Los Angeles in the 1940s. *Focus on Art,* her 1963 book of photographs, gives a sense of that tightly knit community and includes portraits of Edward G. Robinson, Man Ray, Juliet

Man Ray, Max Ernst, Dorothea Tanning, John Huston, and Walter Huston (who competed against Homolka's husband, Oscar Homolka, for an Academy Award in 1948).

JOHN HUSTON · MIGUEL COVARRUBIAS · DIEGO RIVERA

The director, screenwriter, and actor John Huston (*Treasure of the Sierra Madre, The Maltese Falcon*) was a teenage friend of George Hodel's and Fred Sexton's. He married Dorothy Jeanne Harvey in 1926 and divorced her in 1933. Despite their separation, they remained close, and, after Dorothy married George Hodel in 1940, Huston often visited the Hodels.

Huston was well acquainted with Fanny Brice, Paulette Goddard, Edward G. Robinson (whom he directed in the 1948 film *Key Largo*), Galka Scheyer, and Earl Stendahl. During the filming of *The Treasure of the Sierra Madre* in 1948, his friends the Mexican artists Diego Rivera and Miguel Covarrubias intervened with the government of Mexico to ensure that filming could continue unhindered. Rivera and Covarrubias—both well known to the Los Angeles art community—traded artworks through Huston's close friend Billy Pearson.

LILLIAN LENORAK · JOHN FARROW

A letter from police officer Mary Unkefer to the Los Angeles district attorney dated January 30, 1950, indicates that George Hodel drugged and injured Lillian Lenorak at his home after Lenorak informed him that she planned to tell investigators that she had perjured herself at his trial for incest. After Unkefer escorted Lenorak from Hodel's residence, Lenorak was admitted for psychiatric observation at the Camarillo State Hospital. According to a February 20, 1951, report by Lieutenant Frank Jemison of the Los Angeles District Attorney's Office, Lenorak had identified Elizabeth Short as a girlfriend of George Hodel's.

The film director John Farrow, Mia Farrow's father, was also the father of a child with Lenorak. Transcripts of the district attorney's audio surveillance recordings indicate that John Farrow offered Dorothy Hodel a job in 1950. At the time, Farrow was directing *His Kind of Woman*, starring Vincent Price. Price was mentioned in passing by Dorothy Hodel in the D.A.'s transcript of audio surveillance at the Hodel house.

Farrow's 1948 film *Night Has a Thousand Eyes* starred Edward G. Robinson.

ALBERT LEWIN · MARION HERWOOD KEYES

Albert Lewin was the director of numerous films, including *The Moon and Sixpence* (1942), *The Private Affairs of Bel Ami* (1947), and the surrealist-inspired *Pandora and the Flying Dutchman* (1948). Lewin and his wife, Mildred, were friends and patrons of Man Ray and Juliet Man Ray. They were acquainted with Marcel Duchamp, Max Ernst, Dorothea Tanning, Earl Stendahl, Walter Arensberg, and many of Hollywood's elite.

Marion Herwood Keyes, the associate costume designer for Lewin's *The Picture of*

Dorian Gray (1945), was a former secretary for George Hodel at his L.A. County Health Department office, which suggests that the two men may have known each other.

MAN RAY AND JULIET MAN RAY
An iconoclastic artist best remembered for his innovations in photography, Man Ray relocated to Los Angeles in the 1940s after fleeing Nazi-occupied France. Though never completely comfortable in Los Angeles, he called it home for more than a decade, finally leaving with his wife, Juliet; William Copley; and Gloria de Herrera in 1951. Man Ray was close to Albert Lewin and Max Ernst and was a lifelong friend of and collaborator with Marcel Duchamp. He was friends with George Hodel, who seems to have been influenced by Man Ray's artwork and photography.

HENRY MILLER
First published in France, Miller's *Tropic of Capricorn* (1934) and *Tropic of Cancer* (1939) were declared obscene by the U.S. government. Miller's books were frequently smuggled into the country in the 1940s, cementing his status as an underground literary icon. His works were not published in the United States until 1961. Miller lived in Big Sur, California, and was friends with Man Ray, Vincent Price, and Kenneth Rexroth. According to Joe Barrett, a roomer at the Franklin Avenue house, Miller was a guest at the Hodel home. Steve Hodel maintains that Dorothy Hodel was close to Miller and loved visiting him in Big Sur.

DUDLEY MURPHY
A film director in the 1920s and 1930s, Dudley Murphy collaborated with Man Ray and the artist Fernand Léger in 1924 to make the avant-garde film *Ballet méchanique*. From the late 1940s through the 1960s, Murphy and his wife, Virginia, owned Holiday House, a popular getaway for Hollywood's elite. The Murphys were lifelong friends of Dorothy Hodel's, which suggests that the Hodels' relationship with Man Ray may predate Man Ray's Hollywood years.

BILLY PEARSON
Pearson was a close friend of John Huston's, and the two were competitive art collectors. Already celebrated as a jockey, Pearson went on to greater fame on early television game shows, winning both *The $64,000 Question* and *The $64,000 Challenge*, largely due to his knowledge of art. Pearson was a dedicated collector of pre-Columbian works, many of which he smuggled (by his own admission) out of Mexico. He counted Walter Arensberg, Vincent Price, Earl Stendahl, and the Mexican artists Miguel Covarrubias and Diego Rivera among his many friends. Given his close relationship with John Huston, it is likely that he knew George Hodel. When

Hodel was forced to liquidate his possessions in 1950 to pay the legal fees for his incest trial, Pearson purchased most of his art collection, according to Franklin Avenue roomer Joe Barrett.

FRANK PERLS

One of the early dealers in modernism, Perls gave Man Ray his first exhibition in Los Angeles in 1941. He was friends with Vincent Price and close to many others in the Los Angeles art community.

VINCENT PRICE

In addition to being famous as an actor, Price was an enthusiastic art collector, a gallerist, and, later, one of the nation's most visible advocates for the arts. He owned and operated the Little Gallery in Los Angeles with his friend George Macready from 1943 to 1944, an endeavor that opened doors for Price in the art and collecting circles. His many friends included Walter Arensberg, Fanny Brice, Henry Miller, Billy Pearson, Frank Perls, Edward G. Robinson, Earl Stendahl, and Jake Zeitlin. He also knew Man Ray. In 1948, in an attempt to keep the Arensberg collection in California, he founded the Modern Institute of Art with assistance from Robinson, Brice, and others. Located in Beverly Hills, the short-lived museum featured works by Marcel Duchamp and Man Ray in its first two exhibitions.

KENNETH REXROTH

Rexroth, the influential Beat poet, was also a close friend of Dorothy Hodel's. Transcripts of the Los Angeles district attorney's recordings from the Hodel household reveal "Kenny" and George sharing laughs about oral sex and discussing "whores." Rexroth was friendly with Henry Miller and Man Ray. He had an early affinity for modernism, and his acquaintances included Walter Arensberg, William Carlos Williams, the painter John Ferren, and Ben Hecht.

HANS RICHTER • JOSH WHITE • JOSEPHINE PREMICE

During 1945 and 1946, the expatriate artist and filmmaker Hans Richter was working on *Dreams That Money Can Buy,* a film that featured contributions from Marcel Duchamp, Max Ernst, Fernand Léger, Alexander Calder, Man Ray, and himself. Léger's sequence featured the music of Josh White, a popular folk and blues musician who had discovered a crossover audience in the 1940s and was one of the few black figures of the time to appear on Broadway and in Hollywood films. White performed onstage with the Haitian dancer Josephine Premice, who was one of George Hodel's lovers. According to George Hodel's daughter Tamar, White was her father's favorite singer. Tamar met Josh White in 1951 and became his lover in 1955, remaining so until his death in 1969.

EDWARD G. ROBINSON

Venerable actor of stage and screen, Edward G. Robinson amassed a considerable art collection during the 1930s and 1940s. He was one of Hollywood's earliest patrons of modern art, and he assisted Vincent Price in founding the short-lived Modern Institute of Art. He was also friendly with George Hodel, according to Steve and Tamar Hodel. Robinson admired the paintings of Fred Sexton (a longtime friend of George Hodel's) and purchased three of them, according to a *Los Angeles Times* column of May 12, 1940, by Arthur Millier. Robinson was in attendance at Man Ray's 1948 exhibition at the Copley Galleries.

GALKA SCHEYER

Most famously remembered as the brash agent of the "Blue Four" (Alexei Jawlensky, Lyonel Feininger, Paul Klee, and Wassily Kandinsky), Galka Scheyer was a major force in introducing European modernism to Los Angeles in the 1930s and 1940s. She occasionally acted as an intermediary for Walter Arensberg when he wished to purchase works from Marcel Duchamp. A dispute over prices ruptured their relationship in 1936, but it was mended by the time of her death, in 1945. Arensberg helped ensure that her collection was preserved intact at the Pasadena Art Institute (now the Norton Simon Museum, Pasadena). During lean years, Scheyer stayed afloat financially by developing an art education class for children. A misspelled entry in George and Dorothy Hodel's calendar notes: "Gelka Scheyer for children's pictures." Scheyer was also friends with Edward G. Robinson.

FRED SEXTON

A teenage friend of George Hodel's and John Huston's, Sexton was an accomplished artist in his day. He was given his debut exhibition by Earl Stendahl in 1935, and he designed the statuette of the Maltese falcon for Huston's 1947 film of the same name. An article in the *Los Angeles Times* of September 5, 1948, noted that Sexton was the first California artist asked to join the roster of Associated American Artists Galleries and that his work was in the collections of Edward G. Robinson, Paulette Goddard, Ruth Maitland, Alfred Wallenstein, and Mrs. John J. Pike. Fred Sexton was accused along with two other adults of participating in sex acts the night that George Hodel was alleged to have had intercourse with his daughter Tamar.

ELIZABETH SHORT (THE BLACK DAHLIA)

An aspiring actress, Elizabeth Short was murdered at the age of twenty-two. Her body was found on January 15, 1947, sparking one of the largest murder investigations in U.S. history. The case remains officially open and unsolved.

EARL STENDAHL

One of the first art dealers to meet financial success as a dealer in pre-Columbian and modern art in Los Angeles, Stendahl was especially close to Walter Arensberg. After buying the lot next door to the Arensbergs from them in 1940, he commissioned Lloyd Wright to redesign his home there, and he moved his gallery to the same address (7055 Hillside Avenue) in 1946.

Earlier, in October of 1935, Stendahl's gallery debuted the work of Fred Sexton. Stendahl was connected to many Hollywood luminaries, including the actor-collectors Paulette Goddard, Edward G. Robinson, and Fanny Brice, all of whom helped Stendahl bring Picasso's *Guernica* to the Stendahl Art Galleries in 1939. Stendahl sold paintings to William Copley and John Huston and was also close to Billy Pearson — later coaching him for his 1956 appearance on *The $64,000 Question*.

AMILDA KIYOKO TACHIBANA

"Kiyo" was George Hodel's mistress in the early 1940s, and she later married his son Steve. She had a small part in John Farrow's film *Where Danger Lives* (1950) and is listed in the credits for that film under her then-married name, Amilda Cuddy.

BEATRICE WOOD

A highly regarded artist and ceramicist, Wood was a close friend of Walter and Louise Arensberg's, Marcel Duchamp's, Galka Scheyer's, and Lloyd Wright's (who drew up the original plans for her home and studio in Ojai, California). Wood was an integral part of the burgeoning California modernist art scene during the mid-1940s. She worked for a time at Jake Zeitlin's bookstore.

LLOYD WRIGHT

Often confused with his father, Frank Lloyd Wright, Lloyd Wright was himself a masterful architect. His spectacular houses for wealthy California clients included the Samuels-Navarro House, the Lawrence Tibbett House, and the Sowden House, which George Hodel owned from 1945 to 1950. It is not known whether Hodel and Wright knew each other, but it is certainly possible. Wright was close to Walter Arensberg, Earl Stendahl, Beatrice Wood, and Jake Zeitlin.

JAKE ZEITLIN

Jake Zeitlin was an intellectual, gallerist, poet, publisher, and seller of rare books. His bookstores were important gathering places for artists, painters, designers, and architects. Closest in his broad circle were Walter Arensberg, the photographer Will Connell, the architect Lloyd Wright, and Merle Armitage, a book designer and successful theater impresario.

Appendix II
Timeline

1887
Marcel Duchamp is born in Normandy, France, on July 28.

1890
Emmanuel Radnitsky is born to Russian Jewish immigrants in Philadelphia on August 27. He changes his name to **Man Ray** when he turns twenty-one.

1894
Albert Lewin is born to Russian Jewish immigrants in Brooklyn on September 23.

1900
Sigmund Freud's *The Interpretation of Dreams* is published in German.

1907
George Hodel is born in Los Angeles on October 10 to parents of Ukrainian descent.

1913
The first English translation of *The Interpretation of Dreams* is published.

1915
On June 15, **Marcel Duchamp** arrives in New York from Paris on the S.S. *Rochambeau*. His main patron, **Walter Arensberg,** introduces him to Man Ray. **Duchamp** begins work on *The Bride Stripped Bare by Her Bachelors, Even* (1915–23), also known as *The Large Glass*. For the next eight years, he will travel between New York, Europe, and Buenos Aires.

1920
Man Ray creates "Coat Stand."

1921
Walter and Louise Arensberg move from New York to Los Angeles.

1922
Ben Hecht publishes *Fantazius Mallare: A Mysterious Oath,* a hallucinatory novel about an artist's descent into madness.

1923
In February, **Marcel Duchamp** sails for Europe on the S.S. *Noordham*. Except for three visits to the United States, he remains in Europe until 1942. He devotes increasing amounts of time to chess and is believed to be no longer making art.

1923
Man Ray creates the first version of *Object to Be Destroyed,* a working metronome with the image of a human eye fixed to the stem.

1924
Elizabeth Short born in Boston, Massachusetts, on July 29.

1924
André Breton publishes the "Manifesto of Surrealism."

1924
In December, the first issue of the publication *La révolution surréaliste* is released, featuring **Man Ray**'s photograph "Waking Dream Séance."

1924
Ben Hecht publishes *The Kingdom of Evil: A Continuation of the Journal of Fantazius Mallare.*

1924
George Hodel creates two self-portraits and inscribes on the back of the photographs "Portrait of a Chap Suddenly Aware of the Words of Sigmund Freud" and "Merlin Gazes at Cracked Mirrors." Hodel also works as a crime reporter for the *Los Angeles Record.*

1925
Believed to be the date of the first Exquisite Corpse drawing, made by **Jacques Prévert, Yves Tanguy,** and **Marcel Duhamel.**

1925
George Hodel edits the journal *Fantasia* with G. Bishop Pulsifer and reviews *The Kingdom of Evil.*

1926
Marcel Duchamp begins making speculative art purchases and sales for the Arensbergs.

1927
In October, issue 9–10 of *La révolution surréaliste* features the first published illustration of an Exquisite Corpse artwork.

1929
Salvador Dalí and **Luis Buñuel** release the surrealist film *Un chien andalou.*

1929
André Breton publishes the "Second Manifesto of Surrealism" in the twelfth issue of *La révolution surréaliste.*

1932
In September, the magazine *This Quarter* features Man Ray's drawing of a metronome and instructions to smash it with a hammer.

1933
In June, the first issue of *Minotaure* magazine, published in Geneva by **Albert Skira,** is released, featuring a cover by **Pablo Picasso.** Thirteen issues will be published over six years.

1933
The surrealists publish a tribute to **Violette Nozières,** a woman awaiting trial for killing her sexually abusive father. With a cover by **Man Ray,** it features illustrations by **Salvador Dalí, René Magritte, Max Ernst,** and others, and poems by writers including **Paul Éluard** and **André Breton.**

1933
Hans Bellmer begins creating artistic renderings of mangled, bound, and anatomically jumbled dolls.

1934
André Breton, Nusch Éluard, Paul Éluard, and **Valentine Hugo** create an Exquisite Corpse drawing of a woman with raised arms and geometric shapes in her body.

1935
Minotaure 7 features a reproduction of **Man Ray'**s photograph "Minotaur" in the opening pages.

1936
Man Ray makes sketches of the Marquis de Sade, followed by oil paintings in 1938 and 1940.

1936
Marcel Duchamp visits the **Arensbergs** in Los Angeles for three weeks in August.

1938
In January, the exhibition *"Exposition Internationale de Surréalisme"* opens in Paris, featuring, among other works, mannequins that have been manipulated by **Man Ray, André Masson, Marcel Duchamp, Salvador Dalí,** and others.

1939
The last edition of *Minotaure* is published in May.

1939
From August 10 to 21, **Pablo Picasso'**s monumental painting *Guernica* is on view at the Stendahl Art Galleries, run by **Earl Stendahl.** Proceeds are slated toward a fund for Spanish orphans.

FIGURE 147
Glen Kearns
Elizabeth Short on the steps
of Marshall High School,
Los Angeles, California
October 22, 1946

1940
On August 6, **Man Ray** leaves for the United States, sailing on the *Excambion* along with **Salvador Dalí.** Upon arrival in Hoboken, New Jersey, on August 16, Dalí is greeted with fanfare. Among the few things Man Ray brings to the States is a print of **Pablo Picasso**'s *Minotauromachy.*

1940
Shortly after arriving in Los Angeles in October, **Man Ray** meets his future wife, **Juliet Browner.** That year, he also meets **Albert Lewin** at a dinner party at the **Arensbergs'.**

1940
George Hodel marries **Dorothy Harvey Huston** on December 7.

1941
Max Ernst leaves Europe for the United States.

1941
Salvador Dalí's stage-set design for a production of the ballet *Labyrinth,* performed by the Ballet Russe, is reviewed in the October 20 issue of *Time* magazine and elsewhere.

1941
Steve and **John Dion Hodel** are born on November 6. John Dion dies three weeks later.

1942
On June 25, **Marcel Duchamp** arrives in New York on the *Serpa Pinto.* He lives in the United States until shortly before his death.

1942
In October, **André Breton** stages "First Papers of Surrealism," an exhibition of works by surrealist émigrés in the United States, in New York. **Marcel Duchamp** supervises the exhibition design, and proceeds go toward war relief.

1943
Marcel Duchamp moves to a studio at 210 West Fourteenth Street, where he will stay for over twenty years.

1943
On September 23, nineteen-year-old **Elizabeth Short** is arrested for being present as a minor in an establishment where liquor is served. She takes refuge in the home of Santa Barbara police officer **Mary Unkefer** for nine days.

1944
From September 19 to October 29, a retrospective of **Man Ray**'s work is shown at the Pasadena Art Institute.

1944
Hans Richter starts work on his film *Dreams That Money Can Buy,* with sequences by **Marcel Duchamp, Man Ray, Max Ernst, Fernand Léger, Alexander Calder,** and himself.

1944
Man Ray creates a double portrait of **Juliet Browner** and **Dorothy Hodel.** He also completes the sculpture *Objet de mon affection —* *"L'oculiste,"* also known as *The Oculist.*

1944
George and **Dorothy Hodel** divorce.

1945
George Hodel purchases the Sowden House on Franklin Avenue in Los Angeles, designed by Lloyd Wright (the son of Frank Lloyd Wright) and modeled after a Mayan temple.

1945
Just after midnight on May 10, **George Hodel**'s personal secretary **Ruth Spaulding** dies of a suspicious overdose of barbiturates.

1945
Alfred Hitchcock releases the film *Spellbound,* featuring the tagline "The Maddest Love That Ever Possessed a Woman." The film includes a script by **Ben Hecht** and a dream sequence based on imagery by **Salvador Dalí.**

ca. 1945
Man Ray photographs **Juliet Browner** on the sofa at their home, supine, with her arms raised above her head.

1946
From approximately February to September, **George Hodel** serves as Public Health Administrator in China. He returns to the United States because of an unspecified health problem.

1946
In late summer, **Marcel Duchamp** photographs a waterfall at Chexbres, Switzerland, a version of which appears in the final version of the *Étant donnés.*

1946
From September 3 to 30, **Man Ray**'s exhibition "Objects of My Affection," including his sculpture *The Oculist,* is on view at the Circle Gallery in Los Angeles.

ca. 1946
Man Ray photographs **George Hodel** with a sculpture of a Yamantaka — similar to a Yamantaka diety prominently featured in *Minotaure* 11.

1946
On October 25, **Man Ray** marries **Juliet Browner** in a double ceremony with **Max Ernst** and **Dorothea Tanning.** The couples are feted by the **Stendahls,** the **Lewins,** and the **Arensbergs.**

1946
Man Ray gives **George and Dorothy Hodel** his inscribed photographic "Self-Portrait," created that year.

1946
Earl Stendahl's Stendahl Art Galleries move next door to the **Arensbergs'** home on Hillside Avenue.

1946
William Copley arrives in Los Angeles.

1946
In its December 2 issue, *Life* magazine publishes a feature on **Hans Richter**'s film *Dreams That Money Can Buy.*

1947
On January 15, **Elizabeth Short** is found murdered in an undeveloped lot on Norton Avenue in Los Angeles.

1947
On January 22, **Marcel Duchamp** returns home to New York on the S. S. *Washington* after an extended European trip.

1947
During July and August, the Exposition Internationale du Surréalisme is on view in Paris. **Marcel Duchamp** and **Enrico Donati** create a cover design for the catalog *"Le Surréalisme en 1947,"* with a sculptural female breast and the words *"Prière de toucher"* (Please Touch).

1947

In September, the House Un-American Activities Committee (HUAC) subpoenas forty-one witnesses to testify in its hearings to expose American Communists.

1947

In December, **Marcel Duchamp** completes a drawing of his lover, **Maria Martins.** It is the first known study for what will become the figure in his last major work, the *Étant donnés.*

ca. 1947–49

Marcel Duchamp completes additional studies for the nude figure in the *Étant donnés.*

1947

Dreams That Money Can Buy is released.

1948

Early in the year, **Marcel Duchamp** meets with **William Copley** and **John Ployardt** in the lobby of the Biltmore Hotel in New York.

1948

Vincent Price, Fanny Brice, Edward G. Robinson, and others found the Modern Institute of Art in Beverly Hills. It closes in less than two years.

1948

Man Ray gives *The Oculist* to **George Hodel.**

1948

On September 9, **William Copley** and **John Ployardt** open the Copley Galleries in Beverly Hills with an exhibition of works by **René Magritte.** After mounting additional shows by **Joseph Cornell, Roberto Matta, Yves Tanguy, Man Ray,** and **Max Ernst,** the gallery closes in early 1949.

1948–49

From December 13, 1948, to January 9, 1949, **Man Ray**'s solo exhibition "To Be Continued Unnoticed" is on view at the Copley Galleries.

1949

From April 12 to 25, **Marcel Duchamp** visits the **Arensbergs** in Los Angeles. During this time, Man Ray is no longer welcome in the Arensberg home.

1949

On October 6, **George Hodel** is arrested for engaging in sexual acts with his daughter **Tamar Hodel.**

1949

The October 6 issue of the *Los Angeles Daily News* prints an article about **George Hodel**'s arrest in which he states, "Everything is a dream to me. . . . If this is true and I am really here, then these other things must have happened."

1949

An October 28 report by lieutenant **Frank Jemison** identifies **George Hodel** as one of six main suspects in the death of **Elizabeth Short.**

1949

On December 8, **George Hodel** goes on trial for improper relations with his daughter.

1949

On December 24, **George Hodel** is acquitted of all charges.

1950

A January 30 report by Santa Barbara police officer **Mary Unkefer** states that she escorted a drugged and injured **Lillian Lenorak** from the home of **George Hodel.**

1950

From February 18 to March 27, **George Hodel**'s home is put under electronic surveillance by the Los Angeles District Attorney's Office.

1950

George Hodel sells his house and moves to Hawaii, where he studies psychiatry at the Hawaii State Hospital.

1950

From April 19 to 25, **Marcel Duchamp** pays his last visit to the Arensbergs.

1950
In December, **Marcel Duchamp** and the trustees of the Arensbergs' Francis Bacon Foundation successfully negotiate the bequest of the Arensbergs' collection to the Philadelphia Museum of Art.

1951
A February 20 report by lieutenant **Frank Jemison** states that **Lillian Lenorak** identified **Elizabeth Short,** in a photograph, as one of **George Hodel**'s girlfriends.

1951
On March 12, **Man Ray, Juliet Man Ray, William Copley,** and **Gloria de Herrera** sail from New York for France on the S. S. *de Grasse.* Before the ship departs, **Marcel Duchamp** gives **Man Ray** his sculpture *Feuille de vigne femelle* (Female Fig Leaf).

1951
Albert Lewin's surrealist-inspired film *Pandora and the Flying Dutchman* is released, with imagery modeled after **Man Ray**'s artworks as well as **Man Ray**'s photographic portrait of **Ava Gardner.**

1951
Modern art is declared to be Communist propaganda by the Los Angeles city council, which prohibits its public display.

1953
Louise Arensberg dies on November 25.

1954
Walter Arensberg dies on January 29.

1954
On October 16, The **Louise and Walter Arensberg** Collection opens permanently at the Philadelphia Museum of Art, including their collection of pieces by **Marcel Duchamp.** *The Large Glass,* bequeathed by Duchamp patron **Katherine Dreier,** is also installed.

1961
William Copley completes his painting *It Is Midnight Dr. ———.*

1963
Man Ray's memoir, *Self Portrait,* is published.

1966
Marcel Duchamp completes the *Étant donnés.*

1967
Marcel Duchamp compiles a notebook of instructions for assembling and dismantling the *Étant donnés.*

1968
Before the summer, **Marcel Duchamp** asks **William Copley** to view the *Étant donnés* in his studio on East Eleventh Street.

1968
Marcel Duchamp dies in Neuilly-sur-Seine, France, on October 2.

1969
The *Étant donnés* is gifted to the Philadelphia Museum by **William and Noma Copley**'s Cassandra Foundation, which purchased it for about $60,000. It is installed with the Arensberg collection and unveiled to the public on July 7. Photography of the tableau is prohibited for fifteen years.

1976
Man Ray dies in Paris on November 18.

1984
The Philadelphia Museum of Art permits photography of the *Étant donnés.*

1996
William Copley dies in Florida on May 7.

1999
George Hodel dies in San Francisco on May 17.

FIGURE 148

**Affidavit signed by Dorothy Hodel
November 9, 1944**

Among the papers related to the Hodel's divorce proceedings is this newly discovered document dated November 9, 1944, in which Dorothy Hodel lists George Hodel's occupation as "physician and surgeon." Five years later, on March 22, 1950, under direct questioning from Lieutenant Frank B. Jemison about her husband's possible involvement in the Black Dahlia murder, Hodel either lies or cleverly avoids Jemison's question regarding her husband's surgical skill:

FJ: You know that Dr. Hodel has had practice with surgical tools?

DH: I know he has never practiced surgery. His branch of medicine is V.D. generally and Administrative Medicine.

Notes

Introduction: A Death and Its Aftermath
Pages 9–27

1. Hodel was the head venereal disease officer for the Los Angeles County Health Department. He operated both a public health office and two other clinics for the treatment of private citizens.
2. John Gilmore, *Severed: The True Story of the Black Dahlia Murder* (Los Angeles: Zanja Press, 1994), p. 10.
3. See Steve Hodel, *Black Dahlia Avenger: A Genius for Murder* (New York: Arcade, 2003; Harper Perennial, 2004), p. 522.
4. Cervantes' novel had also been influential for Freud and for the Pre-Raphaelite painters admired by the surrealists, including John Everett Millais. Salvador Dalí later portrayed Quixote in several artworks.
5. In the 1940s, Hagemeyer photographed some of the personalities who populate this book, including Salvador Dalí, Henry Miller, and Vincent Price. He also photographed the poet Robinson Jeffers several times during the 1930s. George Hodel named his daughter Tamar after Jeffers's poem of the same name.
6. At the time *Black Dahlia Avenger* was published, this woman had only been identified as "Ruth," by someone who remembered her from the time. After the book's publication, a reader who had known "Ruth" when the two of them were in Hodel's employ called Steve Hodel and identified the woman as Ruth Spaulding. Records show that Ruth Spaulding died in Los Angeles on May 10, 1945, at 12:45 a.m. Steve Lopez's article on this topic, "Another Dance with L.A.'s Black Dahlia Case," appeared in his "Points West" column of the *Los Angeles Times* on April 13, 2003.
7. Typed report to the Black Dahlia grand jury by Lieutenant Frank Jemison, October 1949.
8. A letter from police officer Mary Unkefer to the Los Angeles district attorney dated January 30, 1950, indicates that George Hodel drugged and injured Lillian Lenorak after she informed him that she was going to tell investigators that she had perjured herself at his trial for incest. Lenorak informed Unkefer that she was afraid of George Hodel and that she had witnessed an abortion performed on his daughter Tamar. After the drugging incident, Lenorak was admitted for psychiatric observation at the Camarillo State Hospital. According to the final report by Lieutenant Frank Jemison, filed February 20, 1951, Lenorak identified Elizabeth Short as a girlfriend of George Hodel's.

 Seven years earlier, Officer Unkefer had also had close contact with Elizabeth Short. Following Short's 1943 arrest for underage drinking, she had stayed at Unkefer's home for nine days.
9. Huston later played the father of the Marquis de Sade in the 1969 film *De Sade*, directed by Cy Endfield.
10. Hodel, p. 93.

Surrealism: Damaged Muses and Mischievous Mannequins
Pages 31–45

1. Max Ernst, "Some Data on the Youth of M. E. as Told by Himself," in Max Ernst et al., *Max Ernst: Beyond Painting and Other Writings by the Artist and His Friends* (New York: Wittenborn, Schultz, Inc., 1948), p. 29.
2. For biographical information pertaining to surrealists and many of their war experiences, see Jeannene M. Przyblyski, "Biographies," in Sidra Stich et al., *Anxious Visions: Surrealist Art* (Berkeley and New York: The Regents of the University of California, Berkeley, and Abbeville Press, 1990), pp. 233–53.
3. "Swift is a Surrealist in malice, Sade is a Surrealist in Sadism. . . . Poe is a Surrealist in adventure. Baudelaire is a Surrealist in morality." Quoted in André Breton, *Manifestoes of Surrealism*, trans. Richard Seaver and Helen R. Lane (Ann Arbor: University of Michigan Press, Ann Arbor Paperbacks, 1969, 1972, 2004), pp. 26–27.
4. In Ernst's *Celebes*, the horned object left of center at once evokes a gas mask, a woman's body, and a bull's head, with the animal's eyes doubling as female breasts. The bull also likely alludes to the minotaur myth, with which the surrealists were enamored.

5. Cited in Hal Foster, *Compulsive Beauty* (Cambridge, Mass., and London: MIT Press, 1993, 1995), pp. 135 and 269, n. 28. *Compulsive Beauty* offers an in-depth investigation of surrealism as it relates to Freud's theories of the uncanny and the death drive.

6. Alyce Mahon, *Surrealism and the Politics of Eros, 1938–1968* (London and New York: Thames & Hudson, 2005), p. 47.

7. For a history of Dalí's pavilion, see Ingrid Schaffner, with photographs by Eric Schaal, *Salvador Dalí's Dream of Venus: The Surrealist Funhouse from the 1939 World's Fair* (New York: Princeton Architectural Press, 2002). Also see Lewis Kachur, *Displaying the Marvelous: Marcel Duchamp, Salvador Dalí, and Surrealist Exhibition Installations* (Cambridge, Mass., and London: MIT Press, 2001), pp. 113–52, 159–60, and 211–12.

8. Mary Ann Caws, ed., *Surrealism: Themes and Movements* (London and New York: Phaidon Press, 2004), p. 29.

9. Ibid.

10. Foster, *Convulsive Beauty,* p. 177.

11. Hal Foster, "Violation and Veiling in Surrealist Photography: Woman as Fetish, as Shattered Object, as Phallus," in *Surrealism: Desire Unbound,* ed. Jennifer Mundy (London: Tate Publishing, 2001), p. 207.

12. Dorothea Tanning, *Between Lives: An Artist and Her World* (New York and London: W. W. Norton & Co., 2001), p. 80.

13. See Dawn Ades, "Surrealism, Male-Female," in *Surrealism: Desire Unbound,* ed. Mundy, p. 171. Ades cites scholars Xavière Gauthier, Mary Ann Caws, Rudolf Kuenzli, and Gwen Raaberg in this group.

14. This same image is identified as "*Sans titre — Maquette de décor (Personnages coupés en trois parties)*" (Untitled — Model for decor [Persons Cut into Three Parts]) in Robert Descharnes and Gilles Néret, *Salvador Dalí: L'oeuvre peint 1904–1989* (Cologne: Benedikt Taschen Verlag GmbH, 1993), p. 348. A photograph from a 1948 Monte Carlo reprisal of the ballet *Colloque sentimentale,* which premiered in New York in 1944, shows two towering sculptural

versions of this trisected figure flanking the stage (p. 373).

Man Ray: A Subversive Vision
Pages 47–63

1. William Copley, *CPLY: Portrait of the Artist as a Young Dealer* (Paris: Centre National d'Art et de Culture Georges Pompidou, 1977), reprinted in the exhibition catalog *CPLY: Reflections on a Past Life* (Houston: Institute for the Arts, Rice University, 1979), p. 30.

2. *The Fountain* was rejected by the 1917 Independents exhibition in New York. After the original was lost, Duchamp created several later versions.

3. Quoted from Arturo Schwarz, *Man Ray: The Rigour of Imagination* (New York: Rizzoli International Publications, Inc., 1977), pp. 188–89.

4. Emmanuelle de L'Ecotais and Alain Sayag, eds., *Man Ray: Photography and Its Double* (Corte Madera, Calif.: Gingko Press, 1998), p. 11.

5. For additional surrealist artworks depicting variations on the lateral sectioning of the torso, see, for example, Victor Brauner, *L'Éclair questionne* (1930) and *Mitsi* (1939); Roland Penrose, *Octavia* (1939); Toyen, *Hermaphrodite with Shell* (1930–31); Oscar Dominguez, *Arrival of the Belle Époque* (1936); Salvador Dalí, *Paranoïa* (1936); and René Magritte, *La ruse symétrique* (1928).

6. See Neil Baldwin, *Man Ray: American Artist* (New York: Clarkson N. Potter, Inc., 1988), p. 172. Baldwin writes: "Together, Lee Miller and Man Ray had fought constantly. In her absence, she inspired him to his great midlife work" (p. 175). The writer and curator Ingrid Schaffner maintains that *Observatory Time — The Lovers* refers to both Kiki and Miller: "Inspired by a memory of Kiki's lipstick on his collar, Man Ray devoted two years to making a highly precise blow-up of a photograph of Lee's lips floating in the sky, over the observatory near the studio where they lived together" (*The Essential Man Ray* [New York: The Wonderland Press, 2003], p. 94).

7. Cited in Caws, p. 114.

8. Perls was one of the first art dealers to assist Man Ray in Hollywood. Perls was a close friend

of Vincent Price's, who also tried his hand as a dealer when he ran the Little Gallery in Beverly Hills from 1943 to 1944 and later became one of the nation's most visible advocates for the arts.

9. Letter from Man Ray to Elsie Ray Siegler, written sometime between May 31, 1944, and August 12, 1944.

10. From *In Time*, undated, handwritten notes by Man Ray, archived at the Getty Research Institute, Los Angeles.

11. The work that Man Ray gave the Hodels is reproduced in the Butterfield & Dunning / Butterfield & Butterfield auction catalog *Fine Photographs: May 27, 1999, in San Francisco, Los Angeles, and Chicago,* cover, pp. 5 and 22, (lot #3047), and in the Butterfield & Dunning / Butterfield & Butterfield auction catalog *Fine Photographs: November 17, 1999, in San Francisco, Los Angeles, and Chicago*, pp. 25 and 115 (lot #4061).

12. Roger Shattuck, "Candor and Perversion in No-Man's Land," in Merry A. Foresta, et al., *Perpetual Motif: The Art of Man Ray* (New York and Washington: Abbeville Press and the National Museum of American Art, Smithsonian Institution, 1988), p. 332.

13. The original photograph is dated "Nov '44," verso, in an unidentified hand. See the auction catalog *Sotheby's Photographs: New York, Wednesday, April 28, 1999*, p. 131 (lot #232). A variation on this photograph, in which Juliet Browner stands, her right arm akimbo, her left hand on Dorothy Hodel's back, is reproduced in Butterfield & Dunning / Butterfield & Butterfield, *Fine Photographs: November 17, 1999, in San Francisco, Los Angeles, and Chicago,* p. 22 (lot #4056).

14. A quality reproduction of *The Oculist* can be seen in the Butterfield & Butterfield auction catalog *Modern, Contemporary, and Latin American Art, October 26 & 27, 1999, in San Francisco, Los Angeles, Chicago,* p. 10. The catalog notes that Juliet Man Ray confirmed the work's authenticity in 1980. The description of the object, lot #1014, reads, "Fragments of lead and a rubber sink stopper (replacement) on a curved piece of wood mounted on board."

15. E-mail exchange with Robert Pincus-Witten, November 2, 2005.

16. In *Black Dahlia Avenger,* Steve Hodel observes that Man Ray and Juliet left Los Angeles to visit Paris during the summer of 1947, while the police were investigating the Black Dahlia murder, and left permanently in 1950, when the district attorney's office was investigating George Hodel. Man Ray's correspondence, archived at the Getty Research Institute in Los Angeles, reveals that the 1947 trip was planned before the murder of Elizabeth Short. Man Ray's letters also indicate that he wanted to move back to Paris for some time before he and Juliet did so in 1951.

17. This postcard is reproduced in *Fine Photographs: November 17, 1999, in San Francisco, Los Angeles, and Chicago,* a Butterfield & Dunning / Butterfield & Butterfield auction catalog, p. 22 (lot #4056).

Minotaur and *Minotaure*
Pages 65–79

1. Quotation from the catalog of the Musée d'Antibes (Musée Picasso), Antibes, France; also in Romuald Dor de la Souchère, *Picasso in Antibes* (London: Lund Humphries, 1960).

2. See Martin Ries, "Picasso and the Myth of the Minotaur," *Art Journal* (winter 1973–74); and http://www.martinries.com/article1972-73 PP.htm

3. A hand gesture symbolizing horns, made by extending the index and pinkie fingers from a closed fist, is also used in Mediterranean countries to signal that a man's wife has been unfaithful. See Nancy Armstrong and Melissa Wagner, *Field Guide to Gestures: How to Identify and Interpret Virtually Every Gesture Known to Man* (Philadelphia: Quirk Books, 2003), pp. 160–63. This signal has also been associated with the minotaur myth and its narrative of Pasiphaë's infidelity.

4. Man Ray also attended bullfights during the time he lived in Paris, and two films he made of bullfights date from 1929 and 1937. He owned one of Picasso's minotaur etchings, and when he left Paris for the United States in 1940, this work, *Minotauromachy,* was one of the very few belongings he took with him.

5. As Ries notes, André Masson was originally picked to create the inaugural cover of *Minotaure*, but Skira and the magazine's art director, E. Tériade, asked Picasso to do it instead.

6. For a detailed illustrated study of *Minotaure*, see *Focus on* Minotaure: *The Animal-Headed Review* (Geneva: Musée d'Art et d'Histoire and Editions d'Art Albert Skira S.A., 1987).

7. Irene E. Hofmann, "Documents of Dada and Surrealism: Dada and Surrealist Journals in the Mary Reynolds Collection" (Chicago: The Art Institute of Chicago, 2001); see *http://www.artic.edu/reynolds/essays/ hofmann.php*, p. 20.

8. Masson and the surrealist writer George Bataille initially suggested to Skira that his publications be called *Minotaure* and *Labyrinthe*, as Ries notes.

9. Ingrid Schaffner, "Alchemy of the Gallery," in *Julien Levy: Portrait of an Art Gallery*, ed. Ingrid Schaffner and Lisa Jacobs (Cambridge, Mass.: MIT Press, 1998), p. 42.

10. Dawn Ades and Michael R. Taylor, curators, with the assistance of Montse Aguer, *Dalí* (New York: Rizzoli International Publications, Inc., in association with the Philadelphia Museum of Art, 2004), p. 499.

11. The *Minotaure* photograph was cropped to conceal the wheel's handle, whose position carried phallic connotations in Man Ray's original photograph, possibly to pass muster with the censors.

12. From Jean-Hubert Martin, *Meret Oppenheim* (1984), p. 17; quoted in Baldwin, p. 201, and endnote, p. 401.

13. Sculptures of the Yamantaka often depict the creature's engorged sex organs while he is engaged with his chosen mate. In Man Ray's photograph, Hodel's fingers are laid against her open legs.

14. In *Black Dahlia Avenger*, Steve Hodel writes that in the photograph, "Man Ray and my father juxtapose their own representations of omnipotence, sexuality, and dominance over death itself" (p. 254).

15. Salvador Dalí, "*Les nouvelles couleurs du 'sex-appeal spectral,'*" *Minotaure* 5 (1934): p. 20. Also quoted by Dawn Ades in *Dalí*, p. 202. Ades observes that very different disassembled bodies appeared in *Minotaure* 6: Bellmer's manipulated, preadolescent dolls, reproduced for the first time in the photographic series *Poupée: Variations sur le montage d'une mineure articulée*.

16. See Matthew E. Baigell, "Jewish Artists in New York During the Holocaust Years" (lecture presented in the Monna and Otto Weinmann lecture series at the United States Holocaust Memorial Museum Center for Advanced Holocaust Studies, May 2001, and accessible on its web site: *http://www.ushmm.org/research/center/publications/occasional/2001-03/paper.pdf*).

17. The *Time* article of October 20, 1941, described Dalí's designs as "brightly colored" and "more or less relevant," and noted that the opening-night audience consisted of many "rich, well-furred, well-elbowed European refugees who are increasingly noticeable in Manhattan smart-spots." Dalí's work appeared again in *Time* on November 6, 1944, when the magazine published his image of a woman with a melting face, representing a syphilis victim. The rendering was one of twenty-four "health posters" on display at New York's Wildenstein Galleries to aid postwar relief in Europe. This may have interested George Hodel, given his work as a venereal disease clinician.

18. Charles Henri Ford, ed., View: *Parade of the Avant-Garde 1940–1947* (New York: Thunder's Mouth Press, 1991), pp. xv–xvi.

19. A benchmark of Existentialism, Albert Camus' first novel, *L'étranger (The Stranger)*, revolutionized modern moral and philosophical thought. After needlessly killing a man, the book's unrepentant protagonist, Mersault, undergoes an epiphany in which he opens himself to "the benign indifference of the Universe." It was first published in France in 1942, and an English translation followed in 1946 and was excerpted in *View*, series 6, no. 2, in March of that same year. The book, advancing Camus' belief that human actions are "absurd," can easily be misinterpreted as an exculpation of murder.

20. Man Ray's essay "Ruth, Roses, and Revolvers," with photographs of Henri Ford's sister, the actress Ruth Ford, appeared in the December

1944 issue of *View*. It was later adapted for film in Hans Richter's 1947 movie *Dreams That Money Can Buy*.

21. Huston's stage production of Sartre's *No Exit* starred the actress Ruth Ford.

22. The 1945 Duchamp issue included Breton's essay "The Lighthouse of the Bride," the first detailed analysis of the elements in *The Large Glass*, including the oculist witnesses. This essay first appeared in French in *Minotaure* issue 6 (1935).

Dreams of Love and Death
Pages 81–95

1. Hecht was also an uncredited writer for *The Mad Doctor* (1941), a movie about a deranged physician who marries rich women and then kills them.

2. It stands to reason that artistic interpretations of Freud's theories originated in France. In poetry, French writers including Arthur Rimbaud, Paul Verlaine, and Charles Baudelaire had explored the themes of love and death. Death and sex are in bed together in the French expression *"la petite morte,"* which translates literally as "the little death" and refers to orgasm.

3. Perpetrators of sex crimes have described how a sense of entrancement — a dream state — dominated the experience of assault. "I don't think it was actually the person I was after, I think it was the dream," Dennis Rader, known as the BTK killer, said in a 2005 confession. "I know that's not really nice to say about a person, but they were basically an object. They were just an object." See *courttv Crime Library*: (http://www.crimelibrary.com).

4. In addition, transcripts of Los Angeles district attorney recordings reveal Hodel discussing "photography of a surrealistic nature" at 2:10 p.m. on March 5, 1950 (Los Angeles District Attorney's Office, "Hodel File," transcript, p. 95).

5. Doug Fetherling, *The Five Lives of Ben Hecht* (Toronto: Lester & Orpen Ltd., 1977), pp. 53–54.

6. Krenek was the composer of *"Jonny Spielt Auf"* (Johnny Strikes Up the Band) in 1926.

7. See the Pascal Covici papers, archived at the Harry Ransom Center at the University of Texas, Austin (http://www.hrc.utexas.edu/research/fa/covici.html).

8. Donald Wolfe used the same newspaper article to suggest that Hecht was referring to Maurice Clement, whom Wolfe implicates in the murder. See Donald Wolfe, *The Black Dahlia Files: The Mob, the Mogul, and the Murder That Transfixed Los Angeles* (New York: ReganBooks, 2005), pp. 162–64.

9. In *Spellbound*, the title of a book that the real Edwardes has written is *Labyrinth of the Guilt Complex*, referring to Freudian appropriation of the minotaur myth.

10. A cow's eye was used in *Un chien andalou*. See Susan Felleman, *Botticelli in Hollywood: The Films of Albert Lewin* (New York: Twayne Publishers, 1997), p. 57.

11. Tarin also testified that she "might have been hypnotized on the night during which Dr. Hodel allegedly committed immoral acts involving his 14-year-old daughter," according to the same December 20, 1949, article in the *Los Angeles Times*.

12. Hodel's friend John Huston was also versed in hypnosis. As the filmmaker describes in *An Open Book: An Autobiography by John Huston* (New York: Alfred A. Knopf, 1980), he mastered hypnosis while making the 1946 documentary film *Let There Be Light*, about the treatment of soldiers suffering from psychological trauma during World War II. Huston later made the film *Freud: The Secret Passion* (1962), for which the philosopher Jean-Paul Sartre had written the first script. Huston tried to hypnotize Sartre during their story sessions. See pp. 122–26 and 294–305.

13. Caws, p. 76.

14. Giorgio de Chirico's *The Child's Brain* (1914) is also tied to the surrealists' preoccupation with dreams. The painting portrays a mustachioed man with his eyes closed, standing at a window. The story goes that André Breton was so taken with it when he saw it in a gallery window around 1916 that he jumped off a moving bus to take a closer look. He later bought the painting and hung it over his bed for many years. While the image is generally associated

with childlike dreaming, scholars have also interpreted it in terms of Oedipal conflict. Whatever the case, *The Child's Brain* foretold many later surrealist portrayals of dream states. See Caws, p. 8, and Mundy, p. 57.

15. Interview with Tamar Hodel, August 16, 2005.

16. In its final form, Man Ray's segment shows a film audience imitating en masse the gestures of a character on screen. Originally, the segment included a book with the title *Sade*. The book title was changed to *Ruth, Roses, and Revolvers* in order to get past censors. See Dickran Tashjian, "'A Clock That Forgets to Run Down': Man Ray in Hollywood 1940–1951," in *Man Ray: Paris–LA* (Santa Monica: Smart Art Press, Track 16 Gallery, and Robert Berman Gallery, 1996), p. 98.

The Exquisite Corpse: A Literal Reenactment?
Pages 96–101

1. See Breton, *Manifestoes of Surrealism*, pp. 35–36.

2. Continuing to compare the effect of surrealism with that of drugs in the "Manifesto of Surrealism," Breton wrote, "[Surrealism] also is, if you like, an artificial paradise. . . . Thus the analysis of the mysterious effects and special pleasures it can produce — in many respects Surrealism occurs as a *new vice* which does not necessarily seem to be restricted to the happy few; like hashish, it has the ability to satisfy all manner of tastes." (*Manifestoes of Surrealism*, p. 36)

3. It is believed that the first Exquisite Corpse drawing was created by Prévert, the painter Yves Tanguy, and the writer Marcel Duhamel in 1925 (see Ades, Taylor, and Aguer, p. 184). The first published Exquisite Corpse artwork appeared in issue 9–10 of *La révolution surréaliste* in October of 1927 (see Hofmann, p. 18).

4. See "Exquisite Corpses" by Simone Kahn (1975), reprinted in Caws, p. 200.

5. Alastair Brotchie, comp., and Mel Gooding, ed., *A Book of Surrealist Games* (Boston and London: Shambhala Redstone Editions, 1995), pp. 55 and 90.

6. *Anxious Visions* by Stich et al., p. 49.

7. As Stich writes, surrealist artworks "which displace human features with extraneous

elements, are akin to the exquisite corpse (*cadavre exquis*) images that were created collectively during Surrealist café meetings or soirées" (pp. 46–48).

8. See Ades, Taylor, and Aguer, p. 184.

9. See Schaffner, *Salvador Dalí's Dream of Venus*, p. 132.

10. In photographs, the wound appears triangular. However, Frederick D. Newbarr, the chief autopsy surgeon for Los Angeles County, described it as "an elliptical opening in the skin," according to the transcript of the inquest held for the body of Elizabeth Short at the Los Angeles Hall of Justice on January 22, 1947.

11. The author Donald Wolfe, for instance, cites the variations in the styles of incisions — from the surgical bisection to the more ragged wounds on the face and body — to support his theory that the murder was a collaboration (pp. 32–33). Steve Hodel also raises the possibility that his father may have acted with an accomplice.

After the Murder
Pages 105–106

1. Naomi Sawelson-Gorse, "Hollywood Conversations: Duchamp and the Arensbergs," in *West Coast Duchamp*, ed. Bonnie Clearwater (Miami Beach and Santa Monica: Grassfield Press, Inc., in association with Shoshana Wayne Gallery, 1991), p. 27.

The L.A. Art Scene
Pages 107–119

1. Beatrice Wood, *I Shock Myself: The Autobiography of Beatrice Wood*, ed. Lindsay Smith, (San Francisco: Chronicle Books, 1988, also © 1985, Beatrice Wood), p. 88.

2. Sawelson-Gorse, p. 26.

3. See Victoria Price, *Vincent Price: A Daughter's Biography* (New York: St. Martin's Griffin, 1999), p. 175.

4. Billy Pearson and Stephen Longstreet, *Never Look Back: The Autobiography of a Jockey* (New York: Simon & Schuster, 1958), p. 287.

5. Ibid., p. 273.

6. Paul Karlstrom interview with Vincent Price (Washington, D.C.: Smithsonian Archives of American Art, Oral History Interviews, 1992),

tape 3, side A. See http://www.aaa.si.edu/collections/oralhistories/transcripts/price92.htm.

7. The eighty-two individual sponsors of the *Guernica* show at the Stendahl Art Galleries also included Paulette Goddard, George Balanchine, Dorothy Parker, Nathaniel West, Richard Neutra, and California governor Culbert L. Olson. A reproduction of the invitation, listing all the sponsors, can be seen in Herschel B. Chipp, *Picasso's Guernica: History, Transformations, Meanings* (Berkeley, Los Angeles, and London: University of California Press, 1988), p. 164.

8. Sawelson-Gorse, p. 33.

9. Ibid., pp. 25 and 26.

10. Andrée Rexroth beat Marcel Duchamp in a chess match that most likely took place at the Arensbergs' home. See Linda Hamalian, *A Life of Kenneth Rexroth* (New York and London: W. W. Norton & Co., 1991), p. 388, n. 8. Hamalian writes that the match occurred at the home of "Walter H. Annenberg" between 1931 and 1933, but it is more likely that it happened at the Arensbergs' Los Angeles residence during Duchamp's 1936 visit. Andrée Rexroth's painting *Dorothy* can be seen in the Butterfield & Butterfield / Butterfield & Dunning auction catalog *American and California Paintings and Sculpture, June 17, 1999, in San Francisco, Los Angeles, and Chicago,* p. 95 (lot #1310). Andrée Rexroth died in 1940, but the Hodels maintained a relationship with Kenneth throughout that decade. In *Black Dahlia Avenger,* Steve Hodel asserts that the "Kenneth Rexerall" referred to on the February 19, 1950, entry of the district attorney audio transcripts is Kenneth Rexroth. Hamalian states that Rexroth was indeed visiting Los Angeles in February of 1950 (p. 213).

11. Calvin Tomkins, *Duchamp: A Biography* (New York: Henry Holt & Co., 1996, and Owl Books, 1998), p. 144.

12. "Marcel, as host, took the least space and squeezed himself tight against the wall, while I tried to stretch out in the two inches left between him and the wall, an opportunity of divine discomfort that took me to heaven because I was so close to him." The artist Mina Loy, the painter Charles Demuth, and Arlene Dresser were also on the bed. See Wood, p. 33.

13. Sawelson-Gorse, pp. 27 and 30.

14. Arensberg was named class poet over Wallace Stevens. See Tomkins, p. 144.

15. Correspondence from Henry Miller to Kenneth Rexroth, March 18, 1945, quoted in Hamalian, p. 134.

16. Victoria Price, p. 173.

17. Sawelson-Gorse, p. 35.

18. Felleman, pp. 86, 89.

19. Ibid., pp. 112–13.

20. See Baldwin, pp. 266–69, and Sawelson-Gorse, p. 35.

21. District attorney investigator Lieutenant Frank Jemison's typed report to the Black Dahlia grand jury in October of 1949, after Hodel's arrest on morals charges, identified George Hodel along with five other suspects. Jemison recommended that the investigation of these individuals, singled out from the original pool of 319, be continued. Officials may have been tracking Hodel's movements as early as 1947, however, as Tamar maintains that her father told her that year that the police were watching the house. Thus, Hodel may well have been a suspect in April of 1949, when the Arensbergs were not on speaking terms with Man Ray.

22. Sexton's debut exhibition at the Stendahl Art Galleries was in November of 1935, according to the article "Local Art Year in Review," *Los Angeles Times,* December 29, 1935, p. C10. The Stendahls moved next door to the Arensbergs in 1946.

23. "The Art Thrill of the Week," *Los Angeles Times,* May 12, 1940, p. C8.

Marcel Duchamp and the *Étant donnés,* Part I
Pages 121–131

1. Francis M. Naumann and Hector Obalk Ludion, eds., and Jill Taylor, trans., *Affectionately, Marcel: The Selected Correspondence of Marcel Duchamp* (Ghent and Amsterdam: Ludion Press, 2000), p. 262.

2. Francis Naumann, "Marcel & Maria — Artist Marcel Duchamp's Relationships with Women," *Art in America,* April 2001, p. 105.

3. Tomkins, p. 366.

4. Naumann, p. 106.

5. Tomkins, p. 366.

6. Ibid.

7. Naumann, p. 110.

8. The Menil Foundation, Inc., *Joseph Cornell / Marcel Duchamp . . . in Resonance* (Houston and Ostfildern-Ruit, Germany: Cantz Verlag, 1998), p. 292.

9. Tomkins, p. 382.

10. Menil Foundation, p. 293.

11. Naumann, pp. 107–8.

12. Menil Foundation, p. 294.

13. Lanier Graham, *Duchamp and Androgyny: Art, Gender, and Metaphysics* (Berkeley: No-Thing Press, 2002), p. 55. As others have done, the art historian Juan Antonio Ramírez focuses on the viewer's role in the *Étant donnés,* essentially one of a voyeur. "His participation in the work . . . implies witnessing a crime of passion, or rather, devoting himself to the workings of love." *(Duchamp: Love and Death, Even,* trans. Alexander R. Tulloch [London: Reaktion Books, 1998], p. 248).

14. Tomkins, p. 5. As Tomkins notes, the gas lamp that the figure in the *Étant donnés* holds in her raised left hand may correspond to the "love gasoline" that Duchamp wrote about in relation to *The Large Glass,* secreted from her sexual organs.

15. Thomas Girst, "'A very normal guy': An interview with Robert Barnes on Marcel Duchamp and the *Étant Donnés,*" *tout-fait: The Marcel Duchamp Studies Online Journal* 4 (2002):2. Barnes maintains that the *Étant donnés* was not a secret. He affirms, "Lots of people knew about it." He also states that Duchamp completed the *Étant donnés* in the 1950s, not in 1966.

16. Interviews with Billy Copley, January 3 and February 6, 2006.

17. The Beat generation artist Bruce Conner referred to Elizabeth Short's murder in his 1959 sculptural assemblage *The Black Dahlia.* It is interesting to note that this piece was purchased by Walter Hopps, who spent his teenage years learning about art at the Arensbergs' house and who later organized Duchamp's first major retrospective, in 1963, at the Pasadena Art Museum. For a quality reproduction of Conner's *The Black Dahlia,* see Lisa Phillips, *Beat Culture and the New America, 1950–1965,* p. 55.

18. The photograph of the Chexbres waterfall is the only part of the assemblage that predates the murder of Elizabeth Short.

19. Marcel Duchamp in conversation with Pierre Cabanne, 1966, reproduced in *Marcel Duchamp,* ed. the Museum Jean Tinguely, Basel (Ostfildern-Ruit, Germany: Hatje Cantz Publishers, 2002), p. 134.

20. Naumann and Ludion, notes on pp. 262–63.

21. An image of Man Ray's photograph is reproduced in Anne d'Harnoncourt and Kynaston McShine, eds., *Marcel Duchamp* (Munich and New York: Prestel-Verlag, in cooperation with the Museum of Modern Art, New York, and the Philadelphia Museum of Art, 1989), p. 306, fig. 164.

22. That photograph can be seen in Gilmore.

23. Tomkins, p. 387.

24. Baldwin, p. 276.

William Copley: Surrealist Confidant
Pages 133–145

1. Alan Jones, "A Conversation with William Copley," in *CPLY* (New York: David Nolan Gallery, 1991), p. 5.

2. "Remembering Man Ray: An Interview with James & Barbara Byrnes," in Tashjian, p. 120.

3. See *CPLY,* pp. 6 and 7.

4. *William Copley* (St. Louis: Forum for Contemporary Art, 1997), exhibition catalog, p. 3.

5. See *CPLY,* p. 12.

6. Two years before the publication of *Black Dahlia Avenger,* Wallis explored possible links between Duchamp's *Étant donnés* and Elizabeth Short's murder in his paper "Case Open and/or Unsolved: Marcel Duchamp's *Étant donnés* and the Black Dahlia Murder," presented at the Philadelphia Symposium for the History of Art at the Philadelphia Museum of Art (April 2001). The paper was published as "Case Open and/or Unsolved: Marcel Duchamp and the Black

Dahlia Murder" in *Rutgers Art Review* 20 (2003): pp. 7–24, and as "Case Open and/or Unsolved: *Étant donnés*, the Black Dahlia Murder, and Marcel Duchamp's Life of Crime" in "articles" in *tout-fait: The Marcel Duchamp Studies Online Journal* (January 2005), http://www.toutfait.com/duchamp.jsp?postid=4310. Focusing on historical record and Duchamp's intellectual preoccupation with criminality, Wallis explores the possibility that Man Ray may have played a role in the evolution of the *Étant donnés* as it related to the murder. See *Rutger's Art Review* version, p. 15.

7. Tashjian, p. 113.

8. Man Ray, *Self Portrait* (New York: Little, Brown & Co. in association with the Atlantic Monthly Press, 1963; Bulfinch Press, 1998), p. 292.

9. See *CPLY*, pp. 14–15.

10. Wallis, p. 2.

11. See *William Copley*, p. 5.

12. *CPLY*, p. 13.

13. Tashjian, p. 120–21.

14. The catalog for Copley's 1974 exhibition at the Onnasch Galerie and the Moore College of Art titles this painting *Il est Minuit Dr. _____*, while a 1999 catalog for the exhibition at the Forum for Contemporary Art in Missouri lists the title as *Il es Minuit, Docteur*. We use the first title because Copley was alive when the exhibition occurred and would likely have ensured correct titling.

Marcel Duchamp and the *Étant donnés*, Part II
Pages 146–147

1. Marcel Duchamp, *Manual of Instructions for* Étant Donnés: 1° La chute d'eau, 2° Le gaz d'éclairage . . . (Philadelphia: Philadelphia Museum of Art, 1987), facsimile of Duchamp's handwritten 1967 original, unpaginated.

2. D'Harnoncourt and McShine, pp. 29–31.

3. Tomkins, p. 433.

4. Interviews with Billy Copley, January 3 and February 6, 2006.

Bibliography

Ades, Dawn, and Michael R. Taylor, curators, *Dali.* With the assistance of Montse Aguer. New York and Philadelphia: Rizzoli International Publications, Inc., in association with the Philadelphia Museum of Art, 2004.

Ades, Dawn. "Surrealism, Male-Female." In *Surrealism: Desire Unbound,* edited by Jennifer Mundy. London: Tate Publishing, 2001.

The Archive 16 (June 1982). Special issue on Johan Hagemeyer. Tucson and San Francisco: The Center for Creative Photography, the University of Arizona, in cooperation with the San Francisco Museum of Modern Art.

Armstrong, Nancy, and Melissa Wagner. *Field Guide to Gestures: How to Identify and Interpret Virtually Every Gesture Known to Man.* Philadelphia: Quirk Books, 2003.

Baigell, Matthew E. "Jewish Artists in New York During the Holocaust Years." Washington, D.C.: United States Holocaust Memorial Museum Center for Advanced Holocaust Studies, 2001. http://www.ushmn.org/research/center/publications/occasional/2001-03/paper.pdf.

Baldacci, Paolo. *De Chirico: The Metaphysical Period 1888–1919.* Translated by Jeffrey Jennings. New York: Bulfinch Press, 1997.

Baldwin, Neil. *Man Ray: American Artist.* New York: Clarkson N. Potter, Inc., 1988.

Barnett, Vivian Endicott, and Helfenstein, Josef, eds. *The Blue Four: Feininger, Jawlensky, Kandinsky, and Klee in the New World.* New Haven and Cologne: Yale University Press and DuMont Buchverlag, 1997.

Barron, Stephanie. *Exiles + Emigrés: The Flight of European Artists from Hitler.* With Sabine Eckmann et al. Los Angeles and New York: Los Angeles County Museum of Art and Harry N. Abrams, Inc., 1997.

Baxter, John. "Man Ray Laid Bare." *Tate Magazine* 3 (spring 2005).

Breton, André. *Mad Love.* Translated by Mary Ann Caws. Lincoln and London: University of Nebraska Press, 1987. Originally published as *L'amour fou* (Paris: Éditions Gallimard, 1937).

———."Manifesto of Surrealism" (1924) and "Second Manifesto of Surrealism" (1930). In *Manifestoes of Surrealism,* translated by Richard Seaver and Helen R. Lane. Ann Arbor: University of Michigan Press, 1969, 1972, 2004. Originally published as *Manifestes du surrealisme* (© J. J. Pauvert, 1962).

———. *Surrealism and Painting.* Introduction by Mark Polizzotti. Translated by Simon Watson Taylor in 1972. Boston: MFA Publications, 2002. Originally published as *Le surréalisme et la peinture* (Paris: Éditions Gallimard, 1928).

Brotchie, Alastair, comp., and Mel Gooding, ed. *A Book of Surrealist Games.* Boston and London: Shambhala Redstone Editions, 1995.

Butterfield & Butterfield. *Modern, Contemporary & Latin American Art. October 26 & 27, 1999, in San Francisco, Los Angeles, and Chicago.* Auction catalog.

Butterfield & Dunning / Butterfield & Butterfield. *American and California Paintings and Sculpture, June 17, 1999, in San Francisco, Los Angeles, and Chicago.* Auction catalog.

———. *Fine Photographs: May 27, 1999, in San Francisco, Los Angeles, and Chicago.* Auction catalog.

———. *Fine Photographs: November 17, 1999, in San Francisco, Los Angeles, and Chicago.* Auction catalog.

Carter, Vincent A. *LAPD's Rogue Cops: Cover Ups and the Cookie Jar.* Lucerne Valley, Calif.: Desert View Books, 1993.

Caws, Mary Ann, ed. *Surrealism.* London and New York: Phaidon Press, 2004.

Chipp, Herschel B. *Picasso's Guernica: History, Transformations, Meanings.* With a chapter by Javier Tusell. Berkeley, Los Angeles, and London: University of California Press, 1988.

Clearwater, Bonnie, ed. *West Coast Duchamp.* Miami Beach and Santa Monica: Grassfield Press, Inc., in association with Shoshana Wayne Gallery, 1991.

Copley, William. *CPLY: Portrait of the Artist as a Young Dealer.* Paris: Centre National d'Art et de Culture Georges Pompidou, 1977. Reprinted in the exhibition catalog *CPLY: Reflections on a Past Life.* Houston: Institute for the Arts, Rice University, 1979.

courttv Crime Library: Criminal Minds and Methods. "In Rader's Own Words." http://www.crimelibrary.com/serial_killers/unsolved/btk/44.html.

Cross, John Keir. *The Other Passenger.* London: John Westhouse (Publishers) Limited, 1944.

Cummings, Paul. Oral History Interview with William Copley. Smithsonian Archives of American Art, Oral History Interviews, 1968. http://www.aaa.si.edu/collections/oralhistories/transcripts/copley68.htm.

Dailey, Victoria, Natalie Shivers, and Michael Dawson. *LA's Early Moderns.* Introduction by William Deverell. Los Angeles: Balcony Press, 2003.

Dervaux, Isabelle, et al. *Surrealism USA.* New York and Ostfildern-Ruit, Germany: National Academy Museum and Hatje Cantz Publishers, 2004.

Descharnes, Robert, and Gilles Néret. *Salvador Dalí: L'oeuvre peint 1904–1989.* Cologne: Benedikt Taschen Verlag GmbH, 1993.

Diehl, Gaston. *Max Ernst.* Translated by Eileen B. Hennessy. New York: Crown Publishers, 1973.

Duchamp, Marcel. *Manual of Instructions for Étant Donnés: 1° La chute d'eau, 2° Le gaz d'éclairage . . .* Philadelphia: Philadelphia Museum of Art, 1987. Facsimile of Duchamp's handwritten 1967 original.

Duchamp, Marcel, Richard Hamilton, and George Heard Hamilton. *The Bride Stripped Bare by Her Bachelors, Even: A Typographic Version by Richard Hamilton of Marcel Duchamp's* Green Box *Translated by George Heard Hamilton.* Stuttgart, London, and Reykjavik: Edition Hansjörg Mayer, 1960, 1963, 1976.

Dunne, John Gregory. *True Confessions.* New York: E. P. Dutton, 1977.

Durozoi, Gérard. *History of the Surrealist Movement.* Translated by Alison Anderson. Chicago and London: University of Chicago Press, 2002, 2004. Originally published as *Histoire du mouvement surréaliste,* © Éditions Hazan, 1997.

de l'Ecotais, Emmanuelle, and Alain Sayag, eds. *Man Ray: Photography and Its Double.* Corte Madera, Calif.: Gingko Press, Inc., 1998.

Ellroy, James. *The Black Dahlia.* New York: Mysterious Press, 1987.

Ernst, Max. "Some Data on the Youth of M. E. as Told by Himself." In *Max Ernst: Beyond Painting and Other Writings by the Artist and His Friends.* New York: Wittenborn, Schultz, Inc., 1948.

———. *Une semaine de bonté: A Surrealistic Novel in Collage.* Translated by Stanley Appelbaum. New York: Dover Publications, Inc., 1976. First published 1934 by Editions Jeanne Bucher, Paris.

Etherington-Smith, Meredith. *The Persistence of Memory: A Biography of Dalí.* New York: Random House, Inc., 1992.

The Federal Bureau of Investigation Freedom of Information–Privacy Act web site. Elizabeth Short files. http://foia.fbi.gov/foiaindex/short_e.htm.

Felleman, Susan. *Botticelli in Hollywood: The Films of Albert Lewin.* New York: Twayne Publishers, 1997.

Ferguson, Robert. *Henry Miller: A Life.* New York and London: W. W. Norton & Co. Inc., 1991, 1993.

Fetherling, Doug. *The Five Lives of Ben Hecht.* Toronto: Lester & Orpen Ltd., 1977.

Focus on Minotaure: *The Animal-Headed Review.* Geneva: Musée d'Art et d'Histoire and Éditions d'Art Albert Skira S. A., 1987.

Ford, Charles Henri, ed. View: *Parade of the Avant-Garde 1940–1947*. Foreword by Paul Bowles. New York: Thunder's Mouth Press, 1991.

Foresta, Merry, et al. *Perpetual Motif: The Art of Man Ray*. Washington, D.C.: National Museum of American Art, Smithsonian Institution, 1988.

Foster, Hal. *Convulsive Beauty*. Cambridge, Mass., and London: MIT Press, 1993, 1995.

———. "Violation and Veiling in Surrealist Photography: Woman as Fetish, as Shattered Object, as Phallus." In *Surrealism: Desire Unbound*, edited by Jennifer Mundy. London: Tate Publishing, 2001.

Foster, Stephen C., ed. *Hans Richter: Activism, Modernism, and the Avant-Garde*. Cambridge, Mass., and London: MIT Press, 1998.

Fowler, Will R. *Reporters: Memoirs of a Young Newspaperman*. Malibu, Calif.: Roundtable Publishing, 1991.

Freud, Sigmund. *The Interpretation of Dreams*. Translated and edited by James Strachey. New York: Basic Books, Inc., in arrangement with George Allen & Unwin, Ltd., and The Hogarth Press, Ltd., 1965.

———. *The Uncanny*. Translated by David McLintock with an introduction by Hugh Haughton. New York: Penguin Books, 2003.

Gilmore, John. *Severed: The True Story of the Black Dahlia Murder*. Los Angeles: Zanja Press, 1994.

Girst, Thomas. " 'A very normal guy': An interview with Robert Barnes on Marcel Duchamp and the *Étant Donnés*." *tout-fait: The Marcel Duchamp Studies Online Journal* 4 (2002). http://www.toutfait.com/duchamp.jsp?postid=1193.

Graham, Lanier. *Duchamp and Androgyny: Art, Gender, and Metaphysics*. Berkeley: No-Thing Press, 2002.

Grobel, Lawrence. *The Hustons*. New York: Avon Books, 1989.

Haenlein, Carl, ed., with contributions by Johannes Gachnang, Alan Jones, and Roland Penrose. *William N. Copley: Heed Greed Trust Lust, Paintings 1951–1994*. Hannover: Kestner-Gesellschaft e. V., 1995.

Hamalian, Linda. *A Life of Kenneth Rexroth*. New York and London: W. W. Norton & Co., 1991.

d'Harnoncourt, Anne, and Kynaston McShine, eds. *Marcel Duchamp*. Munich: Prestel-Verlag, in cooperation with the Museum of Modern Art, New York, and the Philadelphia Museum of Art, 1989. First published 1973 by The Museum of Modern Art, New York.

Hecht, Ben. *Fantazius Mallare: A Mysterious Oath*. Drawings by Wallace Smith. Chicago: Covici-McGee, 1922.

———. *The Kingdom of Evil: A Continuation of the Journal of Fantazius Mallare*. Illustrations by Anthony Angarola. Chicago: Pascal Covici, 1924.

Hodel, Steve. *Black Dahlia Avenger: A Genius for Murder*. New York: Arcade, 2003; Harper Perennial, 2004. Foreword by James Ellroy, 2004.

———. "*Black Dahlia Avenger* Frequently Asked Questions." http://www.blackdahliaavenger.com/details.html, "Frequently Asked Questions."

Hofmann, Irene E. "Documents of Dada and Surrealism: Dada and Surrealist Journals in the Mary Reynolds Collection." Chicago: The Art Institute of Chicago, 2001. http://www.artic.edu/reynolds/essays/hofmann.php.

Homolka, Florence. *Focus on Art*. Foreword by Aldous Huxley. New York: Ivan Obolensky, Inc., 1962.

Huston, John. *An Open Book: An Autobiography by John Huston*. New York: Alfred A. Knopf, 1980.

In Focus: Photographs from the J. Paul Getty Collection/Man Ray. Los Angeles: J. Paul Getty Museum, 1998.

Jones, Alan. "A Conversation with William Copley." In *CPLY*. New York: David Nolan Gallery, 1991. Exhibition brochure.

Kachur, Lewis. *Displaying the Marvelous: Marcel Duchamp, Salvador Dalí, and Surrealist Exhibition Installations.* Cambridge, Mass., and London: MIT Press, 2001.

Karlstrom, Paul. Interview with Vincent Price. Smithsonian Archives of American Art, Oral History Interviews, 1992. http://www.aaa.si.edu/collections/oralhistories/transcripts/price92.htm.

Kaufman, Louis. *A Fiddler's Tale: How Hollywood and Vivaldi Discovered Me.* With Annette Kaufman. Foreword by Jim Svejda. Madison: University of Wisconsin Press, 2003.

Knowlton, Janice, and Michael Newton. *Daddy Was the Black Dahlia Killer.* New York: Pocket Books, 1995.

Krauss, Rosalind, and Jane Livingston. *L'amour fou: Photography & Surrealism.* With an essay by Dawn Ades. Washington, D.C., and New York: The Corcoran Gallery of Art and Abbeville Press, 1985.

Krohn, Bill. *Hitchcock at Work.* London: Phaidon Press, 2000.

The Library of Congress American Memory/Historic American Buildings Website. Architectural plans, photographs, and data pages regarding the Lloyd Wright–designed Sowden House at 5121 Franklin Avenue in Los Angeles. http://memory.loc.gov/ammem/collections/habs__haer/index.html.

The Louise and Walter Arensberg Collection: Twentieth-Century Section. Philadelphia: Philadelphia Museum of Art, 1954.

Mahon, Alyce. *Surrealism and the Politics of Eros, 1938–1968.* New York: Thames & Hudson, 2005.

Man Ray. Los Angeles: Los Angeles Museum of Art, Lytton Gallery, 1966.

Man Ray: Paintings, Objects, Photographs: Property from the Estate of Juliet Man Ray, the Man Ray Trust, and the Family of Juliet Man Ray, London, 22nd & 23rd March 1995. London: Sotheby's, 1995.

Man Ray: Paris–LA. Santa Monica: Smart Art Press, Track 16 Gallery, and Robert Berman Gallery, 1996.

Man Ray. *Self Portrait.* New York: Little, Brown & Co. in association with the Atlantic Monthly Press, 1963; Bulfinch Press, 1998.

Man Ray's Man Rays. West Palm Beach and New York: Norton Museum of Art and Aperture, 1994.

Marcel Duchamp. Edited by The Museum Jean Tinguely, Basel. Ostfildern-Ruit, Germany: Hatje Cantz Publishers, 2002.

The Menil Foundation, Inc. *Joseph Cornell / Marcel Duchamp . . . in Resonance.* Houston and Ostfildern-Ruit, Germany: Cantz Verlag, 1998.

Mundy, Jennifer, ed. *Surrealism: Desire Unbound.* London: Tate Publishing Ltd., 2001.

Naumann, Francis M. *Making Mischief: Dada Invades New York.* With Beth Venn et al. New York: Whitney Museum of American Art, 1996.

———. "Marcel & Maria." *Art in America* (April 2001).

Naumann, Francis M., and Hector Obalk Ludion, eds. *Affectionately, Marcel: The Selected Correspondence of Marcel Duchamp.* Translation by Jill Taylor. Ghent and Amsterdam: Ludion Press, 2000.

Pacios, Mary. *Childhood Shadows: The Hidden Story of the Black Dahlia Murder.* Bloomington, Ind.: Authorhouse, 1999.

Passeron, René. *Surrealism.* Paris: Finest S. A. / Éditions Pierre Terrail, 2001.

Paz, Octavio. *Marcel Duchamp, Appearance Stripped Bare.* New York: Viking Press, 1978.

Pearson, Billy, and Stephen Longstreet. *Never Look Back: The Autobiography of a Jockey.* Introduction by John Huston. New York: Simon & Schuster, 1958.

Picon, Gaëtan. *Surrealists and Surrealism, 1919–1939.* Geneva: Éditions d'Art Albert Skira S. A., 1977, 1983, 1995.

Pierre, José, ed. *Investigating Sex: Surrealist Discussions 1928–1932.* Translated by Malcolm Imrie. London and New York: Verso, 1992.

The Portable Dalí. Introduction by Robert Hughes. New York: Universe Publishing, 2003. Introduction excerpted from *The Shock of the New* by Robert Hughes, © 1980, 1992.

The Portable Magritte. Introduction by Robert Hughes. New York: Universe Publishing, 2002.

Price, Victoria. *Vincent Price: A Daughter's Biography.* New York: St. Martin's Griffin, 2000 / © 1999 Victoria Price.

Price, Vincent. *I Like What I Know: A Visual Autobiography.* Garden City, N.Y.: Doubleday & Co., Inc., 1959.

Ramírez, Juan Antonio. *Duchamp: Love and Death, Even.* Translated by Alexander R. Tulloch. London: Reaktion Books, 1998.

Rasmussen, William T. *Corroborating Evidence: The Black Dahlia Murder.* Santa Fe: Sunstone Press, 2005.

Reinhardt, Brigitte, Kay Heymer, Carl Heinlein, and Marc Gundel. *William N. Copley: True Confessions.* Ostfildern, Germany: Verlag Gerd Hatje, 1997.

Richardson, James H. *For the Life of Me: Memoirs of a City Editor.* New York: G. P. Putnam's Sons, 1954.

Ries, Martin. "Picasso and the Myth of the Minotaur." *Art Journal* (winter 1973–74).

Sade, Marquis de. *The 120 Days of Sodom and Other Writings.* Compiled and translated by Austryn Wainhouse and Richard Seaver. Introductions by Simone de Beauvoir and Pierre Klossowski. New York: Grove Press, 1966.

Sawelson-Gorse, Naomi. "Hollywood Conversations: Duchamp and the Arensbergs." In *West Coast Duchamp,* edited by Bonnie Clearwater. Miami Beach and Santa Monica: Grassfield Press, Inc., in association with Shoshana Wayne Gallery, 1991.

Sawin, Martica. *Surrealism in Exile and the Beginning of the New York School.* Cambridge, Mass., and London: MIT Press, 1995.

Schaffner, Ingrid. *The Essential Man Ray.* New York: Harry N. Abrams, Inc., Wonderland Press, 2003.

———. *Salvador Dalí's Dream of Venus: The Surrealist Funhouse from the 1939 World's Fair.* Photographs by Eric Schaal. New York: Princeton Architectural Press, 2002.

Schaffner, Ingrid, and Lisa Jacobs, eds. *Julien Levy: Portrait of an Art Gallery.* Cambridge, Mass., and London: MIT Press, 1998.

Schwarz, Arturo. *The Complete Works of Marcel Duchamp.* New York: Harry N. Abrams, Inc., 1969.

———. *Man Ray: The Rigour of Imagination.* New York: Rizzoli International Publications, Inc., 1977.

Semin, Didier. *Victor Brauner.* Paris: Éditions Filipacci and Réunion des Musées Nationaux, 1990.

Shattuck, Roger. "Candor and Perversion in No-Man's Land." In *Perpetual Motif: The Art of Man Ray,* by Merry A. Foresta et al. New York and Washington, D.C.: Abbeville Press and the National Museum of American Art, Smithsonian Institution, 1988.

Singh, Madanjeet. *Himalayan Art: Wall-Painting and Sculpture in Ladakh, Lahaul and Spiti, the Siwalik Ranges, Nepal, Sikkim and Bhutan.* Greenwich, Conn.: New York Graphic Society, Ltd., in agreement with UNESCO, 1968.

Sotheby's. *Photographs.* Auction catalog, New York, Wednesday, April 28, 1999.

Spies, Werner. *Max Ernst Collages: The Invention of the Surrealist Universe.* New York: Harry N. Abrams, Inc., 1991.

Spies, Werner, and Sigrid and Gunter Metken, eds. *Max Ernst. Oeuvre-Katalog. Band I–VI. Werke 1906–1929.* Houston and Cologne: The Menil Foundation and DuMont Schauberg, 1975, 2004.

Spies, Werner, and Sabine Rewald. *Max Ernst: A Retrospective*. New York and New Haven: The Metropolitan Museum of Art and Yale University Press, 2005.

Stich, Sidra, et al. *Anxious Visions: Surrealist Art*. Berkeley and New York: the Regents of the University of California, Berkeley, and Abbeville Press, Inc., 1990.

Tanning, Dorothea. *Between Lives: An Artist and Her World*. New York and London: W. W. Norton & Co., 2001.

Tashjian, Dickran. *A Boatload of Madmen: Surrealism and the American Avant-Garde, 1920–1950*. New York and London: Thames and Hudson, 1995.

———. " 'A Clock That Forgets to Run Down': Man Ray in Hollywood 1940–1951." In *Man Ray: Paris–LA*. Santa Monica: Smart Art Press, Track 16 Gallery, and Robert Berman Gallery, 1996.

Taylor, John Russell. *Strangers in Paradise: The Hollywood Émigrés, 1933–1950*. New York: Holt, Rinehart and Winston, 1983.

Taylor, Michael R., with Guigone Rolland. *Giorgio de Chirico and the Myth of Ariadne*. Philadelphia: The Philadelphia Museum of Art, 2002.

Taylor, Sue. *Hans Bellmer: The Anatomy of Anxiety*. Cambridge, Mass., and London: MIT Press, 2000.

———. "Hans Bellmer in the Art Institute of Chicago: The Wandering Libido and the Hysterical Body." Chicago: The Art Institute of Chicago, 2001. http://www.artic.edu/reynolds/essays/taylor.php.

Tomkins, Calvin. *Duchamp: A Biography*. New York: Henry Holt and Co., 1996; Owl Books, 1998.

Turpin, Ian. *Ernst*. London: Phaidon Press, 1979, 1994.

Victor Brauner: Surrealist Hieroglyphs. Houston and Ostfildern-Ruit, Germany: The Menil Foundation and Hatje Cantz Verlag, 2001.

Wald, Elijah. *Josh White: Society Blues*. New York and London: Routledge by arrangement with the University of Massachusetts Press, 2002.

Wallis, Jonathan. "Case Open and/or Unsolved: Marcel Duchamp and the Black Dahlia Murder." *Rutgers Art Review: The Journal of Graduate Research in Art History* 20 (2003). Also published as "Case Open and/or Unsolved: *Étant donnés*, the Black Dahlia Murder, and Marcel Duchamp's Life of Crime" in *tout-fait: the Marcel Duchamp Studies Online Journal* (January 2005). http://www.toutfait.com.

Walz, Robin. *Pulp Surrealism: Insolent Popular Culture in Early Twentieth-Century Paris*. Berkeley, Los Angeles, and London: University of California Press, 2000.

Warncke, Carsten-Peter. *Pablo Picasso: 1881–1973*. Edited by Ingo F. Walther. Translated by Michael Hulse. Cologne: Benedikt Taschen Verlag GmbH, 1995.

Webb, Jack. *The Badge: True and Terrifying Crime Stories That Could Not Be Presented on TV, from the Creator and Star of* Dragnet. Introduction by James Ellroy. New York: Thunder's Mouth Press, 2005. First published 1958 by Mark VII, Ltd.

William Copley. New York and Philadelphia: Onnasch Galerie and Moore College of Art Gallery, 1974. Exhibition brochure.

William Copley. St. Louis: Forum for Contemporary Art, 1997. Exhibition brochure.

The William N. Copley Collection. November 5 & 6, 1979. New York: Sotheby Parke Bernet Incorporated, 1979. Auction catalog.

Wolfe, Donald. *The Black Dahlia Files: The Mob, the Mogul, and the Murder That Transfixed Los Angeles*. New York: ReganBooks, 2005.

Wood, Beatrice. *I Shock Myself: The Autobiography of Beatrice Wood*. Edited by Lindsay Smith. San Francisco: Chronicle Books, 1988. © 1985 Beatrice Wood. First published 1985 in Ojai, Calif., by Dillingham Press.

Index

Page numbers of photographs and illustrations appear in italics.

FIGURE 149: MAN RAY, UNTITLED, 1936
© 2006 MAN RAY TRUST / ADAGP (ARS) / TELIMAGE

Copyright © 2006 by Mark Nelson and Sarah Hudson Bayliss
All rights reserved. No part of this book may be reproduced
in any form or by any electronic or mechanical means,
including information storage and retrieval systems,
without permission in writing from the publisher, except
by a reviewer who may quote brief passages in a review.

Every attempt has been made to locate and identify
the proper copyright holders of the works shown in this
book. Any errors or omissions will be corrected in
subsequent editions.

Permission to reprint material from the Gloria de Herrera
Papers, the Jean Brown Papers, and the Man Ray Letters and
Album granted by the Research Library, the Getty Research
Institute, Los Angeles (980024; 890164; 930027).

Bulfinch Press
Hachette Book Group USA
1271 Avenue of the Americas, New York, NY 10020
Visit our Web site at www.bulfinchpress.com

First Edition: October 2006

Library of Congress Cataloging-in-Publication Data
Nelson, Mark.
Exquisite corpse : surrealism and the Black Dahlia Murder /
Mark Nelson and Sarah Hudson Bayliss.
p. cm.
Includes bibliographical references and index.
ISBN-10: 0-8212-5819-2 (hardcover)
ISBN-13: 978-0-8212-5819-4 (hardcover)
1. Hodel, George. 2. Short, Elizabeth, 1924–1947. 3. Man Ray,
1890–1976. 4. Duchamp, Marcel, 1887–1968. 5. Murder —
California — Los Angeles. 6. Surrealism. 7. Murder in art.
I. Bayliss, Sarah Hudson. II. Title.
HV6534.L7N45 2006
364.152'30979494 — dc22 2006001460

Jacket and book design by Mark Nelson
Printed in Singapore

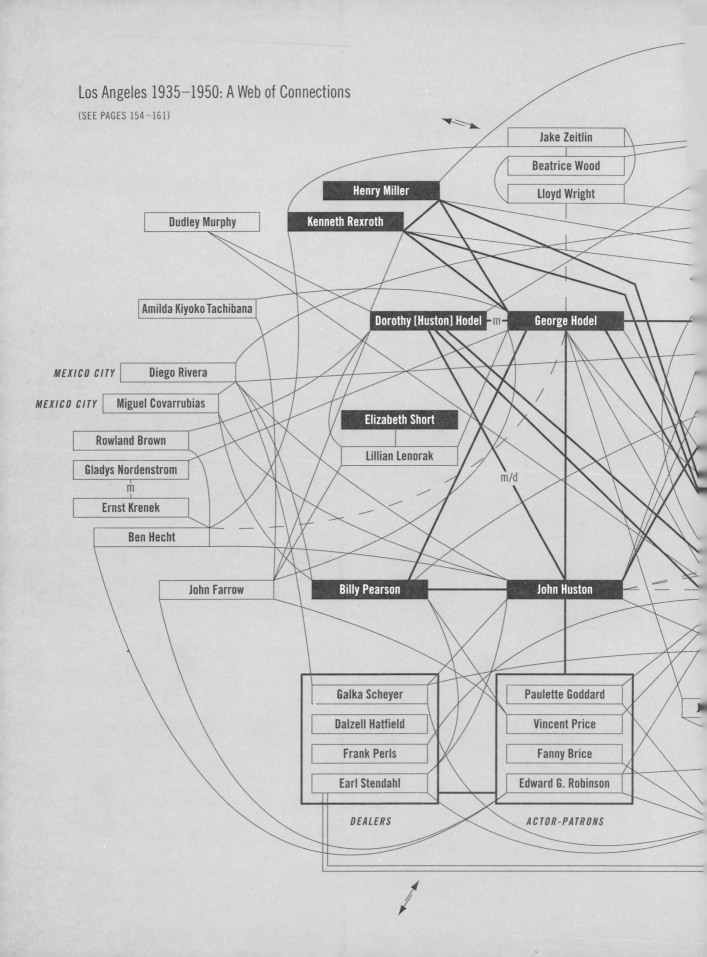

Los Angeles 1935–1950: A Web of Connections

(SEE PAGES 154–161)

Jake Zeitlin

Beatrice Wood

Lloyd Wright

Henry Miller

Kenneth Rexroth

Dudley Murphy

Amilda Kiyoko Tachibana

Dorothy [Huston] Hodel — m — George Hodel

MEXICO CITY Diego Rivera

MEXICO CITY Miguel Covarrubias

Elizabeth Short

Rowland Brown

Lillian Lenorak

Gladys Nordenstrom

m/d

m

Ernst Krenek

Ben Hecht

John Farrow

Billy Pearson

John Huston

Galka Scheyer

Paulette Goddard

Dalzell Hatfield

Vincent Price

Frank Perls

Fanny Brice

Earl Stendahl

Edward G. Robinson

DEALERS

ACTOR-PATRONS